Feminism & Popular Culture

FEMINISM & POPULAR CULTURE

INVESTIGATING THE POSTFEMINIST MYSTIQUE

REBECCA MUNFORD
& MELANIE WATERS

Rutgers University Press
New Brunswick, New Jersey

Library of Congress Cataloging-in-Publication Data

Munford, Rebecca, 1975-
 Feminism and popular culture: investigating the postfeminist mystique /
 Rebecca Munford and Melanie Waters.
 pages cm
 Includes bibliographical references and index.
 ISBN 978-0-8135-6741-9 (hardcover : alk. paper) -- ISBN 978-0-8135-
 6653-5 (pbk. : alk. paper) -- ISBN 978-0-8135-6742-6 (e-book)
 1. Feminist theory. 2. Feminism and mass media. 3. Women in popular
 culture. I. Waters, Melanie, 1979- II. Title.
 HQ1190.M86 2014
 305.4201--dc23
 2013030559

A British Cataloguing-in-Publication record for this book is available from the
British Library.

First published in the United States 2014
by Rutgers University Press, New Brunswick, New Jersey

First published by I.B.Tauris & Co Ltd in the United Kingdom

Visit our website: http://rutgerspress.rutgers.edu

Manufactured in Great Britain

Contents

Foreword
Imelda Whelehan

As I write this foreword I am also preparing a lecture for a Gender Studies course about the legacy of radical feminism. Many of the resources I use to get myself back in the radical feminist mood are ghostly impressions of the past, battered old copies of *Ms.* and *Spare Rib*, photocopies of ephemera retrieved from archives and libraries. As I handle them and try to make out the fading print, I am reminded of the originals I copied, themselves ghostly purpled Roneo-ed versions of someone's hand-typed notes – a form of reproduction common when I was at school in the 1970s, but alien and incomprehensible to most of today's readers. So much radical and socialist feminist second wave knowledge lies in these faint and ageing pieces of paper. Those lucky enough to gain access to archives containing women's liberation newsletters will know the feeling of handling something falling apart, often mis-stapled or unpaginated, and full of typos. Such artefacts hint at the once material presence of the writer(s), time-poor and bashing out their thoughts on old manual typewriters with unreliable ribbons before taking them to the streets, consumed with a sense of their urgency and relevance. I pick up a few I have copied, but when were they written? Such was the rush to share these ideas that some do not even have dates: all that mattered for women's liberation was the here and now.

My computer screen acts as a window to the past as I watch *A Woman's Place* (1971), a documentary that shows footage from the Oxford Ruskin conference in 1970. Grainy black and white images show well-spoken men being asked about the crèche they are running while the women have their conference. Asked if they would perform this service again, the answer is very much in the negative – perhaps one glimpse of 'women's work' is enough to raise the male consciousness. The graininess makes the scenes ghostly and unreal as does the content which the scenes depict – children playing seem to weave through the furls of smoke from the cigarettes being smoked by the men. And this is the biggest jolt of all – my contemporary self is momentarily shocked at seeing a room full of children while adults unselfconsciously smoke their cigarettes. This single huge change in social mores underscores the fact that this is an alien world; these people are ghosts. As I switch DVDs to *Town Bloody Hall* (1979), Betty Friedan hoves into view in the audience during the question period of the 1971 New York Town Hall debate on women's liberation, reconstructed as a documentary by Don Pennebaker and Chris Hegedus; Germaine Greer looks out of place, as if she meant to attend a ball but got hijacked into this strange angry place. Friedan is dead now, of course, and as I write it is 50 years since the publication of *The Feminine Mystique* (1963). This ancient but inspirational book is still constantly in print, but I wish I could conjure the ghosts of those dead feminists like Friedan and Adrienne Rich; and also the spectres of the youthful pasts of Greer and others to convey to my students what women's liberation meant for them. I imagine a group of radical feminists enjoying a chaotic sit-in at the *Ladies Home Journal* in 1970. Apparently over 100 women occupied the (male) editor-in-chief's office demanding he be replaced by a woman, more black editorial workers to match readership, a daycare centre for working mothers and the elimination of degrading advertising, as well as the publication of articles on women's liberation (see Echols 196). Ultimately the editor negotiated with only a few women from this larger group, and all they got was a pull-out section on women's liberation. As

I imagine this bustling editorial office, in my mind the scene is blended with the retro-nostalgic images of the TV series *Mad Men* (2007-) with be-suited secretaries servicing thrusting young men.

My contemporary position (sitting in my office in the Southern Hemisphere thinking about and teaching Gender Studies) and my historical position (as a child of feminism, but without a feminist mother) makes imagining these spectres important, and it represents the spaces I fill where my memory cannot stretch. I use film footage, photographic stills, illustrations and gobbets of radical feminist writings to help stir my students' imaginations in place of asking them to remember, which is impossible. Their reality is that of 'postfeminism' and most of them have a sense of what that might mean, or at least what it means for them. Beyond the visual and *yes* other aids I provide they will surf the internet and find all kinds of bits and pieces from which they can further construct a notion of feminism, cut off from its historical anchor. They may find that a '*Mad Men* aesthetic' overlays more authentic mental images of the 1960s, as the recent furore over Faber's new cover for Sylvia Plath's *The Bell Jar* (1963) suggests. This fiftieth anniversary edition shows a woman fixing her make-up; the lower part of her face is all that is visible, with the angle of the compact mirror reflecting more of the face from below. The garish reds and pinks of the background, the compact and the woman's heavily-rouged lips clash with a hint of a green dress, recalling *Mad Men* and generic chick lit covers simultaneously.[1] While Faber has defended the cover as an attempt to sell Plath to a new generation of readers, a tension remains: is the young woman's 'performance' of femininity overlaid with postfeminist knowingness, or does this illustration trivialize and undermine the feminist message that many found in Plath's only published novel?

This volume begins with a discussion of feminism's first foray into the mass media with the publication of *Ms.* magazine in 1972, when some among the women's liberation movement moved away from the position that all publicity is bad publicity to an intervention in the form of this glossy feminist organ which

engaged with consumer culture the better to reach the women as yet untouched by radical politics. It had a mixed reception from a feminist perspective: radical Kathie Sarachild welcomed its publication, describing it as 'a molotov cocktail that looked like a martini' (qtd in Echols 154), only later to dismiss it as liberal feminist patriarchal collusion. A magazine that deployed the tools of the mass media with a glamorous spokesperson at its head was always going to be easy prey in a movement which was sceptical of feminist 'celebrity', or any initiative that essentially required the 'master's tools' to make it work. In selecting this title, *Feminism and Popular Culture*, Rebecca Munford and Melanie Waters are both courting trouble by reminding us of the tense relationship between feminism and the mass media, and summoning the spirit of an age not long past where purity of motive and deep suspicion of patriarchal power structures necessitated long and fraught struggles over how to deliver a popular but political feminism.

It would be fair to point out that these second wave pioneers did not entirely succeed in their project, and the rocky career of *Ms.* is testimony to the opposing pulls of gender politics and mainstream publishing. Because of its early and troubled decision to take advertising, *Ms.* is an evocative place to start the discussion of feminism and popular culture; it crystallizes the essential contradictions of such an encounter whilst announcing the birth of 'popular feminism', writ large, as the authors so acutely note, on the body of Wonder Woman. Feminism, it is suggested here, is 'undead' (p. 8); and this certainly accords with my own view, arrived at through nearly a quarter of a century of feminist teaching and research, of feminism's unfinished business. Moreover, feminism via *Ms.* channels a Wonder Woman with her superpowers restored to their former glory, rescuing her from the fogs of the feminine mystique.

This volume's focus on a 'hauntology' of feminism is offered as an antidote to the forgetful and partial impressions of feminism that emerge from postfeminist discourses of gender. Images of housewives, career women and the never-ageing 'girl' pervade

popular culture as seeming testimony to the lack of need to be original in popular cultural depictions of femininity. Yet there is always a flaw in the glass, a breaking through of a feminist consciousness, which threatens to destabilize the postfeminist certainties about what women want. For years critics of postfeminist discourse have been filleting popular culture, and calculating the losses and gains for feminism in contemporary representations of women, but recently one senses weariness, and even a renewed surge of anger. As Angela McRobbie notes, feminism is the unspeakable shade now, 'a monstrous ugliness which would send shudders of horror down the spines of young women today, as a kind of deterrent' (2009: 1). These spectres of a feminism betrayed leave McRobbie hungry for a return to materialist analyses of the impact of popular culture on women in order to further explore the ways it obscures women's cultural and political victories; she also recognizes the urgent need to explore the possibility that postfeminist popular culture, itself a commodified, politically empty feminism, gives the female consumer all the 'feminism' she requires. As Rosalind Gill suggests, perhaps not enough of this valuable work has, over the years, formulated its aim 'as an understanding of contemporary sexism' (2011: 64). Charlotte Brunsdon has already identified the phenomenon of the 'feminist ur-article' in which '[s]econd-wave feminism is remembered and demonized, as personally censorious, hairy and politically correct' (2005: 112). She asserts that such articles (claiming she is guilty of writing them herself) tend to put writers on the side of the work of popular culture against which the model feminist in the critic's head is positioned as out of touch – as one of those 'censorious feminists who will not let [the critic] like the story and its iconography, that is, the accoutrements of femininity' (113).

The joyless, tutting feminist who Brunsdon characterizes as summoned only to be demolished by the feminist 'ur-article' is the misremembered straw figure who is replaced as the restrictor of meaning and choice in the practice of 'othering feminism', lest we find out something unpleasant about our contemporary

relationship to popular culture. Pleasure is embraced, but somewhere in history pleasure and feminism became antithetical. This volume, by clearly identifying the postfeminist project as one of serial forgetting, enables a thorough consideration of what is lost, as well as reminding us that second wave feminism's core project was in remembering and acknowledging the realities of the lives of contemporary women, and of reminding them that life might be otherwise. It did the job so well during the late 1960s and 1970s that a significant number of women were joining political groups, cheerfully identifying as feminist and demanding more appropriate images of their own lives in the popular domain. Cast in this light, feminism's historical authenticity is contrasted to the persistent fictions of postfeminism, nowhere more starkly than on the cover of *Time* magazine, discussed in this volume, where TV character Ally McBeal is portrayed in full colour against the monochrome agedness of feminism's past.

Feminism and Popular Culture refuses this narrative, whereby feminism is read backwards through the likes of Ally McBeal, offering a historically grounded and enthralling account of feminism's legacy within the popular. It reminds us of the essential tensions between feminism and popular culture and acknowledges that although popularity and accessibility were the aims of the second wave, the popular was imbued with the voice of the father, especially in the realm of representational practices that wrought continued violence on the female body. Rather than re-enacting feminism's flaws and absences it recalls those moments of analytical clarity that haunt contemporary postfeminist narratives. In doing this there is also an acknowledgement of a deepening undercurrent of anxiety and doubt within feminist studies of popular culture. Much research has worried over the staples of postfeminism – Buffy, Bridget, Madonna, *Sex and the City* and, more recently, Gaga, *Mad Men* and *Twilight* – but this book anatomizes the shifts within postfeminist culture itself and the gathering gloom of retreatism and domestic entrapment which gestures back through second wave feminism's rediscovery and rereading of Charlotte

Perkins Gilman's *The Yellow Wallpaper* (1892). As is noted in this volume, the postfeminist Gothic, so prominent in recent popular cultural representations, has drifted into a state of selective amnesia. It forgets about the models of 'power feminism' that dominated the genre in the 1990s, and instead reverts to a default positioning of its female heroines as victims. The 'victim' feminism portrayed by writers such as Naomi Wolf as the mentality that blocked the progress of women to equality is the other ghost of the past that cannot rest. Regrettably, Wolf herself has had cause to rethink the modalities of power feminism, in relation to her own experiences, in her later work.

The increasingly visible and unmistakably feminist spectres that can be found on the surfaces of postfeminist narratives act as palpable projections of the anxiety of critiques of postfeminism, while, as these authors note, 'popular culture returns again and again to the same retrograde configurations of female identity' (p. 103). As problematic as Friedan's *Feminine Mystique* may be, it is perhaps timely to review 50 years of second wave feminism to consider whether the 'postfeminist mystique', as these authors describe it, resonates with Friedan's analysis. If, as Friedan declares, the feminine mystique suggests that women's core destiny lies in the appropriate display and fulfillment of their femininity, the most troubling aspect of the postfeminist mystique is that it is ultimately focused on the same goal, a goal it can only realize by positioning feminism as the madwoman in the attic, the illegitimate other of femininity as described by Sandra M. Gilbert and Susan Gubar in their classic 1979 feminist rereading of Charlotte Bronte's *Jane Eyre* (1847). But, like Bertha Mason, feminism is too disordered and unpredictable to be contained so easily; and where there are ghosts, there is the sense of a previous, perhaps more legitimate, occupier.

Acknowledgements

We are especially grateful to Philippa Brewster at I.B.Tauris for her unerring faith in this project and her patience in awaiting its completion.

Thanks are also due to the librarians at the Women's Library, the Feminist Archive North at the University of Leeds, the New York Public Library, the British Library, the Library at Northumbria and the Arts and Social Studies Library at Cardiff University for their support and assistance during the researching and writing of this book, as well as to *Ms.* magazine for kindly allowing us to use their iconic Wonder Woman as our cover image. Thanks, too, to Stacy Gillis for her involvement in the initial planning and administration of this project. Hannah Wilks also deserves a special mention for her copy-editing.

We would like to extend our gratitude to those friends and colleagues at Cardiff University and Northumbria University with whom we have discussed this book; these exchanges have been an ongoing source of inspiration and have helped us to shape and modify many of our ideas. We are especially indebted to Paul Crosthwaite, Ann Heilmann and Tomos Owen for their perceptive and helpful comments on earlier drafts of this book, and to members of the Gendered Subjects research group at Northumbria University for their advice and support. Particular thanks go to Imelda Whelehan, whose input and insights have enhanced this work immeasurably.

This book could not have been written without the help and encouragement of our friends and family, and it is to them this book is dedicated. Thanks, then, to Roberta, Alan, Kath, Tom, Bob, Les, Judith, Keith, Jen, Matilda, and especially to Tomos, Paul and Poppy.

Introduction
Wonder Women: 'All the world is waiting for you'

'Wonder Woman for President'. This demand, emblazoned in scarlet above the arresting image of a colossal Wonder Woman storming through main-street America, heralded the arrival in 1972 of a new feminist magazine on news-stands across the United States. *Ms. magazine*, co-founded by feminist journalist and activist Gloria Steinem, featured articles on abortion, domestic violence, pornography, housework and national politics and represented a vital intervention in mainstream media coverage of the women's movement by providing an explicitly feminist account of its aims and activities to a mass readership. In providing a link between women's glossy magazines and feminist political periodicals, the format of *Ms.*, writes Imelda Whelehan in *The Feminist Bestseller* (2005), 'aimed to counteract the more pernicious effects of the mass media in the US by offering a more reliable account of Movement activities and of issues of importance to women' (59). A public emissary of feminist perspectives, *Ms.* soon became, 'like the acronym NOW, a verbal symbol of the women's movement' (Cohen 325; qtd in Whelehan 59); as co-founding editor Letty Cottin Pogrebin puts it, the *Ms.* authors translated a 'movement into a magazine' ('HerStory' para. 2). Reproducing the outward format

of traditional women's glossies and framing its debut appearance in such a clearly demarcated space of popular culture, the magazine represented an attempt to mobilize the commercial marketplace for political ends. As Amy Erdman Farrell chronicles in *Yours in Sisterhood: Ms. Magazine and the Promise of Popular Feminism* (1998), in making an ally out of capitalism, *Ms.*

> worked to disrupt cultural hegemony from the inside, to fashion a new representation of women, and of women's magazines, within the context and the constraints of the commercial market. [...] The strength of this 'new magazine for women' was its ability to be both a women's magazine, which had a place on the battlefield of existing women's magazines, and a resource within the women's movement, a mass circulation text that could connect women to a national community of feminism. (16)

The magazine's dual identity facilitated the dissemination of a feminism that could not only coexist with, but was enabled by, consumer culture. Its launch in the early 1970s, announced by the formidable body of Wonder Woman, thus marked a seminal moment in the evolution of 'popular feminism'. That is, *Ms.* articulated the possibilities and potential of a mode of feminism that was 'popular' in terms of both its communality and its cultural location.[1] This was a mode of feminism that was, nonetheless, 'unpopular' for those detractors who deemed its alliance with the commercial marketplace to be tantamount to political betrayal (see Farrell 15).

The tensions and ambivalences underlying the 'double identity' of *Ms.* are self-consciously referenced through the provocative reincarnation of the iconic 1940s comic book figure of Wonder Woman on the cover of its first regular issue. Making her preview appearance in issue #8 of *All Star Comics* at the end of 1941, and becoming a recurrent feature of *Sensation Comics* in January 1942, Wonder Woman became the subject of her own comic in the summer of that year, charged with the task of entering 'a world torn

by the hatreds and wars of men' to 'fight for liberty and freedom and all womankind' (Marston and Peter 11). While Wonder Woman's unequivocally gendered mission was overtly resonant with the political aims and concerns of the women's liberation movement in the 1960s and 1970s, her protean identity over the preceding 30 years – from 1942 to 1972 – indexes the shifting and potent relationship between femininity, female agency and popular culture. More particularly, her burdened body acts as a stage for the dialectical relationship between feminism and femininity that continues **MC** to haunt popular discourses of female agency. Reading Wonder Woman's body becomes, in Mitra C. Emad's analysis, 'an exercise in swinging between the binaries of women's physical empowerment (and sexual freedom) and representations of a body in bondage, lassoed into submission, sometimes by her own power' (956).

An active participant in and advocate of America's involvement in World War II in her early comic book issues, Wonder Woman embodied a mode of female empowerment and independence opened up by the wartime economy and exemplified by the Rosie the Riveter campaign. Issues of *Sensation Comics* in 1943 depict Wonder Woman accompanying American marines in an attack on Japanese forces and persuading young women to get involved in America's war effort, placing this model of emergent female power in a national and patriotic context.[2] The post-war backlash against women's education and professionalism, however, saw Wonder Woman's retreat back into the domestic sphere and the realms of heterosexual romance. In *Backlash: The Undeclared War Against Women* (1991), her seminal anatomization of a regressive and chameleonic media discourse that blames feminism for creating 'a generation of unhappy single and childless women' (17), Susan Faludi identifies Wonder Woman as a casualty of media accounts of the dangers of education and work, both of which were 'stripping women of their femininity and denying them marriage and motherhood', not to mention causing them 'mental instability' (72). While post-war magazine fiction was representing careers for women in 'a more unattractive light […] than any time since the

turn of the century', on the pages of the comic books 'even the post-war Wonder Woman was going weak at the knees' (73). In her introduction to *Wonder Woman* (1995) Steinem similarly bemoans how, 'like so many of her real-life sisters in the post-war era of conservatism and "togetherness" of the 1950s', Wonder Woman 'had fallen on very hard times' (14). By 1949, Wonder Woman was well and truly domesticated through her subordination to narratives of 'romantic adventure' that saw her helpless and simpering in the arms of Captain Trevor. This narrative diminishment was further consolidated in the 1950s: while the January 1956 issue (#79) depicted the 'untamed' Wonder Woman miniaturized to the size of an ant, the October issue that same year (#85) continued the superhero's Lilliputian adventures by depicting her diminutive body in a glass bottle.

It was in 1968, a landmark year of feminist reappraisal, that Wonder Woman (under new editorial control) underwent her most significant transformation. Divested of her Amazonian superpowers, and demoted to a fashion-conscious spy girl, the 'New Wonder Woman', appeared on the cover of the October 1968 issue (#178) dressed in a mini-dress and thigh-length black leather boots. Wonder Woman's reincarnation coincided with the New York Radical Women's protests against the Miss America Pageant in Atlantic City, which took place that September. The demonstration received front-page newspaper coverage, generating an unprecedented amount of media attention for the women's liberation movement (see Faludi, 1991: 99). Part of the demonstration famously involved setting up a 'freedom trash can' into which were tossed the 'instruments of torture' that constituted traditional femininity – such as girdles, bras, false eyelashes, high heels, make-up and women's magazines (Morgan 585). This rejection of 'woman-garbage' symbolized a denunciation of feminine constraints and a refusal of the fetishized female body. Yet from this repudiation of fashion and dress rose one of the most resilient caricatures of second wave feminism: the figure of the 'bra-burner'. Bras, it seems, were not even burnt during the

protests – although, as Faludi puts it in *Backlash*, 'according to press accounts of the time, the bonfires of feminism nearly cremated the lingerie industry' (99). Whelehan describes how this 'creative addition' to the media coverage of the protests has 'stuck as part of our mass misremembering of the origins of the modern women's movement, so that younger women will continue to associate bra-burning with going too far; with going beyond the limits of rational protest'. The sexualized image of the bra-less woman, she continues, was quickly taken up by the mainstream media in order to 'contain the "danger" of the women's protest against competitive standards of femininity' (2000: 1). In making the unconstrained 'bra-less woman' synonymous with 'the feminist', and securing a long-lasting association between feminism and underwear in the popular imagination,[3] media representations of the women's liberation movement betrayed an anxiety about its threat to the discipline and orderliness of the social body. Not only a site of containment, the female body thus becomes a site for an act of forgetting – and a distortion of history – that co-opts feminist discourse into its scripts of traditional femininity.[4]

It is no surprise, then, that just as feminists in Atlantic City were tossing the trappings of traditional femininity into the 'freedom trash can', this very paraphernalia was being retrieved in order to re-fashion the 'New Wonder Woman' as a paradigm of fashionable – and clearly legible – femininity. Diana Prince, Wonder Woman's earthly alter ego, might have thrown out her cleavage-enhancing bustier in 1968 but, stripped of her mythological superpowers, she is reinstated to do the proper work of femininity as the owner of a boutique. Steinem's 1995 introduction laments Wonder Woman's change of fortunes:

> Though she still had adventures and even practiced karate, any attractive man could disarm her. She had become a kind of female James Bond, though much more boring because she was denied his sexual freedom. She was Diana Prince, a mortal who walked about in boutique, car-hop clothes and took the advice of a male mastermind

named 'I Ching'. It was in this sad state that I rediscovered my Amazon superhero in 1972. (15)

Redeploying the language of heterosexual romance and superheroism, Steinem describes how, like the other founding editors of *Ms.*, she had been 'rescued' in her childhood from the pow and splat of boys' comics by a super woman who had shown little girls that they too might have 'unknown powers'. It was now time to 'rescue Wonder Woman in return' (15).

Steinem's decision to 'rescue' Wonder Woman from her 'sad state' by re-birthing her on the cover of *Ms.* – with her superpowers and red bustier restored – both exemplified a wider project of feminist cultural recovery and marked an explicit intervention in popular culture and its representations of the conflicted relationship between femininity and feminism.[5] After some difficulty, the editors of *Ms.* finally succeeded in persuading Wonder Woman's publishers to agree to the inclusion of her original image 'on the cover of a new and unknown feminist magazine'. In 1972, Steinem recalls, 'Wonder Woman appeared on news-stands again in all her original glory, striding through city streets like a colossus, stopping planes and bombs with one hand and rescuing buildings with the other' (15). The political landscape of the main street figured on the cover is foregrounded by the juxtaposition of this classic image of American life with the framing representation of military warfare and its call for 'Peace and Justice in '72'. Clutching her trademark golden lasso, Wonder Woman looms large as a symbol of anti-war regeneration and the embodiment of the political power and presence of the feminist movement: 'Her momentum, her strength, and her size expressed the enthusiasm and energy of the early women's movement; she represented the figure of "womanpower", the public relations slogan used by national women's organizations to communicate the potential of women, economic and otherwise' (Farrell 54).[6] The vast body of Wonder Woman – mobile and unhindered – reimagines popular anxieties about the feminist body as disordered and unconstrained. Nevertheless, in representing

Wonder Woman as a dangerous gargantuan body, the *Ms.* cover remains an extremely contradictory text. While successfully mobilizing popular discourses about the feminist movement, the image of a gigantic Wonder Woman storming through public space also echoes 'the discourses of danger surrounding the women's movement in the 1970s' (Emad 968). Wonder Woman is readable here as an image of feminism running out of control, signalling the ways in which her body might offer itself up once again for co-option by the mainstream.[7]

Still, the July 1972 *Ms.* cover represented a deliberate, direct and – within certain parameters – successful challenge to the ever-increasing domestication of the post-war Wonder Woman. Alongside articles on the economics of housework, body hair, Simone de Beauvoir and women's voting practices, the July 1972 issue included an article by one of its co-founders, Joanne Edgar, entitled 'Wonder Woman Revisited', which claimed Wonder Woman as a figure of feminist liberation and announced that she would return to the comic book world in her full and original Amazonian glory in 1973.[8] Steinem recounts how, '[o]ne day some months after her rebirth', she received a phone call from 'one of Wonder Woman's tougher male writers. "Okay", he said, "she's got all of her Amazon powers back. She talks to the Amazons on Paradise Island. She even has a Black Amazon sister named Nubia. Now will you leave me alone?" I said we would' (17). In 1972, Steinem was also involved in producing *Wonder Woman: A Ms. Book* (published by Holt, Rinehart and Winston), featuring 13 of William Moulton Marston's more 'feminist' episodes and an 'interpretative essay' by Phyllis Chesler (see Marston 1972).[9] Implicated in complex patterns of appropriation and re-appropriation, freedom and constraint, Wonder Woman's reinstatement on the cover of the first regular issue of *Ms.* emblematizes the complex and contradictory nexus of debates that has characterized – and continues to characterize – the fraught relationship between feminism and popular culture.

The *Ms.* cover exemplifies many of the strategies and temporal slippages with which we are concerned in this book; not least is

the way that images and ideas from the past might return to haunt us – reminding us of projects that have been forgotten or cast aside, and helping us to calibrate 'new' feminist 'lines of flight'.[10] While her crisp lineaments and bold block colours give every impression of robust fleshiness, the Wonder Woman that appears on the cover of *Ms.* is peculiarly spectral: culled from the pages of her own comic book to make way for her less-powerful descendants, it is the spectre of the original Wonder Woman who rises up from the graveyard of 1940s popular culture in order to take up her role as standard-bearer for a 1970s generation of feminists. Transported through time to 1972, she is the ghostly projection of a feminist future that was once imagined, but never realized. Her symbolic reanimation thus problematizes 'enlightenment' theories of feminist progress by suggesting that the seeds of women's future empowerment lie in the past as much as in the present. As we go on to argue in the chapters that follow, these ghostly visitations reveal the vexed and volatile relationship between feminism and popular culture. If media speculation about the 'death of feminism' has given rise to a body of popular texts that seek to define and diagnose the condition of postfeminism, then this book seizes on a selection of these texts in order to investigate the implied 'afterlife' of feminism, querying the extent to which contemporary culture is haunted by the ghosts of an undead feminism. Through reference to a suggestive vocabulary of haunting that we identify in feminist polemical writing and popular culture alike, we ask who is conjuring these ghosts, and to what ends?

In order to answer these questions, we must return to one of the works that has shaped the course of the women's movement in the latter half of the twentieth century and which continues to haunt popular figurations of feminine and feminist identities today: Betty Friedan's *The Feminine Mystique* (1963). Published 50 years ago, *The Feminine Mystique*'s exploration of the 'problem that has no name' played an instrumental role in the galvanization of popular feminism – one which is discernible in the *Ms.* editors' selection of the 'historical' Wonder Woman image for the cover of their

first regular issue. Just as Steinem found her model of second wave
empowerment in the annals of comic-book history, so Friedan,
over a decade earlier, had trawled through the magazine archives of
the New York Public Library in an attempt to source the origins of
the 'feminine mystique'.

The postfeminist mystique

At the heart of Friedan's *The Feminine Mystique* lies a deep suspicion
of the mainstream media's constructions of femininity and the
power they exert over women's physical and mental well-being.
This suspicion, tethered to her concern that post-war women
returned to the home 'as a reaction to feminism', is mapped across a
distinctly Gothic set of co-ordinates.[11] 'The fact is', she announces,
'that to women born after 1920, feminism was dead history. It
ended as a vital movement in America with the winning of that
final right: the vote' (88). It is from the corpse of 'dead [feminist]
history' that the feminine mystique arises. According to Friedan,
this mystique

> says that the highest value and the only commitment for women is the
> fulfilment of their own femininity. It says the great mistake of Western
> culture, through most of its history, has been the undervaluation of this
> femininity. It says this femininity is so mysterious and intuitive and close
> to the creation and origin of life that man-made science may never be
> able to understand it. (38)

We go on to discuss the implications of Friedan's mystique in
detail in chapter three, though it serves as a lens for our reflections
throughout the book. Friedan's contention, after all, is that the
feminist gains of the early twentieth century had been countervailed
in the 1950s by the aggressive re-valorization and re-mystification of
femininity in the mass media. Through an analysis of the mystique,
she identifies a pattern of progress and regress – in which potential
lines of feminist flight are stymied by the censorious manoeuvrings

of popular culture – that has since become a paradigmatic feature of feminist cultural analyses.[12]

In her description of the displacement of the independent 'New Woman, soaring free' by the lamentably 'empty' image of the 'happy housewife heroine' (58), Friedan establishes the reactionary logic that has been the focus of many subsequent critiques of popular culture, and which finds its most lucid expression in the vocabulary of 'backlash', 'rollback', 'backsliding' and 'retreatism' that has marked feminist responses to a range of postfeminist phenomena.[13] Certainly, by the end of the twentieth century, it seemed that feminism was once again 'dead history'. In spite of feminism's political successes in the 1970s and beyond, popular culture has become a site where nostalgic and highly stylized images of traditional femininity are endlessly reproduced. The re-enchantment and re-mystification of precisely those models of femininity that were investigated and debunked by second wave feminists suggests that popular culture is now haunted by a 'postfeminist mystique'.

What is meant by the 'postfeminist mystique' is the subject of sustained enquiry in this book. Put simply, we argue that the postfeminist mystique – like the feminine mystique before it – works by mobilizing anachronism. Derived from the Greek *ana-* (backward) and *khronos* (time), anachronism is defined in the *Oxford English Dictionary* as 'anything done or existing out of date; *hence*, anything which was proper to a former age, but is, or, if it existed, would be, out of harmony with the present'. As Valerie Rohy explains in her work on sexuality and race, anachronism takes account of particular 'temporal anomalies' and can allude to a 'broad range of effects opposed to the regular, linear, and unidirectional pattern that [might be called] *straight time*' (xiv; emphasis in original). The postfeminist mystique is, as we go on to explore, illustrative of such temporal anomalies. It reactivates modes of feminine identity that were 'proper to a former age', but which seem 'out of harmony' with a present that has – so we are told – reaped all the benefits of second wave feminism. Indeed, as we suggest in the chapters that follow, one of postfeminism's

own 'anachronistic' manoeuvres is its recurrent reinvigoration of particular models of white, middle-class femininity that belong to the image repertoire of 'pre-feminist' cultural productions. While this move 'forgets' the work of both the civil rights movement and the women's liberation movement, it also belies the instrumental critical work that has sought to redress the 'whiteness' of some facets of second wave feminism (see hooks).[14]

As it is central to our theorization of the 'postfeminist mystique', the concept of anachronism is equally integral to one of the texts that we use to cast light on its ghostly operations: Jacques Derrida's *Specters of Marx* (1993). We expose the chief contentions of *Specters of Marx* to closer scrutiny in chapter one, but it serves the current discussion to note Derrida's understanding of the spectre as a form of anachronism, whose presence signals that "'[t]he time is out of joint": time is *disarticulated*, dislocated, dislodged[,] [...] *deranged*, both out of order and mad' (20; emphasis in original). Significantly, the spectre is not straightforwardly an emissary of the past, but also potentially a spirit of the 'future-to-come' (19). Thus disordering progressive temporal structures by obscuring the chronology of the past, present and future, the spectre simultaneously disrupts the moment in which it appears, revealing the 'non-contemporaneity of present time with itself' (29).

In anachronism, the past is revisited upon us: what we thought to be gone returns, confirming its ability to influence the present. At this level, anachronism replicates the 'de-synchroniz[ing]' (Derrida 6) manoeuvres of the Freudian uncanny, in which what has been repressed – that is, material which has been turned away and estranged from the self – returns. In the uncanny, of course, the repressed material which returns does so in forms which are simultaneously familiar and strange, othering the present as well as the past. Anachronism, we argue, is a prevalent feature of postfeminist culture; so, too, is the uncanny. The uncanny, in fact, helps to explain how anachronism functions in the postfeminist mystique by offering a framework within which its insistently Gothic depictions of feminism and femininity can be accounted

for. As we define it here, then, the postfeminist mystique 'ghosts' images and styles of femininity (and feminism) that belong to the past as a means of exposing what is missing from the present and – more speculatively – the future. As an exercise in nostalgia, this ghosting is often conservative in its political implications: through a combination of fashion, wit, irony and heterosexual romance, it valorizes a past in which men and women were not equal and in doing so queries feminist narratives of progress. However, as Friedan and Steinem alike discovered, the re-contextualization of images from the past can also serve the radical agenda of the feminist present; by seizing on decades-old depictions of women that celebrated female power and independence, both Friedan and Steinem threw into relief the retrograde tendencies of popular culture (in the late 1950s and early 1970s respectively) in order to mount new feminist calls-to-arms. As we see it, then, anachronism – and the anachronistic figure of haunting – can serve a variety of political ends.

One of the most common reference points for current discussions of postfeminism's entry into popular discourse – and for the sounding of feminism's death knell – is Susan Bolotin's 'Voices from the Post-Feminist Generation', which appeared in *New York Times Magazine* on 17 October 1982. Anatomizing the views of a generation of young women who were eager to distance themselves from what they perceived to be second wave feminism's outmoded politics, Bolotin's article has since come to signify a key moment in media speculations about the death of feminism – what Camille Nurka describes as 'postfeminism's proclamation of [feminism's] time of death' (183). Echoing Friedan's questioning of women's retreat to the home in the 1950s and 1960s, Angela McRobbie in *The Aftermath of Feminism* (2009) asks 'Why do young women recoil in horror at the very idea of the feminist? To count as a girl today appears to require this kind of ritualistic denunciation, which in turn suggests that one strategy in the disempowering of feminism includes it being historicised and generationalised and thus easily rendered out of date' (16). These 'historicising'

and 'generationalising' strategies are central mechanisms of the discourses of postfeminism which use the 'post' prefix as a signifier of pastness (see Genz 18–19). Readily appropriated by a media culture eager to announce feminism's demise, 'postfeminism' has also provided a focus for contemporary feminist debates about femininity and empowerment. Variously discussed in terms of 'new', 'retro' and 'anti-' feminism, definitions of postfeminism are manifestly diverse but share an insistence on the non-academic currency of the term. As Yvonne Tasker and Diane Negra explain in *Interrogating Postfeminism* (2007), 'the contradictory aspects of postfeminist discourse relate to its resolutely popular character.' (19). Significantly, then, postfeminism has become the lens through which contemporary discussions of the relationship between popular culture and feminism are most often refracted.

In *Specters of Marx*, Derrida observes that 'every period has its ghosts (and we have ours), its own experience, its own medium, and its proper hauntological media' (241 n.21). The chapters that follow are prevailingly concerned with the ghosts of feminism and how they manifest in contemporary popular culture. While the 'hauntological media' through which such manifestations occur are varied, the medium in which feminism's ghosts have enjoyed most sustained exposure in the late twentieth and early twenty-first centuries is, most probably, television. Television's status as the preferred venue for feminist hauntings is reflected in the regularity with which we return to television fictions in our analyses of feminism's pop cultural configurations. Although we are committed to the study of film, literature, print journalism and digital media as a means of understanding feminism's cultural presence, it is in television, as a 'technology for conjuring the dead, the alien, the interdimensional, the uncanny' (Sconce 126), that the strange temporal (dis)locations that characterize mainstream representations of feminist and feminine identities are writ especially large.

From the shadowy city spaces of *Mad Men* (2007–) to the dystopic suburbia of *American Horror Story* (2011–), this book traces the maniacal career women, hysterical housewives and

amnesiac girls who roam the postfeminist landscape. Through recourse to these figures, it illuminates postfeminism's obsessive resuscitation of seemingly anachronistic models of femininity and asks why these should be gilded with new appeal at this particular historical moment. Our analyses of these models are shaped by some of the works that have defined modern feminist thought: Mary Wollstonecraft's *A Vindication of the Rights of Woman* (1792); the essays of Virginia Woolf; Simone de Beauvoir's *The Second Sex* (1949); Betty Friedan's *The Feminine Mystique* (1963); Shulamith Firestone's *The Dialectic of Sex* (1970); Germaine Greer's *The Female Eunuch* (1970); and Susan Faludi's *Backlash* (1991). We return again and again to these texts as a way of locating our reflections on representations of female identity in a broader historical context. By tracing the ideas and images explored in these landmark critiques, we are better able to understand how the postfeminist mystique engages with and recasts the feminist past.

In the first chapter we speculate on the cultural tendency to configure feminism as 'Gothic', asking whether the present moment might best be described as a time of 'postfeminism' or 'ghost feminism'. Drawing on Derrida's *Specters of Marx* we develop a hauntology of feminism, tracing the movements of feminism's ghosts as they traverse the variegated precincts of popular and academic discourses. Set against second wave feminism's project of cultural recovery and remembering, postfeminism seems instead to engage in the work of selective forgetting. Situating amnesia as a pre-eminent postfeminist modality, we suggest that a palimpsestuous reading of popular culture allows for the productive recuperation of feminist memory.

In the second chapter, 'Postfeminist haunts: working girls in and out of the urban labyrinth', we explore configurations of professional femininity in relation to the city as an uncanny space of repetitions and returns. From Carrie Bradshaw and Bridget Jones to Betty Suarez and Peggy Olson, the professional, city-dwelling working girl has assumed a definite and defining position in the postfeminist landscape, suggesting that a 'woman's place' is no longer

in the home but, rather, in the midst of the multifarious consumer pleasures of the public sphere. The city has been identified as a privileged site for forging postfeminist cultural sensibilities but, as we illuminate in our readings of such texts as *Sex and the City* (1998–2004), *Ugly Betty* (2006–10) and *Mad Men*, it remains a hostile geography, whose labyrinthine structure threatens to entrap the female subject within an anachronistic temporality. Also caught in this anachronistic temporality is the figure of the housewife, the focus of chapter three, 'Haunted housewives and the postfeminist mystique'. Rendered uncanny through her endless returns to popular culture, the housewife seems doomed to conform to the scripts of domestic femininity that the second wave almost laid to rest. Beginning with feminism's many invocations of the housewife, from Wollstonecraft's stinging critique of idle wives to Woolf's murderous encounter with the Angel in the House, we examine the varied conjurations of the housewife in popular fictions from *Stepford Wives* (1975; 2004) to *American Horror Story*. In doing so, we analyse the seductive lure of the postfeminist mystique and its peppy reinvigoration of domestic femininities.

In the last two chapters we turn to postfeminism's ongoing fascination with the girl and girlishness. Chapter four, 'Who's that girl? slayers, spooks and secret agents', situates the girl as a figure of possibility and 'becoming'. Moving between different states of being, the girl's lines of flight are often thwarted by cultural anxieties about her potential for unruliness. While the girl heroes of the 1990s – exemplified by Buffy the Vampire Slayer – are distinguished by their resilient bodies and formidable superpowers, the girlish woman of the twenty-first century is often pathologized as a figure of disorder whose roguish behaviour threatens the integrity of the body politic. Examining motifs of brainwashing and electroconvulsive shock therapy in contemporary popular texts, most notably *Homeland* (2011–), we contextualize the cultural fascination with the image of the young woman as a 'clean slate' to be reconditioned and re-inscribed. In the final chapter, 'The return of the repressed: feminism, fear and the postfeminist Gothic', we

illuminate the Gothic as a peculiarly hospitable site for feminism's spectral visitations in a variety of texts, including *Medium* (2005–11), *Tru Calling* (2003–05), *True Blood* (2008–) and Stephenie Meyer's *Twilight* saga (2005–08). As we propose here, with reference to motifs such as psychic insight, hysterical amnesia, supernatural possession, exorcism and vampirism, the Gothic has provided a suggestive language for postfeminist negotiations of debates about maternal biology, reproductive legislation and sexual violence. Through these analyses of postfeminism's historical slippages and haunted temporalities, *Feminism and Popular Culture* not only takes account of the complex ways in which popular culture navigates ongoing debates within and about feminism, but also explores its implications for feminism's future.

1

'Postfeminism' or 'ghost feminism'?

It is far harder to kill a phantom than a reality.
(Virginia Woolf, 'Professions for Women')

Speculation always speculates on some specter.
(Jacques Derrida, *Specters of Marx*)

A spectre is haunting popular culture – the spectre of feminism. Here the flickering visage of Emily Wilding Davison as she throws herself in front of the king's horse; there a crepuscular Andrea Dworkin addressing the first Take Back the Night march; behind us the spectral swell of whistle-blowing liberationists storming the 1970 Miss World Pageant in London. Attended upon by such phantoms, feminism is not only in perpetual communion with its past and those who formed it, but also with itself. Certainly, the tendency to Gothicize feminism (and feminists) is an increasingly prevalent strategy within popular and academic scholarship about feminism: Angela McRobbie traces the 'hideous spectre of what feminism once was' as it stalks popular culture (2009: 1); Jane Gerhard acknowledges the 'ghost of the scary lesbian/feminist' as a defining feature of postfeminism (37); Lori A. Brown even speculates that feminism – already, in her opinion, 'a spooky word' – might itself be 'a kind of ghost' (216). While these spectral formulations

of feminism are not exactly new (an article in a 1989 issue of *Spare Rib* chronicles the haunting of 'Post-Feminist Pat' by 'the ghost of feminis[m] past' [58]), they have grown in frequency in the past decade. Feminism's perceived ghoulishness is a topic to which we will return throughout this book, but we might here begin to consider why it should be configured in these terms at this particular moment. What is it about the concept of haunting that lends itself so readily to the description of feminism in the twenty-first century?

According to the *Oxford English Dictionary*, 'to haunt' means 'to visit frequently or habitually with manifestations of [the] influence and presence of imaginary or spiritual beings', or 'to appear frequently as a spirit or ghost'. To some extent feminism's new rhetorical (after)life as a monstrous spectre follows logically from the mainstream media's repeated pronouncements of its demise. From the 'Is Feminism Dead?' cover of *Time* magazine in 1998 to the 2005 publication of Phyllis Chesler's *The Death of Feminism* and beyond, the last gasps of women's liberation have been the object of continuous coverage for the past two decades. For every obituary, however, there are reports of feminism's ongoing vitality. In *Reclaiming the F-Word* (2010), for example, Catherine Redfern and Kristin Aune 'put to rest the myth that feminism is dead today and, in particular, that young women are not interested in feminism or that feminists are only interested in a narrow range of issues' (Redfern para. 1). Sylvia Walby in *The Future of Feminism* (2011) likewise insists that '[f]eminism is not dead', though she concedes that it is 'less visible than before' and has become – in the process of 'taking on new powerful forms' – 'unrecognisable to some' (1–2). Even in Walby's account of feminism's rude health, its distorted appearance and decreased visibility imply a peculiar ghostliness: if it is not dead, it is not alive in the same way that once it was.

As Walby's reflections indicate, the repeated – if erroneous – sounding of feminism's death knell has altered the movement's appearance within the popular imaginary; suspended somewhere between life and death, it is marked by both presence and absence. What, then, are the implications of this position? Are there,

moreover, any benefits to be derived from this apparent liminality? Just as Derrida's attempt to theorize ghostly figurations in and of Marx's writing is facilitated in *Specters of Marx* by his introduction of the concept of 'hauntology', so this same concept might likewise assist in illuminating some of feminism's own spectral dimensions. Deliberately evocative of 'ontology', with all its implications of being and presence, hauntology refutes such certainties by invoking the ghost as a figure of undecideability that productively unsettles received categories of identity. More crucially, though, Derrida uses hauntology as a tool for excavating the strange temporality of haunting – what he terms the '*non-contemporaneity with itself of the living present*' – in which the ghost functions as a sign of slippages between the past, the present and the future in order to reveal the radical contingency of the 'now' (xviii; emphasis in original). As Fredric Jameson describes it in 'Marx's Purloined Letter' (1995), 'the living present is scarcely as self-sufficient as it claims to be [and] we would do well not to count on its density and solidity, which might under exceptional circumstances betray us' (2008: 39). For Derrida, however, the 'living present' is not only a moment that is always and already haunted by the ghosts of the past, but one which is also, simultaneously, haunted by the future: 'the specter', he claims, '*is* the future, it is always to come, it presents itself only as that which could come or come back' (49; emphasis added). Using the term '*revenant*' (from the French *revenir*, to return or come back), Derrida explains that the spectre '*begins by coming back*' (11; emphasis in original); indeed, 'no one can be sure if by returning it testifies to a living past or a living future' (123). Part legacy, part prophecy, the spectre is an emissary of pasts and possible futures that the present cannot exorcize: 'they are always *there*, spectres, even if they do not exist, even if they are no longer, even if they are not yet' (221; emphasis in original).

What, then, does Derridean hauntology add to an analysis of feminism's ghosts? With its investment in notions of otherness, memory, nostalgia, inheritance and futurity, hauntology appears to encompass many of the issues that have beset debates in the

late twentieth and early twenty-first centuries about feminism's relationship to the past and its potential to intervene in women's futures. Derrida's investment in the spectre as a vehicle of nostalgia – for futures that were not realized, or potential that was not fulfilled – speaks, moreover, to postfeminism's idealized formulations of female identities that seem to 'ghost' the styles and politics of previous eras. If feminism is an ontology, a way of being, then it is also a hauntology in the Derridean sense – a way of being that is shaped by anxieties about the past, concern for the future and an overarching uncertainty about its own status and ability to effect change in a world where its necessity is perpetually cast into doubt.

As a meditation on politics *after* the 'death of communism', or what Francis Fukuyama augurs as the 'end of history', *Specters of Marx* shows how the ghosts of communist revolution continue to haunt the living present as signs of what might have been, and what might yet still be; they are, in essence, ghosts of political possibility. If Derrida's text responds to a post-communist moment in which neoliberal values appear to hold sway over a politics of revolution, then postfeminism perhaps invites consideration along similar lines. Certainly, the spectres of feminism and/or postfeminism seem to enjoy an afterlife that is just as vibrant as those of Marx. Like the spectres of Marx(ism) which Derrida conjures, the ghosts of feminism(s) past refuse to be exorcized. Though neither present nor real – at least in any straightforward sense – these ghosts not only serve to unsettle the living present, but also shape our attempts to understand it. This is evidenced abundantly in the mainstream media's coverage of gender issues, where the ghosts of feminism(s) past are always coming back to haunt us. Melanie Philips, for example, began an article for the *Daily Mail* by stating that the 2011 Slutwalks would have 'Emmeline Pankhurst [...] revolving in her grave' (para. 1), while Tracy Spicer's consideration of recent Hollywood representations of 'female sexual empowerment' appears under the headline 'Germaine Greer would be so proud' (para. 24). Couched in this species of conditional and/or speculative rhetoric, such writing hinges on the notion that feminism is

somehow, mysteriously, elsewhere, but that feminists nonetheless remain available for comment by proxy. Even Greer, a woman who is conspicuously living, not to mention *present* within and across a range of different media, is invoked as if she, like Pankhurst, were long dead. Just as Derrida's invocation of Marx's spectres followed the fall of the Berlin Wall and the implied 'death of communism', so these ghostly evocations of feminism take place in a context where the 'post-ness' or 'past-ness' of feminist politics is routinely asserted as if it were fact.

Spurious though its many obituaries may be, feminism's consignment to history makes it usefully available to the possibility of ghostly return. While this rhetoric of spectrality might intimate the dilution of feminism's political potency, it also implies persistence, a refusal to go away. As Woolf noted in 'Professions for Women' (1931), 'it is harder to kill a phantom than a reality' (102). By taking this on board, then, we might concede that the ability to haunt could be a heartening indication of feminism's transcendent political fortitude. Certainly, if Derrida's spectropoetics is underpinned by concerns about the seemingly marginalized role of revolutionary politics in late industrial capitalism, then our own more speculative gestures towards a hauntology of feminism are prompted by similar concerns about the potential instrumentality – and necessity – of feminist politics in the context of postfeminism's neoliberal sway.

In order to speak about ghosts, argues Derrida, one must also speak about 'inheritance, and generations, and generations of ghosts, which is to say about certain others who are not present, nor presently living, either to us, in us, or outside us' (xviii). This approach is echoed in Terry Castle's *The Apparitional Lesbian* (1995), Paulina Palmer's *Lesbian Gothic* (1999) and Victoria Hesford's 'Feminism and its Ghosts' (2005), which offer varied analyses of the lesbian as a spectre of feminist 'otherness'. 'Haunting', in Hesford's words, 'is intrinsic to every dominant social and political order because it is a sign of what has been forcibly expunged or evacuated from that order; the other that threatened to disrupt the emergent hegemony' (229). For Hesford and Derrida alike, the ghost not

21

only substitutes for what is not there, but renders apparent that which has been cast out in order to safeguard particular power arrangements. In this way, the ghost encourages us to develop an ethics of responsibility towards the barely visible 'others' of the past, present and future, auguring a 'politics of memory [...] inheritance, and of generations' (Derrida xviii). Derrida's insistence upon the shared importance of memory and inheritance resonates with debates in and about feminism – debates in which anxieties about past debts and future obligations are routinely consolidated in metaphors of intergenerational conflict and identification. While the complexities and limitations of the feminist generational metaphor have been foregrounded in works by Judith Roof (1997) and Astrid Henry (2004), it is a metaphor which – through its repeated invocation of ghostly mothers and matricidal daughters – renders the spectral dimensions of the relationship between feminism and popular culture especially apparent.

Matricidal returns

Whether real or symbolic, revered or reviled, absent or present, mothers are the discursive lifeblood of feminist thought. 'We think back through our mothers' (2001: 65), proclaimed Woolf in *A Room Of One's Own* (1929). While concerned specifically with the world of fiction, and the apparent absence of any literary 'mothers' to which aspiring women writers might refer, Woolf's remark speaks also to feminism's deep investment in the metaphorics of motherhood as a means of negotiating the relationship between the past and the present. Just as Woolf understood herself as a 'daughter', set adrift from the symbolic mothers who might help to validate her writerly 'crime against the fathers' (Marcus 10), so she has been claimed, like Wollstonecraft before her, as the 'foremother' and 'founding mother' of modern feminism (Bowlby 23). Woolf's double identity as rebellious child and wise parent is repeated again in the figure of Beauvoir, whose ironic self-identification as a 'dutiful daughter', coupled with her public disavowal of motherhood as the

underlying source of women's oppression, sits alongside her cultural status as feminist 'matriarch' (Simons 125). Extending this genealogical plotting, it is in Beauvoir that Kathie Sarachild finds 'the mother of Betty Friedan' (27) – whose own emergence as a feminist daughter is similarly coextensive with her ordination as the 'Mother Superior' of women's liberation (Wilkes 27).

Though queried and contested, the mother–daughter 'matrophor' is the most enduring motif within feminist scholarship, and one which has been deployed with continued regularity in the discourses of third wave feminism since Rebecca Walker, the daughter of Alice Walker, announced 'I am the Third Wave' in a 1992 article for *Ms.* magazine (41).[1] Striking a clear distance between her own feminism and her mother's second wave politics, Walker's decisive statement offers a suggestive illustration of Reina Lewis's observation, made in the same year, that 'for young women, the spectre of feminism really does reside with the authority associated with their mother or their mother's generation' (92). Thus haunted by the spectral authority of real and imagined mothers, the third wave is at risk of imprisoning itself in a state of *intra* perpetual daughterhood. A number of third wave feminist texts share a common ground in their eagerness to signal a break from an earlier feminist generation – a break that is embedded in their celebration of 'girl culture' and an understanding of feminist history framed by the mother–daughter metaphor. As Henry notes in *Not My Mother's Sister* (2004), the pivotal role of the generational metaphor within third wave debates is all but inevitable: second wave feminists are not only *symbolic* mothers to the third wave, after all; rather, 'given that the age difference between each wave's representatives is roughly the equivalent of one familial generation', they are also, potentially, the *biological* mothers of third wavers (3).

The matricidal logic implicit in the third wave's nominal distancing of itself from the second wave agenda is enacted to some extent in Jennifer Baumgardner and Amy Richards' *Manifesta: Young Women, Feminism, and the Future* (2000). Here, in a chapter entitled 'Thou Shalt Not Become Thy Mother', Baumgardner and Richards

compose a 'Letter to an Older Feminist' in which they invoke their second wave 'mothers' in order to disavow them: 'You're *not* our mothers. [...] We want to reprieve you from your mother guilt. [...] Now you have to stop treating us like daughters' (233; emphasis added). If, as Baumgardner and Richards suggest, maternalistic constructions of feminist relationships are unhelpful to 'younger' and 'older' feminists alike, then these matriphobic invocations not only obfuscate feminism's past, but also stymie its future.

For Faludi, feminism's faltering along a mother–daughter divide muddies in particular the legacy of a suffrage-era feminism that had at its centre 'a celebration of the mother–daughter bond and the transmission of female power and authority from one generation to the next' (2010: 35).[2] She goes on to map the 1920s as a key moment in feminism's fraught history and 'a pivot point between the old maternal feminism and a feminist culture much more matricidal' (39). This was a decade inhabited most visibly by the girlish flapper who, emerging in the wake of the social and sexual freedoms afforded by the Great War and the achievement of women's suffrage, 'would dance her way across dozens of magazine covers, jitterbugging with sugar daddies, motoring with college boys, admiring her own image in the mirror – and never sharing the stage with an older (or any) woman' (38). An embodiment of the independent and fashionable 'modern woman' and a voracious consumer, the flapper augurs the postfeminist single girl anatomized in chapter two. She is also, according to an article published in the *New York Times* in 1922, 'shameless, selfish and honest, but at the same time she considers these three attributes virtues. Why not? She takes a man's point of view as her mother never could, and when she loses she is not afraid to admit defeat, whether it be a prime lover or $20 at auction' (Hooper 13). If this new model of girlish femininity required a rupture from the social, political, economic and aesthetic constraints of an earlier generation, it also necessitated a violent rejection of the feminist foremothers who had enabled its emergence. It is the legacy of this murderous 'feminist betrayal', concludes Faludi, that 'haunts modern feminist life' (39).

Tellingly, the first documented use of 'postfeminism' occurred in 1919 when it was appropriated by a woman's literary group in Greenwich Village to signal a shift in political focus from 'women' to 'people'. This displacement of gender politics has been viewed as marking the end of the first wave of feminism (Meyers 118). This first public assertion of postfeminism may account for popular culture's frequent returns to the 1920s as a site for exploring the ambivalences of contemporary femininity and female power. In Aaron Spelling's *Charmed* (1998–2006), which follows the trials of three sisters who discover they are witches, for example, Phoebe (Alyssa Milano) experiences flashbacks to a past life in the 1920s in which she gives in to the dark potential of her supernatural powers and is subject to a curse that will affect her future life ('Pardon My Past' 2.14). Similarly, series four of *Buffy the Vampire Slayer* concludes with an episode in which Buffy appears on stage, dressed as a flapper. This particular episode, in which the First Slayer (Buffy's primeval ancestor) infiltrates the dreams of each member of the Scooby Gang, is the threshold across which past and future cross paths ('Restless' 4.22). More recent television series have likewise turned to the 1920s to signal the dangerous consequences of female empowerment. In *American Horror Story*, the 1920s haunted

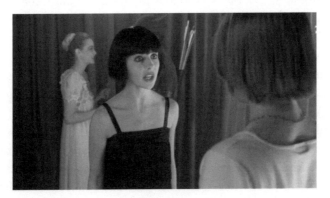

Figure 1
The 1920s is a recurrent point of reference in postfeminist fictions, as demonstrated here in *Buffy the Vampire Slayer* ('Restless' 4.22).

mansion is the site of illegal abortions, performed by the crazed, Frankenstein-like Dr. Charles Montgomery (Matt Ross) at the encouragement of his young, money-hungry wife Nora (Lily Rabe), whose name is haunted by Henrik Ibsen's feminist heroine in *A Doll House* (1879). As we explore further in chapter four, the 1920s are glimpsed too in the flickering labyrinthine opening credits to *Homeland*, as images of a young girl playing a trumpet are intercut with archival footage of Louis Armstrong (an association that is sustained in the series' insistent references to jazz). Postfeminism, as these examples would suggest, is not only concerned with consigning feminism to history but also with reanimating the glamour of an earlier age, a pre-feminist past.

This fascination with putting feminism in its place also characterizes the suite of popular feminist discourses that emerged in the early 1990s. In *The New Victorians: A Young Woman's Challenge to the Old Feminist Order* (1995), Rene Denfeld proposes that second wave feminist debates surrounding sexuality, sexual violence and pornography produced a neo-Victorian discourse of sexual repression and political powerlessness. Focusing on such prominent figures as Catherine MacKinnon, Mary Daly, Andrea Dworkin and Robin Morgan, as well as Women's Studies professors on American campuses, Denfeld argues that, since the 1970s, second wave feminists have become 'the new Victorians' in their promotion of nineteenth-century values of sexual morality, spiritual purity, and political helplessness' (10). According to Denfeld, these feminists present a Victorian vision of female sexuality as chaste and sexless, and a notion of women as 'paragons of virtue'. Equating second wave feminist views on female sexuality with Victorian moral-purity campaigns and the religious right, Denfeld suggests that new Victorian feminism is dangerous because its 'promotion of repressive sexual morality and spiritual passivity promulgates the vision of an ideal woman, sexually pure and helpless yet somehow morally superior to men and all male-influenced institutions' (10, 16). To prevent young women from turning away from feminism, she advises that '[w]e must toss New Victorianism in the rubbish

can and return to a movement that addresses women's concerns while respecting their personal lives and empowering their choices' (20–21). Denfeld's criticism, then, is directed towards the prescriptive and alienating language of martyrdom and victimhood that, she proposes, colours feminist debates about female sexuality and sexual identity. In this formulation, second wave feminists are once again positioned as abstemious and authoritarian mothers attempting to police the sexual practices and expressions of their wayward daughters.

In her construction and condemnation of 'New Victorian' feminism, Denfeld's discussion is representative of a broader move in the mid-1990s in the US to denounce the 'puritanical' hue of second wave feminist discussions of sex and sexuality and, in particular, the anti-pornography campaigns of the 1970s and 1980s. Her analysis sits alongside that of other media-friendly conservative feminist writers – such as Naomi Wolf, Katie Roiphe, Christina Hoff Sommers and Camille Paglia – who, in their respective attacks on second wave feminist narratives of victimhood and victimization, have positioned themselves as ambassadors for a more powerful, chic and sexual version of feminism. For example, with a typical mixture of bluster and bravado, and heralding Madonna as the 'true feminist' who 'exposes the puritanism and suffocating ideology of American feminism', Paglia declares that '[c]ontemporary feminism cut itself off from history and bankrupted itself when it spun its puerile, paranoid fantasy of male oppressors and female sex-object victims' (4, 10). At a safe distance from Paglia's particular and peculiar brand of kitsch feminism, but echoing its underlying critique, Wolf, in *Fire with Fire: The New Female Power and How to Use It* (1993), delineates two opposing models of feminism: 'victim feminism', which is 'when a woman seeks power through an identity of powerlessness'; and 'power feminism', which is 'unapologetically sexual; understands that good pleasures make good politics' and 'examines closely the forces arrayed against a woman so she can exert her power more effectively' (147, 149). In this victim/power binary, Wolf locates two traditions of feminism: 'One tradition

is severe, morally superior and self-denying; the other is free-thinking, pleasure-loving and self-assertive' (181). Resting on a distinction between victim feminism and power feminism, the postfeminist discourse of figures such as Denfeld and Wolf suggests that the 'gains forged by previous generations of women have so completely pervaded all tiers of our social existence that those still "harping" about women's victim status are embarrassingly out of touch' (Siegel 75). Postfeminist discourse, then, is inevitably haunted insofar as it is not only structured through generational conflict, but also through a dis(re)memberment of feminist history.

In the context of postfeminism, popular culture's obsession with its own (recent) past has disquieting implications. As Whelehan opines in *Overloaded*, this obsession has augured in an age of 'retro-sexism' that is characterized by 'nostalgia for a lost, uncomplicated past peopled by "real" women and humorous cheeky chappies, where the battle of the sexes is most fondly remembered as being played out as if in a situation comedy such as *Man About the House* or *Butterflies*'. For Whelehan, this 'retrospective envisioning' provides 'a dialogue between the past and the present and is symptomatic of a real fear about a future where male hegemony might be more comprehensively and effectively attacked than has so far been the case' (11). As we argue throughout this book, this dialogue between the past and the present is troublingly selective. In line with Whelehan's argument, twenty-first-century popular culture has been repeatedly drawn to styles and narratives of historical periods that slightly predate points at which feminism takes its next leap into the future. This selective nostalgia is reflected in the current glut of period dramas set in the 1910s and 1920s, just prior to women's enfranchisement in the United States and the United Kingdom (in 1920 and 1928 respectively), and the 1950s and 1960s, in advance of – or in some cases coextensive with – the rise of the second wave and related campaigns for sexual equality.

The recent interest in the 1910s and 1920s is marked by the popularity of fictions set in this period – most notably *Downton Abbey* (2010–), *Upstairs Downstairs* (2010–12), *Parade's End* (2012),

Boardwalk Empire (2010–) and *The Great Gatsby* (2013), but also shows which engage with this era through the use of flashbacks, such as *True Blood* and *American Horror Story* – which present affluent worlds in which women have limited power, but fabulous clothes. Similarly, the 1950s and 1960s provide an attractively furnished historical home for mainstream programming like *Mad Men*, *The Hour* (2011) and *Pan-Am* (2011–12), as well as films like *On The Road* (2012). While some of these fictions take account of the problems encountered by women at home and in the workplace, they do so while luxuriating in period detail to the extent that these problems – located as they are within the privileged mien of the middle classes – might almost appear desirable. At the same time, they provide a context in which women's liberation can be paid lip service without compromising the broader glorification of old-style femininities and masculinities. Taking account of these tendencies in relation to Whelehan's argument, popular culture's dewy-eyed nostalgia for times past – times which often predate the birth of those who seek to revive them – is not merely a benign exercise in creative misremembering, but a politicized attempt to discredit feminism and derail any future attacks on gender inequality through the use of particular kinds of cultural capital and retro-chic.

The postfeminist palimpsest: memory and amnesia in popular culture

If second wave feminism engaged in an enormous feat of remembering, in which women's histories, achievements and the wrongs perpetrated against them were recovered to collective memory and recorded for posterity, then postfeminism might often seem to partake in the countervailing work of both disremembering and forgetting. In contemporary popular and critical discourses, this 'work' is aptly personified by the figure of the amnesiac or the forgetful woman, but is also discernible in the retrograde femininities that these texts tend to resuscitate. Gill Plain and Susan Sellers have observed that the 'very success of the feminist project has

ungratefulness to feminism
bitterness

resulted in a curious case of amnesia, as women within and without the academy forget the debt they owe to a critical and political project that undid the hegemony of universal man'. The result of this amnesia, they argue, 'is a tension in contemporary criticism between the power of feminism and its increasing spectrality' (1).[3]

Although the postfeminist text is often marked by amnesia, its historicizing manoeuvres leave traces of the very histories they seek to erase. The postfeminist text, then, might be usefully understood as a kind of palimpsest. Originally a term to describe a vellum or parchment that was inscribed with text, scraped clean, then inscribed again, the palimpsest has been seized upon by late twentieth-century theorists as a metaphor for describing postmodernism's 'haunted' relationship to the past. As Ashraf H. A. Rushdy explains, 'the palimpsest shows the complexity of representation, where different historical periods are marked on the same textual space' (8). Haunted by 'ghostly trace[s]' of earlier inscriptions which '*seemed* to have been eradicated' (Dillon 12; emphasis in original), the palimpsest is a surface upon which successive generations might make their mark, allowing for the simultaneous acknowledgement of the present and the absent, the visible and the invisible, the now and the then. In this way, the palimpsest proposes itself as a suggestive model for reading postfeminist culture, presenting the possibility of remembering and recovering a past which is supposed lost. As Sarah Dillon explains in her pioneering analysis, the palimpsest demands a particular kind of 'palimpsestuous reading' which accounts for the multiplicity of the inscriptions by which it is constituted:

cool

> Palimpsestuous reading [...] does not focus solely on the underlying text, for to do so would be to unravel and destroy the palimpsest, which exists only and precisely as the involution of texts. Rather, such reading seeks to trace the incestuous and encrypted texts that constitute the palimpsest's fabric. Since those texts bear no necessary relation to each other, palimpsestuous reading is an inventive process of creating relations where there may, or should be, none; hence the appropriateness of its epithet's phonetic similarity to the incestuous. (254)

For our purposes here, we are not only interested in the palimpsest as a body of text(s), but as a body of text(s) which was once, itself, part of a body. As Elizabeth Grosz notes in *Volatile Bodies* (1994), 'the metaphor of the textualized body' has been used to situate the body as 'a page or material surface, possibly even a book of interfolded leaves [...] ready to receive, bear, and transmit meanings, messages of signs, much like a system of writing' (117). As 'palimpsest' originally described a *vellum* manuscript, after all, it has a demonstrable connection to the body and in this way seems an especially apposite metaphor for an analysis of feminism, in which the body figures as the site at which cultural anxieties about women are inscribed again and again.

In *Twilight Memories* (1995), Andreas Huyssen delivers a depressing prognosis for postmodern culture, pronouncing it 'terminally ill with amnesia' (1). While such a prognosis is hardly definitive (there is always the possibility that memory might be recovered), Huyssen's pessimistic prediction provides a neat condensation of *fin-de-siècle* discourses about memory and forgetting. As he goes on to reflect,

> [t]he undisputed waning of history and historical consciousness, the lament about political, social, and cultural amnesia, and the various discourses, celebratory or apocalyptic, about *posthistoire* [...] have been accompanied [since the beginning of the 1980s] by a memory boom of unprecedented proportions. (5)

In light of this paradoxical scenario in which the 'culture of memory' unfolds within a 'culture of amnesia', Huyssen argues that the cultural critic must strive to 'think memory and amnesia together rather than simply to oppose them'. While Huyssen is concerned here with postmodern culture and 'its television politics of quick oblivion' (7), postfeminist culture – characterized as it is by a combination of aesthetic nostalgia and political amnesia – seems to invite a similar kind of approach. It is by understanding how memory and amnesia operate together, and thinking about postfeminist culture in terms of its selective memory, that we

can start to examine the nature of its hauntedness and begin to recuperate those things that it has attempted to cast out. These phenomena are registered repeatedly in the texts with which we are concerned in this book, but we will begin by exploring how they are played out through the styles and strategies of one postfeminist icon, Madonna, and the generations of female artists who have been identified as the potential inheritors of her mantle.

Madonna and child?

On 13 February 2011 Lady Gaga arrived at the 53rd Annual Grammy Awards in Los Angeles encased in a giant egg. As the makeshift womb bobbed above the crowds lining the red carpet, carried aloft by four rubber-clad male models, her creative director explained that Lady Gaga was 'incubating' and would not be 'born' until her performance that evening. Once on stage, the flamboyant pop star emerged from another (slightly larger) luminescent cocoon to the opening verse of 'Born This Way', a song which explores, in Lady Gaga's words, the idea that '[w]ho you are when you come out of your mother's womb is not necessarily who you will become' (Werde 34). With its gynaecological props and thrusting choreography, the Grammys' staging made the song's anthemic preoccupation with birth and regeneration spectacularly explicit, inaugurating Lady Gaga as both a creator – the self-avowed 'Mother Monster' to her fans – and the strange progeny of the performance itself. Released just after the Grammy Awards, Nick Knight's video for 'Born This Way' embellished this creation myth yet further, casting the star as 'the Eternal Mother' giving birth to a new race of fluid-slicked, Gaga-faced 'wombs'. This dual identification of Lady Gaga as mother and daughter set the context for subsequent coverage of 'Born This Way', which pivoted on the legitimacy of Gaga's claim to the status of creator. Here, the song's apparent similarity to Madonna's 1989 single 'Express Yourself' was used to underline the younger woman's own artistic matrilineage. Citing an over-indebtedness to Madonna's sound and aesthetic, critics

including Neil McCormick interrogated Lady Gaga's status as a creator, situating her instead as a pale descendent of Madonna, the still-reigning 'Queen of Pop'. Both artists were quick to comment on such comparisons, with Lady Gaga referencing Madonna as a key influence on her artistic development: 'I genuinely love her so much. I think she is so amazing. She could never be replicated and [...] it's not my fault that I kind of look like her, right? [...] [I]f anything, it's more annoying to me that people would insinuate that I don't like to be compared to her. [...] She's wonderful and inspiring and liberating' (Lady Gaga qtd in Fry para. 39). Oozing filial deference and admiration, Lady Gaga situates herself as the daughter-inheritor of Madonna's legacy: she loves Madonna; 'look[s] like' Madonna; wants to be compared to Madonna; is inspired by Madonna; and, elsewhere, concedes to her as 'Queen' (see Westervelt para. 3).

Madonna's status as a pop matriarch and cultural icon has been atomized with exhaustive diligence in works by Cathy Schwichtenberg (1993), Ann Brooks (1997), Sheila Whiteley (2000), Susan McClary (2002), and Georges-Claude Guilbert (2002). Her status as a feminist is, however, less assured. Famously hailed as '*the* true feminist' by Paglia, who applauded the star for teaching 'young women to be fully female and sexual while still exercising control over their lives' (4; emphasis added), Madonna has deflected direct questions about her feminist sympathies by claiming instead that she is a 'humanist'. She has nonetheless cultivated an overtly flirtatious relationship 'with a kind of (popular) feminism', conjuring with different feminine styles in ways that defy easy classification (Fouz-Hernández and Jarman-Ivens xvii). From the crucifix-laden bride of 'Like a Virgin' (1984) to the lingerie-clad, stiletto-heeled dominatrix of 'Girl Gone Wild' (2011), Madonna is, as Patricia Pisters points out, 'semantically slippery' and 'can rarely be consigned to a stable category: when one thinks she is pleading for equality, she foregrounds hyper-femininity and difference; when one thinks she is relying on binaristic or stable representations of sexuality, she simultaneously deconstructs those binarisms' (26).

Much of the feminist and feminine play that Pisters identifies here takes place around ideas of 'girlhood' and 'girlishness', with the figure of the girl remaining a consistent, if endlessly flexible, point of reference within and across Madonna's oeuvre. In her songs ('Like a Virgin', 'Material Girl', 'Bad Girl', 'Mer Girl', 'Girl Gone Wild'), videos ('Papa Don't Preach', 'Oh Father', 'What It Feels Like For a Girl'), and live performances (*Who's the Girl?*, *The Girlie Show*), the girl 'embod[ies] very different meanings, very different imaginations of how to do cultural work with femininity' (23). If, as Sarah Projansky has discussed, 'postfeminism depends on girlness, is defined by it in fact' (2007: 43), then what happens to Madonna's status as a postfeminist icon when young women keep recognizing her as a mother? How can her 'girlness' be preserved against repeated insistences upon her maternity?

In light of Madonna's preoccupation with her own 'girlness', it is perhaps unsurprising that she remained coolly ambivalent in her response to Lady Gaga's recent daughterly effusions: 'I certainly think she references me a lot in her work. And sometimes I think it's amusing and flattering and well done. [Her songs seems to be a] statement about taking something that was the zeitgeist, you know, 20 years ago and turning it inside out and reinterpreting it' (qtd in Sheridan paras 7–8). Madonna acknowledged Lady Gaga's perceived musical debt more publicly during her 2012 *MDNA* tour, where she performed a controversial medley of 'Born This Way' and 'Express Yourself'. While such a gesture appears to celebrate the reciprocal counterflow of ideas and influence that constitutes popular culture, Madonna's decision to conclude the medley with an insistent chorus of 'She's Not Me' complicates what might otherwise be interpreted as a playful homage to the newer artist. On the one hand, Madonna seems to demand recognition for her role in the formation of this new pop icon, on the other she is determined to disavow her through this apparent statement of disidentification and self-individuation.[4] Certainly, Madonna refuses to settle into the maternal niche that Lady Gaga carves out for her, performing the 'Express Yourself'/'Born This Way' medley as a cheerleader-

majorette, the de facto symbol of gym-slipped, pert-bosomed, all-American girlhood. With her pom-poms, mini-dress and bright red knickers, Madonna – now in her fifties – remains the 'Material Girl'. Thus (re-)inscribing herself as the eternal daughter, Madonna complicates the family tree that Gaga attempts to trace: she signals her refusal to relinquish the postfeminist power she wields as a 'girl', while simultaneously reappropriating Gaga's song in a way that advertises her creative – and matriarchal – supremacy over the princesses of popular culture.

Without wishing to overstate the cultural significance of the Madonna–Lady Gaga fracas, it does illustrate, in appealingly flamboyant fashion, the conflicts by which feminism is itself beset. More specifically, it focalizes the extent to which relationships between women are characterized in relation to patterns of inheritance and disinheritance that are similarly central to feminist history. Madonna and Lady Gaga each invoke and disavow motherhood by turns in order to exhibit the power they wield and locate themselves within the broader landscape of (female) popular culture. Just as the 'Born This Way' video shows Gaga giving birth to a new race 'which bears no prejudice, no judgement, but boundless freedom', so Madonna identifies herself as Gaga's own point of origin, while at the same time refusing to acknowledge her as a daughter.

If Madonna is a reluctant mother to Lady Gaga, then she is more than happy to acknowledge her 'legitimate' progeny, those good daughters who follow the script she sets out for them. This is clearly exemplified by her controversial performance with Britney Spears and Christina Aguilera at the 2003 MTV Video Music Awards. Wearing updated versions of the iconic bridal garb worn by Madonna in her 'Like A Virgin' video (complete with 'Boy Toy' belts), Spears and Aguilera took to the stage to sing the pop classic.[5] After a verse and a chorus, however, the music paused as Madonna herself, dressed as a groom, emerged from the top of a giant wedding cake (echoing her solo performance of the track at the 1985 MTV Video Music Awards) and launched into her own new single, 'Hollywood'. For the remainder of the performance,

Spears and Aguilera orbit Madonna, who is clearly positioned as the headline act, matching her choreography and harmonizing with her lead vocal. Dressing up in her cast-off clothes and singing her old songs, Spears and Aguilera can do little more than 'ghost' Madonna: even when she is not physically present, she is signified through the female artists' referencing of her earlier style and sound. Towards the end of the number, Madonna bestows a lingering kiss on each of her young 'brides', marking them out as legitimate, but also subordinate. Again, then, she complicates the implied family tree: at the moment when she appears to recognize her maternity, she eschews the conventional trappings of motherhood in order to take on the masculine (patriarchal) role of husband. Refusing to be shuffled from the stage, Madonna does not relinquish power to her daughters, but continues to preside over them.

By complicating linear models of progress, the case of Madonna implies that such models are not necessarily appropriate to the explication of cultural phenomena. Rather, the past and the present appear to dwell side by side. Without these models, though, how can we know where we are *now*? Certainly, it is difficult to detect 'progress' in a culture that organizes itself around the principles of recycling and recombining.[6] That said, the decision to invoke particular aspects of particular historical periods at particular times and in particular contexts might well provide some valuable insights into the politics of the present. As Joseph P. Natoli argues in *Postmodern Journeys* (2000), the 'stories the present spins [...] about the past tell us more about the present than they do of the past'. He goes on to observe that in most instances 'the present revisits the past because it needs something there to bolster and repair something in the present "order of things"'. For Natoli, then, the present is not '"something" solid but rather something that, with the help of the past, can be molded to meet present needs' (96). In its return to the past, the postfeminist mystique sets to recycle models of 'timeless' femininity – articulated through the figures of the happy housewife, the girl and the Gothic heroine – that it regards as damaged by second wave feminism.

2

Postfeminist haunts
Working girls in and out of the urban labyrinth

> At the heart of the urban labyrinth lurked not the Minotaur, a bull-like male monster, but the female Sphinx, the 'strangling one', who was so called because she strangled all those who could not answer her riddle: female sexuality, womanhood out of control, lost nature, loss of identity.
> (Elizabeth Wilson, *The Sphinx in the City*)

> Let's get liberated.
> (Peggy Olson, 'Waldorf Stories' 4.6, *Mad Men*)

In 'Street Haunting: A London Adventure' (1927), Virginia Woolf casts an at once enthralling and unsettling picture of the haunted spaces and ghostly presences of the modern city. The pretext for Woolf's narrator to satisfy her desire to go 'street rambling' is the purchase of a pencil – a ploy that signals from the outset an intimate connection between the position of the woman writer and the woman walker (70). In 'Street Haunting', the public space of the modern city is cast as a Gothic site of dispossession and dislocation for the female subject who roams away from the familiar and known 'self' associated with the home to become part of 'that vast republican army of anonymous trampers' in the city (70): 'The shell-

like covering which our souls have excreted to house themselves, to make themselves a shape distinct from others, is broken, and there is left in all these wrinkles and roughnesses a central oyster of perceptiveness, an enormous eye' (71). In this metonymic moment, the 'I' is transformed into a giant eye, a metamorphosis that affords an intimate and vulnerable relationship to the newly visible haunts of the city. To the 'passing, glimpsing' narrator, who traces the illuminated contours of the urban surface, the city 'seems accidentally but miraculously sprinkled with beauty' (75). Haunted by the hidden, invisible presence of 'derelicts', the city is also a space for fashioning and furnishing new identities, spaces and narratives; it allows the woman walker-writer to 'put on briefly for a few minutes the bodies and minds of others' (81). Mobilizing a sense of 'haunting' as at once 'frequenting' and 'ghosting', the city space envisaged in 'Street Haunting' offers up a rich, if disquieting, image of the woman 'street haunter', who records and makes legible the ghostly figures that occupy its margins, and deviates from the 'straight lines of personality' (81) to create new stories about the life around her.

The figure of the female writer-walker in Woolf's account of the joys of 'street haunting' resonates with, and offers a counter to, conceptions of the male *flâneur* as the pre-eminent stroller and detached observer of the haunts of modern urban life. The *flâneur*, as announced by the French poet Charles Baudelaire in the mid-nineteenth century and analytically amplified by Walter Benjamin in the 1930s, revels in the kaleidoscopic movements of the modern city, discerning and documenting its magical projections and ephemeral forms. For the 'perfect *flâneur*', writes Baudelaire in 'The Painter of Modern Life' (1863), 'it is an immense joy to set up house in the heart of the multitude, amid the ebb and flow of movement, in the midst of the fugitive and the infinite' (9). An individual 'whose state of heightened individuality and interiority spurs him to romantic journeying in the infinity of the self', Baudelaire's *flâneur* is especially 'open to stimuli and walks the streets of the modern city at a slow and leisurely pace, an observer and recorder of modernity, the archetypal modern subject, passive

and open, restrained and appreciative, a customer of the world' (Buse *et al.* 4). The *flâneur* and the modern city are thus implicated in a mutually defining relationship of haunting and hauntedness.

That this dominant definition of the *flâneur* is distinctly and inevitably gendered has been much discussed by feminist critics. Griselda Pollock, for example, argues that the literature of modernity, which is concerned with 'transformations in the public world and its associated consciousness', is a literature that describes 'the experience of men' (93). Public space often remained a hostile and alienating space for women, 'where one risked losing one's virtue, dirtying oneself' (97). Women's presence in urban space seems to be inevitably tinged by the prospect of streetwalking or the 'unfeminine' associations of the working woman – an identification heightened by the visibility of the prostitute as, to quote Janet Wolff, 'the central trope in the discourse of modernity' (19). According to Elizabeth Wilson in *The Sphinx in the City*, women's urban presence is a source of unease and, more particularly, of fear and desire:

> The city offers untrammelled sexual experience; in the city, the forbidden – what is most feared and desired – becomes possible. Woman is present in cities as temptress, as whore, as fallen woman, as lesbian, but also as virtuous womanhood in danger, as heroic womanhood who triumphs over temptation and tribulation. (6)

The sphinx-like female subject lurks at 'the heart of the urban labyrinth' (Wilson 7) as an over-determined symbol of both the desires and anxieties summoned by the modern city. Analysing the recurring image of the labyrinth in critical accounts of and reflections on the modern city, Wilson points out that the idea of the maze 'as having a secret centre' contradicts 'that other and equally common metaphor for the city as labyrinthine and centreless. Even if the labyrinth does have a centre, one image of the discovery of the city, or of exploring the city, is not so much finally reaching this centre, as of an endlessly circular journey, and of the retracing of the same pathways over time' (3). The city becomes an uncanny space

of returns and repetitions. In this configuration, the woman walker haunts the city – not as one who frequents its phantasmagoric spaces, but rather as one who ghosts its very architecture.

In 'The Uncanny' (1919), his anatomization of 'that class of the frightening which leads back to what is known of old and long familiar' (195), Freud identifies an uneasiness about the sexual presence of women in the city as a particular species of uncanny experience. Freud's definition of the uncanny emerges from the slipperiness of the terms *heimlich* (meaning 'familiar' or 'belonging to the home') and *unheimlich* (meaning unfamiliar). Associated with the home, and with the private, *heimlich* does not only signify 'what is familiar and agreeable'; it can also mean 'what is concealed and kept out of sight' (199). The disquieting recurrence and repetition of material that has been estranged through repression, the uncanny is something 'that ought to have remained secret and hidden but has come to light' (200). Although Freud's conceptualization of the uncanny has its origins in his thinking about the home (to which we will return in more detail in chapter three), the essay offers too an anecdotal account of his uncanny experience walking 'through the deserted streets of a provincial town in Italy' (213):

> I found myself in a quarter of whose character I could not long remain in doubt. Nothing but painted women were to be seen at the windows of the small houses, and I hastened to leave the narrow street at the next turning. But after having wandered about for a time without enquiring my way, I suddenly found myself back in the same street, where my presence was now beginning to excite attention. I hurried away once more, only to arrive by another *detour* at the same place yet a third time. Now, however, a feeling came over me which I can only describe as uncanny, and I was glad enough to find myself back at the piazza I had left a short while before, without any further voyages of discovery. (213)

Returning again and again to the same street, Freud reveals the city to be a peculiarly haunted fabric of hidden desires and mysterious meanings. This is an urban space inhabited by painted women in the

windows – painted women to which the male perambulator cannot help but return. The streets may be labyrinthine and enclosing; but they have at their centre an image of the painted woman as a figure of repressed desire. Here woman haunts the city; but once again she ghosts rather than frequents the urban architecture.

The ghostly and haunting vocabulary of the uncanny has often been deployed to imagine the spaces of the city. For example, in his seminal work, *The Architectural Uncanny* (1992), Anthony Vidler articulates in detail the intimate relationship between architecture and the uncanny since the eighteenth century, highlighting the house as 'a site for endless representations of haunting, doubling, dismembering' and 'the labyrinthine spaces of the modern city' as the site of 'modern anxiety, from revolution and epidemic to phobia and alienation' (ix). As Vidler's formulation suggests, the labyrinth may promise multiple routes, movements and freedoms, but it is also a disorientating space where one risks losing one's way, or is condemned to retrace one's steps again and again. This chapter is concerned with the ghostly presences, hauntings and detours that continue to characterize women's experience of the city. Tracing the movements of the working girls who haunt (ghost/frequent) the urban spaces in television series such as *Sex and the City* and *Mad Men*, and those who return to the precincts of homely space in, for example, *Ugly Betty* and Allison Pearson's novel *I Don't Know How She Does It* (2002), it is concerned in particular with analysing the ways in which the city works as a peculiarly fertile venue for the postfeminist mystique.

Occupation: single girl

Notwithstanding its uncanny effects and labyrinthine entrapments, the city has been a key site for the navigation of newly liberated and visible femininities and, in particular, constructions of the working woman in twentieth-century representations. In her analysis of the 'working-girl-investigator', Helen Hanson notes the importance of secretarial work in the late nineteenth and early twentieth centuries,

especially insofar as it authorized women's presence in the city (15). Both first and second wave feminists argued for education and work as the basis of women's freedom from the constraints of marital dependency and, more generally, the right to participate. The rise of second wave feminism and the entry of unprecedented numbers of women into the world of work and paid labour brought with it a corresponding increase in the cultural visibility of the 'working woman' (see Scott 319). According to Friedan in *The Feminine Mystique*, work is 'the key to the problem that has no name'. 'The identity crisis of American women', she argues, 'began a century ago, as more and more of the work important to the world, more and more of the work that used their human abilities and through which they were able to find self-realization, was taken from them' (291). Work, then, represents 'the right to a new, fully human identity' (292), puncturing the mystique of 'feminine fulfilment' that is predicated on a kind of forfeiting of self. Friedan laments that the 'daughters and granddaughters' of feminists have 'been deceived' or have 'deceived themselves, into clinging to the outgrown, childlike femininity of "Occupation: housewife"'. It is this retreat from occupation as activity and employment into occupation as passivity and invasion (the state of 'being occupied by') that 'has succeeded in burying millions of American women alive' by turning them into lifeless Gothic subjects (293). In contrast to the suburban home, the city is marked as a space of greater opportunity, where there are 'more and better jobs for educated women; more universities, sometimes free, with evening courses'; there is also, Friedan suggests, 'less room for housewifery to expand to fill the time' in the city (215). Thus, the city, it would seem, possesses a particular magical temporality that potentially militates against the 'feminine mystique'.

The possibilities offered up by city life were, however, articulated more fully by Helen Gurley Brown in her bestselling *Sex and the Single Girl* (1962). Published just one year before *The Feminine Mystique*, Brown's 'guide' turned its attention instead to the single, urban, working girl as 'the newest glamour girl of our times' (5).

Financially autonomous, career-oriented and unremitting in her pursuit of romantic and sexual gratification, the single girl, writes Brown, 'has had to sharpen her personality and mental resources to a glitter in order to survive in a competitive world' (5). Free from the tedious drudgery of a sexually and emotionally moribund marital life she is 'known by what she does rather than by whom she belongs to' (89). Thus, Brown advises:

> while you're waiting to marry, or if you never marry, a job can be your love, your happy pill, your means of finding out who you are and what you can do, your play pen, your family, your entrée to a good social life, men and money, the most reliable escape from loneliness (when one more romance goes pfft), and your means of participating, not having your nose pressed to the glass. (90)

The single girl's professional status, then, is explicitly identified as grounding her sense of agency and the possibility of assuming a civic identity (of 'participating'). Not only does she privilege career aspirations over marital ones but she also 'has a better sex life than most of her married friends. She need never be bored with one man per lifetime' and her 'choice of partners is endless and they seek *her*' (7; emphasis in original). In Brown's imagining, the professional single girl embodies a new heterosexual lifestyle imagined through choice and consumerism. – but is this enough?

In her debunking of the sexual double standard and her irreverent attitude towards domestic life, Brown, who was editor-in-chief of *Cosmopolitan* magazine from 1965 to 1997, was 'a welcome iconoclast' for many young women in the 1960s (Douglas 68).[1] Her notion of the single girl, purposely calling on the paraphernalia (make-up, manicures, sexy outfits) and work (cooking, sewing, interior design) of traditional femininity in order to fashion her identity, foregrounds its status as a set of disciplinary practices: 'single girls *need* lecturing [...] can you think of *anybody* who needs her glossy hair, waxen skin, stalwart nails, shiny eyes, peachy cheeks, glassy tongue [...] bouncy step and racy blood *more* than a

single woman?' (167; emphasis in original). Nevertheless, in spite of its gestures towards an emancipatory critique of the cultural conditions of traditional femininity, *Sex and the Single Girl* remains an inexorably ambivalent text, especially in its construction of the 'single girl' as an adult identity that is thoroughly immersed in performance. Whelehan summarizes the paradox at the heart of Brown's reimagining of women's sexual subjectivity:

> while directing the energies of the single 'girl' towards her future married stage, [Brown] criticises the stigma attached to the spinster image, rejecting any sense that a single girl's career is merely temporary and claiming for her full adult status (but remaining a 'girl' all the same), both in social and sexual terms. (2000: 142)

The extent to which the linguistic designation of the 'single girl' militates against her transgressive potential is further highlighted by Hilary Radner, who argues that the conflation of the categories of woman/girl works to maintain her nubile status and, therefore, extend her marriageability beyond her youth (1993: 58).[2] The economy of nubile femininity formulated by Brown functions, in other words, to *defer* rather than to *deter* marriage. Thus, despite her glitter and glamour, and her sexual and professional knowingness, the single girl's ultimate pursuit remains underwritten by a heterosexual quest narrative and an adherence to the disciplinary practices of traditional femininity. Nonetheless, Brown's vision of the single girl, recapitulated across the pages of *Cosmopolitan* through the mid-1960s and onwards, remains an important landmark in popular representations of a model of the 'liberated woman' firmly grounded in the trappings of femininity.

In *Backlash*, Faludi identifies 1950s television programming as a fraught site for the representation of single women. She observes that, while post-war television offered a number of shows foregrounding the figure of the single woman, most of these were cancelled by the mid-1950s. Unmarried women surfaced only rarely and briefly in television of the early and mid-1960s, very often as patients in doctor

and hospital shows where their illnesses were 'typically caused by some "selfish" act − getting an abortion, having an affair or, most popular, disobeying a doctor's orders' (191). This hiatus was, however, followed by the powerful re-emergence of the single woman in the 1970s, alongside the mobilization of the women's movement. Charlotte Brunsdon notes the manifestation in this period of 'particular characters or personae who can, in some sense or aspect, be seen to represent either "the feminist" or "the liberated woman"', highlighting in particular the '*Cosmo* girl', 'the independent woman', 'the strong woman/the boss' and 'the post-feminist girly' (1997: 47). In *Prime-Time Feminism* (1996), Bonnie Dow dissects popular television series, including *The Mary Tyler Moore Show* (1970–77), *One Day at a Time* (1974–85), *Designing Women* (1986–93) and *Murphy Brown* (1988–98), arguing that such shows have not only played an important role in 'defining what it means to be a "liberated woman"', but in interpreting and translating the "meaning" of feminism into public discourses' (xv–xvi). Attending to the interpretative activity of these texts, Dow argues that the debut of *The Mary Tyler Moore Show*, in conjunction with an upsurge of media attention to the women's movement in 1970, 'marked a qualitative shift in public consciousness of the presence of an organized feminist movement' (xvi). Many of these series identify the city as a vital site for the liberated woman's realization of her freedoms. This is a connection often telegraphed in the opening credits, which, as Dow points out, 'serve as a kind of introduction to the premise of the show' (2002: 261). In the credits for *The Mary Tyler Moore Show*, for example, the city is depicted as a space full of possibility and excitement for the newly liberated and relocated Mary. However, this media-friendly image of feminism, which tends to privilege identity and lifestyle over politics, also worked to consolidate what Dow describes as 'a racially, sexually and economically privileged *version* of feminism that, for the American public, has to come to represent feminism *in toto*' (1996: xxiii; emphasis in original). It is this particularized and bounded 'version' of lifestyle feminism that persists, albeit in reconfigured modes, in postfeminist articulations of the single girl.[3]

Postfeminist prime time

The 1990s saw the vigorous return of the prime-time single girl and the consolidation of what Radner has identified as a new mode of 'public femininity' centred on the interconnected modes of material and sexual consumption (1993: 57). Emphasizing the experience of white, affluent, heterosexual professional women, shows such as *Caroline in the City* (1995–1999), *Suddenly Susan* (1996–2000), *Ally McBeal* (1997–2002) and *Sex and the City* not only marked a shift in the representation of the 'liberated woman' but in popular accounts of feminism, locating a new model of female freedom squarely in relation to urban experience. One of the first and most conspicuous bodies to rise from feminism's speculative corpse was that of Ally McBeal. Marking a key moment in the fraught relationship between feminism and popular culture in the mid-1990s, *Ally McBeal* provided a compelling site for discussions about popular television's dialogue with feminist issues, its redeployment of feminist vocabularies and that most urgent postfeminist conundrum: can women really 'have it all'? On one hand, its legal context provided a framework for concerted explorations of sexual harassment and violence, marital and domestic rights and gender discrimination; on the other hand, the series reiterated conventional codes of femininity and an individualized mode of empowerment (played out most emphatically in relation to the romantic anxieties and insistent neuroses of its eponymous protagonist, played by Calista Flockhart).

Quickly claimed as the postergirl for a postfeminist generation, Ally McBeal represented the birth of a new brand of hyper-solipsistic lifestyle feminism. Summoned as evidence of feminism's demise, a colour image of Ally McBeal appeared, alongside black-and-white photographs of Susan B. Anthony, Gloria Steinem and Betty Friedan, on the front cover of the now infamous 'Is feminism dead?' issue of *Time* magazine, published on 29 June 1998. The vibrant representation of Ally McBeal stood in stark contrast to the spectral images of Anthony, Steinem and Friedan, whose disembodied heads

emerged from the black backdrop as the past to postfeminism's present. Feminism's death is thus articulated in the shift from black-and-white to colour, and from figures in feminism's political history to a fictional television character. This manoeuvre, remarks Kristyn Gorton, delineates 'a "then" and "now": two distinct feminisms, one representing women "today", and the other, either labelled "second wave" or "seventies" feminism, depicting feminisms of the past' (212). Moreover, continues Gorton, '"today's" feminist is a woman who is identified by the character she represents, not by her own name. Her agency is exchanged for the character she portrays. The metonymic shift may appear trivial but, in a political movement that stresses agency, it is an important one' (215). Emphasizing style and performance over history and politics, the ghostly sequence of disembodied heads consigns feminism to the past; collapsing the first and second waves of feminism into one self-contained and concluded moment, the *Time* cover buries Friedan and Steinem alive in its visual conjuring of feminist history.

This peculiarly ghostly moment in popular accounts of feminism's history and present might usefully be interpreted in terms of McRobbie's argument in *The Aftermath of Feminism* that postfeminism 'positively draws on and invokes feminism as that which can be taken into account, to suggest that equality is achieved, in order to install a whole repertoire of new meanings which emphasise that it is no longer needed, it is a spent force'. For feminism to be 'taken into account', however, it has to be 'understood as having already passed away' (12). McRobbie argues that this move is apparent in Helen Fielding's *Bridget Jones's Diary* (in its newspaper column, novel and film incarnations), where 'the infectious girlishness of Bridget Jones produces a generational logic which is distinctly post-feminist' (12). This, suggests McRobbie, is another text in which 'the ghost of feminism is hovering' (22). For example, when she first meets her improbably-named, would-be suitor Mark Darcy, Bridget tells him that she is reading Faludi's *Backlash* when she is actually reading John Gray's *Men Are from Mars, Women Are from Venus* (Fielding 14). It is in spite of feminism that Bridget wants

47

romance and marriage, and the text works hard to re-contextualize her faith in choice and opportunity through its fleeting references to a feminism that appears to be at a distance from these desires.[4] McRobbie goes on to illuminate how 'the tropes of freedom and choice which are now inextricably connected with the category of young women' play a definitional role in casting feminism as 'aged' and 'redundant' (11). Indeed, 'choice' has become a pre-eminent term in postfeminism's individualist discourse of agency and empowerment. In contemporary popular culture, writes Elspeth Probyn, '"choice and women" has become an item. Moreover, binding women and choice together gives a construction of women as thinking about choice but unable to choose' (262). Perceptibly haunted by an earlier political import that has since been evacuated, the notion of 'choice' has been readily seized upon in various popular media as a means of legitimizing retrograde femininities and women's decision to return to traditional domestic roles.

The extent to which 'choice and women' have been bound together in the popular consciousness is nowhere better illustrated than in *Sex and the City*, whose philosophy is perhaps best captured by the aphoristic title of its series six episode, 'A Woman's Right to Shoes' (6.9). First broadcast in June 1998, the series has been repeatedly located as a touchstone for popular and academic discussions of postfeminist discourses of choice. Indeed, having sounded feminism's death knell in 1998, two years later *Time* magazine offered another colourful cover image of its afterlife in the form of the glamorous stars of *Sex and the City*. The editorial accompanying the cover image, entitled 'Who needs a husband?', identified the cast members as representative 'daughters of the women's movement' (Edwards para. 8). The four central protagonists of the series – Carrie Bradshaw (Sarah Jessica Parker), Samantha Jones (Kim Cattrall), Miranda Hobbes (Cynthia Nixon) and Charlotte York (Kristin Davis) – may be positioned as benefiting directly from the political gains of second wave feminism, but if they are daughters of the women's movement they are born of feminism in its most popular incarnation. Living, working, shopping and dating

in Manhattan, they embody a mode of public femininity that has its ancestry in Brown's *Sex and the Single Girl*.

Rejecting descriptions of the series as 'fashion fetishism, lightweight escapism, anti-feminist slush', Naomi Wolf pronounces, with more than a touch of bombast, that *Sex and the City* is in fact 'the first global female epic – the answer to the question posed in Virginia Woolf's *A Room of One's Own*. What will women do when they are free?' (2003: paras 16–17). However, in *Sex and the City*, the possibilities of women's freedom are envisaged less in terms of a room of one's own than in relation to the illusory public spaces of the postmodern city. While the opening credits for *The Mary Tyler Moore Show* depicted Mary beginning her life in the city, the opening credits of *Sex and the City* (to which we will return below) make it clear that Carrie Bradshaw has already arrived in the glittering and alluring metropolis. Carrie notes in the first episode of *Sex and the City* that 'this is the first time in the history of Manhattan that woman have had as much power and money as men, plus the equal luxury of treating men like sex objects' ('Sex and the City' 1.1). A postfeminist cityscape, Manhattan is presented as a space that affords both financial independence and sexual freedoms for the new female subject – a female subject marked time and time again as white, middle-class and single. It is these new sexual freedoms that provide the inspiration for Carrie's column in the fictional newspaper, the *New York Star*. As a journalist – or, as she describes her occupation at the end of the first episode, 'a sort of sexual anthropologist' ('Sex and the City' 1.1) – Carrie is positioned as at once an inhabitant and an observer of the city.[5] She offers a postfeminist version of the writer-walker and 'street haunter'.

Manhattan's emergence as an exemplary postfeminist haunt is evinced by its status as a location for liberated feminine identities in television shows like *Ugly Betty*, *Damages* (2007–12), *Mad Men* and *Girls* (2012–), as well as films such as *Kissing Jessica Stein* (2001), *The Devil Wears Prada* (2006) and *The Women* (2008). However, if this urban space is haunted ('frequented') by the postfeminist subject,

to the disposition of MC + Co.

Sex and the City makes clear that it is also haunted ('ghosted') by its textual history:

> Welcome to the Age of Uninnocence. No one has breakfast at Tiffany's and no one has affairs to remember. Instead, we have breakfast at 7am and affairs we try to forget as quickly as possible. Self-protection and closing the deal are paramount. Cupid has flown the co-op. How the hell did we get into this mess? ('Sex and the City' 1.1)

Intertextually informed by the courtship rituals of Edith Wharton's novels, this is a history that is also illuminated by a cinematic romantic tradition – for example, *An Affair to Remember* (1957), *Breakfast at Tiffany's* (1961), *Annie Hall* (1977) and *Manhattan* (1979) – in which the city is configured as 'a playground for lovers to wander, their dreams embedded in its grand skyline, museums, autumn leaves and smoky jazz haunts' (di Mattia 22). Although the city is initially depicted as having broken away from the scripts of heterosexual courtship which furnished its history, the relentless references to 'old' New York – to the 'great and glamorous circa 1940' ('Defining Moments' 4.3) – mark it as a space haunted by the ghostly images and styles of the past. Configured here as a palimpsest, a literary trope that, as Huyssen proposes in *Present Pasts* (2003), 'can also be fruitfully used to discuss configurations of urban spaces and their unfolding in time without making architecture and the city simply into a text' (7), the city is conjured as an archive of a glamorous pre-feminist past that unfurls anew in the nostalgic mists of the postfeminist present.

For Carrie, Old New York is embodied by 'Mr Big' (Chris Noth), with whom she is romantically entangled for the duration of the series and who, as his name suggests, represents a monumental masculinity which often gives meaning and sense to her reading of the city ('I heart NY' 4.18). But this postmodern city is posited too as a labyrinth or dream space; a site of eclecticism and change, *Sex and the City*'s Manhattan is an urban phantasmagoria where identity can be constructed and deconstructed, fashioned and refashioned.

It is congruent with, in David Harvey's terms, a postmodernist conceptualization of the urban fabric as

> necessarily fragmented, a 'palimpsest' of past forms superimposed upon each other, and a 'collage' of current uses, many of which may be ephemeral. Since the metropolis is impossible to command except in bits and pieces, urban design (and note that postmodernists design rather than plan) simply aims to be sensitive to vernacular traditions, local histories, particular wants, needs, and fancies, thus generating specialized, even highly customized architectural forms that may range from intimate, personalized spaces, through traditional monumentality, to the gaiety of spectacle. (66)

Privileging the transient over the permanent, and design over plan, the space Harvey describes is one particularly attuned to and shaped by the feminine. It is a space in which the intimate and personalized are brought out from under the shadow of traditional monumentality into the 'complex of urban experience that has long been a vital crucible for the forging of new cultural sensibilities' (66). Here, then, the postmodern metropolis is figured as (dis)organized according to late capitalism's celebration of a consumer-driven commodity culture that is individualistic, insatiable and knowingly frivolous.

In *Sex and the City*, Manhattan provides a site for forging a postfeminist cultural sensibility. The limitations and possibilities of this new sensibility are illuminated by the representation of Carrie as a kind of postfeminist *flâneuse*. The opening credits depict her wandering through Manhattan amidst incongruously fast-moving images of the city's skyline and street traffic. The first frames expose only Carrie's head, enclosed by vertiginous skyscrapers and frenetic streets. Carrie is dressed, anachronistically, in a diaphanous pink leotard and cropped white tutu. Moving through the city, she appears to embody a highly stylized mobility. This is a mobility that is, nonetheless, interrupted when she is dirtied by the muddy street water sprayed by a passing bus which bears on its side an advertisement for her own newspaper column: an image of Carrie

wearing a flesh-coloured dress and the slogan 'Carrie Bradshaw knows good sex'. Stella Bruzzi and Pamela Church Gibson point out that both images of Carrie 'reveal the contours of [her] body, rendering it vulnerable to the masculinised cityscape and its gleaming phallic signifiers' (118). While the two images offer an uncanny reflection of one another insofar as they make Carrie's body visible, they work too to dislocate the woman writer-walker as a figure of creative agency. Here the urban wanderer and the journalist are divided into two separate images; both are marked by their association with the streetwalker.

In his famous essay, 'Walking in the City', Michel de Certeau distinguishes between the 'voyeur' and the 'walker'; his 'rhetoric of walking' envisages walking as a 'series of turns (tours) and detours that can be compared to "turns of phrase" or "stylistic figures"' (100). The walker thus enunciates the city with his footsteps – or 'pedestrian speech acts' (97). In the opening credits of *Sex and the City*, however, the use of low-angle shots suggests that, unlike Certeau's walker, who enjoys an 'elevated', bird's eye view of the city and, like Icarus, 'transforms the bewitching world by which one was "possessed" into a text that lies before one's eyes', Carrie remains 'clasped' in the 'mobile and endless labyrinths far below' (92). Thus, while, according to Jane Arthurs, the streets in *Sex and the City* 'have lost the danger of a sadistic or reproving masculine gaze' and are 'shown to be a place of freedom and safety' (93), the opening credits invite a more ambivalent reading of Carrie's urban mobility. Trapped in the labyrinth, the woman walker's journey remains precarious.

The instability of Carrie's position in New York is presaged by the dirtying of her fairy-tale dress in the opening credits; moreover, throughout the series, her mobility within the city is compromised by her alignment with traditional associations of streetwalking and 'unrespectable' womanhood – an association that is foreshadowed when Mr Big asks Carrie if she is a kind of 'hooker' in the very first episode ('Sex and the City' 1.1). As Susan Zieger points out in her discussion of the series' configurations of citizenship,

Carrie is mistaken for a prostitute several times in the series, most memorably when she is left $1,000 after spending the night with a Frenchman ('The Power of Female Sex' 1.5). Zieger argues that such moments of misreading articulate a broader anxiety about the kinds of labour women may be performing in the city: 'sexual labour haunts the scene of sexual consumption. In order to remain a citizen – in its more literal sense, someone who can freely circulate throughout the city – the women must constantly prove that their sexual consumption is not sexual labour' (104). Time and again, then, the streetwalker returns to the surface of the palimpsestic city to haunt the meanings attached to women's urban movements; these uncanny detours and repetitions return us once again to the body of the painted woman. Still haunted by the ghostly return of modernity's narratives of sexual disorder, the city remains marked as a potentially hostile geography that threatens to enclose the female subject within its labyrinthine walls.

Mad women

If shows such as *Sex and the City* self-consciously position themselves in a post-second wave feminist temporality, the past few years have seen an explicit return to the late 1950s and early 1960s – to a moment just pre-dating, or concurrent with, the beginnings of the women's liberation movement. Series such as ABC's *Mad Men* and *Pan Am*, as well as the BBC's *The Hour*, are characterized by their highly-stylized retro aesthetics, making strategic use of meticulously choreographed representations of history in their attempts to satisfy the cultural appetite for nostalgia. Identifying pastiche as a defining aesthetic aspect of postmodernist texts, Fredric Jameson draws out the Gothic permutations of the nostalgia economy, arguing that:

> [p]astiche is, like parody, the imitation of a peculiar or unique, idiosyncratic style, the wearing of a linguistic mask, speech in a dead language. But it is a neutral practice of such mimicry, without any of

parody's ulterior motives, amputated of the satiric impulse, devoid of laughter. (1991: 17)

For Jameson, pastiche offers aesthetic routes to the past that displace 'real' history, leaving us with 'nothing but texts' (18). Like *Sex and the City*, *Mad Men* is marked by its knowing visual composition and intertextuality; a peculiarly citational text, it plays unremittingly with the mutually implicated discourses of fashion and nostalgia in its representation of the glamorous world of advertising, a world invariably viewed through a seductive haze of cigarette smoke and whiskey vapours. The show, which takes as its focus Sterling Cooper, a fictional advertising agency on Madison Avenue, is set in the early 1960s at a moment of pivotal social change in post-war America – shaped by, amongst other events, the Vietnam War, the Cuban missile crisis and the assassination of JFK, as well as the campaign for civil rights and the emerging women's liberation movement. Its early narratives centre on the personal and professional lives of advertising creative Don Draper (Jon Hamm). Thus, *Mad Men* not only gazes at the hyper-sexualized workplaces of Madison Avenue, but also at the suburban households of middle-class, white families and the unhappy housewife, whose anger and hysteria belie the perfect image of family life that the ad man trades on. In this way, the series places a sustained focus on the frustrated narratives of the various mad women who inhabit its walled spaces.

Like many of the television series discussed here, the first episode of *Mad Men* opens with a stylized representation of the Manhattan cityscape – albeit one that foregrounds instead the Madison Avenue office as an interior urban space. The opening credits depict the solid black silhouette of an ad man, clutching his briefcase as he enters a modern office, complete with desk, chairs and the outline of glasses and decanters on the cabinet behind it. As the pictures begin to slowly slide down the wall, the outline of the office itself dissolves as the ground falls away beneath the ad man's feet. He, in turn, begins sliding downwards as he falls in front of a series of graphic skyscrapers. The surfaces of the surrounding buildings are

made up of images – of the ideal American family but also, and predominantly, of female body parts (a moving leg, a smiling face and a curvaceous body in a red swimming suit). Fragmented into bits and pieces, the female body becomes part of the architectural backdrop across which the ad man embarks upon his vertiginous journey through the imaginative landscape of the world of work. As Harvey suggests, 'the metropolis is impossible to command except in bits and pieces' (66); in the opening credits, this postmodern view of the fragmented urban fabric is articulated in terms of the feminine. In this resolutely masculinised landscape, in which the ad man appears to be more substantial than the ephemeral lines of the buildings surrounding him, the feminine is consigned once again to its architectural/textual surfaces.

However, while *Mad Men* returns the suave male hero to prime time television, it offers too, in its treatment of Joan Holloway (Christina Hendricks), Peggy Olson (Elisabeth Moss) and Betty Draper (January Jones), a disquieting enquiry into historical and contemporary negotiations of femininity and its representations as they coalesce across the co-ordinates of sex, work and the single girl. The opening season is set in 1960, just two years before the publication of Brown's *Sex and the Single Girl* and three years before Friedan's *The Feminine Mystique*. Engaging directly with the complex interrelationship between post-war women's professional and sexual freedoms, *Mad Men* stages a dialogue between feminism and postfeminism that takes place in a pre-feminist world made glamorous by the postfeminist mystique. While Friedan's unhappy housewife is embodied by the appositely named Betty Draper (to whom we will return in the next chapter), Brown's imagining of the independent working girl resonates strongly in the series' representation of Joan Holloway and Peggy Olson. According to Meenasarani Linde Murugan, Hendricks was told by Matthew Weiner to read *Sex and the Single Girl* as part of her preparation for the role of Joan Holloway. Most particularly, she suggests, Joan represents Brown's model of the 'working girl' as both sexualized and feminized – the young woman who will unapologetically use

her sexuality for professional and personal advancement (174). Certainly, Joan's seductive glamour echoes Brown's image of the single girl as someone who is able to 'glitter in order to survive in a competitive world' (5). However, it is, perhaps, Peggy Olson who – on the surface at least – bears a closer resemblance to Brown's working girl (and, indeed, Brown herself, who was similarly promoted to a copywriting position at Foote Cone and Belding, the advertising agency where she was initially employed as a secretary).

The first shot of Peggy arriving in Madison Avenue depicts her already inside the building, stepping into the elevator where she quickly becomes subject to and framed by the leering gaze of three male advertising executives 'enjoying the view' ('Smoke Gets in Your Eyes' 1.1). The female body is scrutinized and dissevered throughout this episode (and the series more generally) – by the ad men who comment liberally on different aspects of Peggy's dress and appearance, the gynaecologist who gives her an internal examination before prescribing her the contraceptive pill, and even Peggy herself, who is told by Joan to put a paper bag with some eyeholes over her head, get undressed and 'really evaluate where [her] strengths and weaknesses are' ('Smoke Gets in Your Eyes' 1.1). Just as Peggy is contained by the claustrophobic spaces of the office and the subordinating structures of the male gaze, so her identity as a working woman requires self-discipline and self-regulation. In order to negotiate the world of advertising successfully, she must also learn to pitch her 'femininity' effectively.[6]

While *Sex and the City* playfully references earlier styles and models of femininity to mark the individuality of the four central characters (see Bruzzi and Gibson 118–20), *Mad Men* fashions distinct and limited modes of traditional femininity. Tonya Krouse argues that the show offers just two primary roles for women: that of the 'chaste housewife', exemplified by Jackie Kennedy; and the 'promiscuous mistress', embodied by Marilyn Monroe (189). The delineation of femininity across these models provides the thematic focus of 'Maidenform' (2.6), an episode concerned less with the clothed body than with women's undergarments. Bespeaking

the series' broader fascination with breasts, bras and décolletage, the episode opens with a montage of Betty, Joan and Peggy each putting on their underwear in front of their mirrors, as they prepare to get 'dressed up' for their respective roles as housewife, office manager and copywriter. In each case, the choice of underwear is key to sculpting and framing the body to meet the requirements of the particular scripts of femininity it must perform in the variously circumscribed spaces of the office and the home. The montage unfolds to 'The Infanta' (2005) by The Decemberists, an anachronistic music choice which sets in play a 'moment of temporal collapse' (Murugan 172) that draws distinct lines between the past and the present. According to Murugan, this chronological incongruity 'allows us to perhaps see our contemporary selves in these women as well as perhaps envision how these women will change in the coming years with the cultural shifts' that will take place (172). While, as Murugan suggests, the seductive frames of the montage invite an identification with these earlier images of womanhood, this is an identification that reads the glamorous spectacle of retrograde femininity (one that, once again, privileges white, middle-class, heterosexual identity) as a *prêt-à-porter* postfeminist identity. If, as Peter Buse and Andrew Stott suggest, anachronism 'draws attention to the part that rhetoric plays in the construction of histories' (14), it not only works here to visualize pre-feminist and postfeminist shared investments in beauty culture and fashion (a field of signification in which anachronism is often experienced), but also to dislocate and distort a feminist chronology by making feminism itself seem anachronistic.

The series' feminist potential is, nonetheless, explored through the characterization of Peggy, who exemplifies the changing figure of the working girl in the especially hostile environment of the advertising industry – both as a place of work and a site for articulating restrictive definitions of femininity. In this particular episode, Playtex, an existing and happy client of Sterling Cooper, asks the agency to design a campaign that 'does what Maidenform is doing' ('Maidenform' 2.6). Playing with the age-old virgin/whore

dichotomy, the advertising team pitches a black-and-white, split image of the same model dressed as both Jackie and Marilyn on the basis that, in the words of Don, 'women have feelings about these women because men do; because we want both, they want to be both'. While the ad men attempt to categorize the various secretaries in the office according to these two types, they are unable to position Peggy, who Ken Cosgrove (Aaron Staton) jokingly labels 'a Gertrude Stein'. Peggy becomes a figure of anxiety for both the ad men and the female secretaries because she refuses to submit herself to the designated scripts of femininity authorized by Madison Avenue generally and the 'Maidenform' campaign specifically. Indeed, the ad men's confident circumscription of female desire within a virgin/whore binary in the visual image is unsettled by the advertising slogan that comes with it – 'Nothing fits both sides of a woman better than Playtex' – which gestures towards the schizophrenic position that the female subject must inevitably inhabit in the illusory spaces and mirror surfaces of the workplace.[7]

The choice of Maidenform bras as the focal point for so overt an exploration of female sexuality and the workplace is significant, not least because of the bra's status as a site for conflicted definitions of women's social and economic freedoms in the twentieth century. The bra – and brassiere manufacture more generally – played an important role in defining the modern woman. Maidenform was founded (as Maiden Form) by Enid Bisset and Ida and William Rosenthal in 1922. Its brassiere designs represented a marked shift away from the emphasis on flattened breasts that dominated in the 1920s and pioneered a new style of bra that uplifted the breasts. According to Jill Fields, uplift 'became associated paradoxically both with the continuing 1920s preoccupation with the look of youth and the emerging 1930s trend towards restoring the "womanly" figure' (93). Synonymous with both freedom and style, the uplift bra came to represent particular ideas about modern femininity – a femininity that, notably, diverged from the more androgynous, even boyish, look of the flapper and reinstated the idea of 'feminine curves'. Fields contends that Maiden Form's *single dominating ideal*

was 'the glorification of the natural feminine figure' (qtd in Fields 97; emphasis in original); the polysemic 'Maiden Form' thus stood for a new kind of freedom for the young (unmarried) woman, but one that simultaneously reinstated assumptions about the natural female body. Maiden Form was also, as Jane Farrell-Beck and Colleen Gau discuss in *Uplift: The Bra in America* (2002), the first underwear maker to advertise on city buses in 1932; moreover, having prospered during the Great Depression, the brand 'bombarded visitors to the hugely popular 1939 New York World's Fair with seventy neon signs, which lighted various entrances to the fairgrounds' (77), a move that foregrounded a yet more dramatic connection between women's underwear and the urban economy.

In 1949, Maidenform launched its famous 'dream campaign', which ran into the late 1960s and featured in a range of women's magazines, including *Vogue*, *Ladies' Home Journal* and *Harper's Bazaar*, as well as publications like the *New Yorker*. The campaign consisted of a series of dream-themed advertisements in which women acted out a particular fantasy, fully dressed from the waist down, but wearing only their bras on their top halves; the women were usually displayed in a public space (in a bull ring, a boxing ring, walking a tightrope above some skyscrapers, in London, on a boat, etc.). While many of the fantasies expressed in the ads reinforced assumptions about typically feminine activities (the first ad featured the declaration 'I dreamed I went shopping in my Maidenform bra') other dream themes articulated professional aspirations (such as being 'a toreador', a 'lady ambassador' and a 'lady editor'). In this respect, the language of the advertisements was somewhat ambivalent. While the undress of the women reiterated their 'pin-up' status, the ads also, suggests Fields, 'gave expression to women's employment fantasies at a time when many white middle-class suburban housewives – some of whom had worked during the war – were feeling unhappily confined at home' (195). Thus, the advertisements enacted a contradictory manoeuvre by positioning the half-dressed woman as simultaneously a spectator and a spectacle in the advertisement's *mise-en-scène* (see Fields 194).

The tensions between private and public space, and between spectator and spectacle, exemplified by the Maidenform campaign speak to *Mad Men*'s fraught representational politics. This conflict is writ especially large in the case of Peggy's predicament as an up-and-coming junior copywriter working on a campaign that trades on misogynistic attitudes about women's 'place'. Shut out from the casting room, and excluded from the after dark meetings taking place in the city's drinking haunts, Peggy complains to Joan that 'there is business going on and I'm not invited' ('Maidenform' 2.6). In response to Joan's advice to 'stop dressing like a little girl' if she wants to be 'taken seriously', Peggy refashions herself in a low-cut blue dress and bright red lipstick, and goes to the strip club where the account executives and Playtex clients are meeting. Sitting on the knee of one of the clients, she gazes uneasily at the stripper while turning away from the reproving gaze of Pete Campbell (Vincent Kartheiser) with whom she had sex on the first day of her job. While this masquerade gives Peggy a route into the masculine spaces of business, her enactment of sexualized femininity remains contingent on the framing structures of the mad men's gaze. The suggestion, then, is that the working girl's position is always tinged by anxieties about the kind of labour she is undertaking outside of the home. For women, work is always a potentially dirty business.[8]

Emphasizing the relationship between underwear and outwear, inside and outside, spectator and spectacle, representations of the bra come to illuminate the shadowy question of women's (in)visibility in *Mad Men*'s treatment of the modern workplace. But the idea of 'underwear' also works to signal the presence of submerged narratives of the body – the ghostly traces of scars and wounds lying beneath the surface of the working girl's 'feminine' costumes. A poignant shot in 'A Night to Remember' (2.8), just two episodes after 'Maidenform', brings into focus an image of Joan sitting on her bed in her underwear. The camera slowly moves in to show her soberly inspecting and stroking the ghostly red imprints that her bra strap has left on her shoulder, a somatic memory of the bra's material and symbolic inscription of the disciplinary practices

Figure 2
The body of Joan (Christina Hendricks) in *Mad Men* is
conspicuously inscribed by the disciplinary practices of traditional
femininity ('A Night To Remember' 2.8).

of traditional femininity. Peggy's professional femininity is also
haunted by the repressed memory of her unheeded pregnancy –
discovered when she collapses with stomach pains the very same
day that she is promoted to a junior copywriter ('The Wheel' 1.13).
The implications of the choice Peggy makes – between the potential
roles of mother and career girl – are picked up in the next series.
In 'The New Girl' (2.5), another episode very much concerned
with what Don's lover Bobbie (Melinda McGraw) describes as
the 'powerful business' of being a woman, there is a flashback to
Don visiting Peggy in hospital suffering from a post-natal 'psycho-
neurotic disorder'. As this analepsis makes clear, Peggy needs to
forget about giving birth and being a mother in order to fully enter
the workplace – a forgetting that is signalled by the reference to
electroconvulsive therapy (the attendant amnesiac effects of which
will be discussed in chapter four) embedded in Don's reassurance
that 'this never happened. It will shock you how much it never
happened.'[9]

The tension between historical memory and forgetting which
structures *Mad Men*'s complex treatment of feminist politics comes
to the fore in *Birth of an Independent Woman* (2009), the two-part

documentary that appeared as part of the Special Features component of the DVD for the second series. *Birth of an Independent Woman* offers a brief account of post-war women's social history and the rise of the women's liberation movement. Part one of the documentary focuses on 'The Problem' with a direct nod to Friedan's exposition of the 'problem that has no name' which haunted America's suburban housewives. The documentary begins with a series of still images of Susan B. Anthony, Margaret Sanger, Gloria Steinem, Betty Friedan and Sojourner Truth (images which contrast the colourful movement of *Mad Men*'s episodes); like the 1998 *Time* cover, which speculated about feminism's death, *Birth of an Independent Woman* transforms feminism into an archive by displacing feminist activity to the recesses of history. Blending newsreel footage, newspaper clippings and interviews with feminist critics and scholars, including Marcelle Karp, Michelle Wallace, Ellen C. Dubois and Diana York Blaine, the documentary traverses such topics as the post-war exclusion of women from the labour force, the frustrations of the housewife and the interrelationship between the women's liberation movement and the civil rights movement. Interspersed with these strands of historical commentary are short clips from the television series, which are positioned as archival evidence of the various hues of sexism colouring the worlds of work and home in the 1960s. These clips, suggests Mary Celeste Kearney, 'offer evocative displays of women's intimate experiences of gender oppression, which are rarely articulated in mainstream histories of the period' (424). Nevertheless, while the documentary plays a valuable role in making visible the historical significance of the women's liberation movement in the US, its presence on the DVD poses what Mimi White aptly describes as 'something of a rhetorical conundrum' in relation to the programme's treatment of femininity (155). Its intertwinement of 'fictional' and 'historical' narratives not only mitigates the glamorization and hyper-stylization of retrograde gender roles; it also emphasizes the 'pastness' of feminism – and sexism – by consigning it to the marginal space of the DVD extra. If, as Kearney suggests, the documentary offers an

'archive of feminist memories' (420), this is an anachronistic archive where 'time is out of joint' (Derrida 21) – where feminism exerts a spectral presence as it returns to and from the maddening dialogue between a pre-feminist past and a postfeminist present.

Coming back home

The work of historical 'forgetting' that marks the postfeminist mystique similarly resonates in the wave of recent narratives that focus on the 'return' or 'retreat' of the independent working woman. Where the motif of 'leaving home' has long been a staple of fictions like *The Mary Tyler Moore Show* and *One Day at a Time*, which have helped to define the figure of the 'independent woman' and her relationship to feminism, it has become a growing source of ambivalence and anxiety. As Joanne Hollows asks, '[h]ow can women now leave home when they've never been there?' (104). Indeed, the 'leaving home' motif is carefully circumnavigated in postfeminist fictions like *Sex and the City*, where the protagonists are already so 'at home' in the urban phantasmagoria of Manhattan that any memories of a home-beyond-the-city have been all but erased. In the fast-paced, fashion-conscious metropolis, the concepts of 'home' and 'family' are defined less in relation to where one is from, than in relation to where one is *right now*. Through its strategic evasion of storylines that refer to the women's lives prior to their arrival in the city, *Sex and the City* works to imply the irrelevance of the family home – and the act of leaving it – to the conjuration of late twentieth-century female identities. Read in more abstract terms, this species of historical forgetting usefully exemplifies the amnesiac dimensions of postfeminism itself, which – in its varied and frequent attempts to re-domesticate women – often fails to remember the home as the key site of women's oppression.

Sex and the City's liberation of its women from the ties of home and family is rethought in more recent shows like *Ugly Betty*. Levelling its critique at the class and racial prejudices that invariably and insistently inflect the professional world of the working girl,

Ugly Betty offers an ironic turn on the earlier series' girly aesthetics as it tracks the trials and tribulations of aspiring journalist Betty Suarez (America Ferrera), a young, working-class Mexican American woman, as she starts a job at *Mode*, a fictional Manhattan-based fashion magazine. While the first episode initially appears to trade on the 'leaving home' motif, with Betty venturing into the city to take up her role as personal assistant to the Editor-in-Chief of *Mode*, Daniel Meade (Eric Mabius), the series as a whole explores Betty's inability to convincingly establish her independence from her home and family in Queens. This tension is heightened by the movement between images of the glittering and polished surfaces of Manhattan's iconic architecture and shots of the cluttered and vibrant family house where Betty lives – for most of the series – with her father, sister and nephew. As Kathleen Rowe Karlyn suggests, in *Ugly Betty* 'the question of belonging, and of how it shapes social hierarchies', is dramatized through the tension between the two contrasting worlds Betty inhabits (208). Indeed, from the first episode ('Pilot' 1.1), the primary geographical movement is Betty's perpetual vacillation between her work in the towering, mirrored office space in Manhattan, a space that is distinctly coded as white and affluent, with her Mexican American home life. Even in series three, when Betty decides to move out of the Suarez residence into her own Manhattan apartment ('The Manhattan Project' 3.1), her domestic and familial ties keep pulling her back to Queens. Indeed, neither her family-orientated father, Ignacio (Tony Plana), nor her sister, Hilda (Ana Ortiz), can understand Betty's desire for independence, and both are quick to chastise her when her career ambitions and life in the city interfere with her responsibilities as a 'good' daughter, sister and aunt.

The ambivalence about female autonomy that Ignacio and Hilda articulate is replicated at a narrative level in plotlines where Betty is 'punished' for an apparent dereliction of her domestic duties. When an overstretched Betty leaves the opening of Hilda's new hair salon to attend to an emergency at *Mode*, she appeals to her father for understanding: 'This is my career. I am working hard to

try and move up and if that means I'm going to miss a family party every now and then, well I don't have a choice. I have to do this.' Ignacio, however, cannot endorse Betty's prioritization of work over family and reminds her that the support she receives must also be reciprocated: 'You do have a choice – you're choosing to leave. No-one supports you more than your family. We are always behind you 100 per cent, but right now Hilda needs you' ('Dress for Success' 3.11). Betty's failure to heed her father's words is punished swiftly and decisively, when – after resolving the crisis at work – she returns to find the party over and the home abandoned as a result of a heart attack that Ignacio suffered in her absence. Ignacio's heart attack can be interpreted as a symptom or manifestation of the daughter's abandonment of the family – and the father specifically – for the career-oriented world of the city. Following her father's recovery and the spiralling debts resulting from her attempt at self-reliance, she sublets her apartment and is welcomed back to the family homestead. Home, in this context, is not advanced as a site of escape, but as a site for the constitution of female identity. For all the ways in which her independence is compromised by her domestic obligations, then, the Suarez home provides an ongoing source of strength for Betty as she negotiates the challenges of a career in the ruthless and duplicitous world of fashion journalism.

If the birth of the liberated woman is no longer straightforwardly synonymous with the act of 'leaving home', then what does it mean for the liberated woman to *go* home? As 'leaving home' becomes an increasingly complicated proposition for women, the theme of 'going home' has assumed a new ascendency within narratives that seek to explore the shaping of feminine and feminist identities. This 'retreatist' plotline, which Diane Negra advances as 'one of postfeminism's master narratives' (15), is mobilized in such films as *Sweet Home Alabama* (2002), *The Holiday* (2006), *New In Town* (2009) and *The Proposal* (2009), as well as in the television series *Gilmore Girls* (2000–07), *Men In Trees* (2006–08) and *Heartland* (2007-). Typically tracing the reluctant movement of the independent, urban-dwelling professional woman to a rural, small-town setting, the retreatist

(handwritten marginalia) feminist?

bt is individual/ism
feminist? int solidarity of community

ur-text exposes the heroine to a (hitherto unknown or forgotten) world in which personal relationships, the home and the community take priority over the ruthless commercial machinations of late-capitalist enterprise. While the protagonist initially experiences the remote environment into which she is jettisoned as alien, hostile and at odds with her usual tastes and routines, she gradually acclimatizes to her new habitat and comes to appreciate the quaint, simple charms of small-town life – charms which are invariably enhanced by the presence of an attractive romantic prospect. Through the folksy wisdom and kind-hearted hospitality of the locals, the heroine undergoes a process of re-education, in which her urban 'feminist' individualism is reassessed alongside a home-and-community-orientated ethics of care. In the preferred denouement of the retreatist plotline, then, the success of the heroine's re-education is tested when she is faced with a choice between the glitz and sparkle of her high-powered cosmopolitan life and the small-town relationships she has developed over the course of the narrative.

Permutations of the 'retreatist' plotline are exemplified in recent films like *New in Town*, which follows Lucy Hill (Renée Zellweger), an ambitious Miami executive, as she relocates to a remote Minnesotan town to oversee the downsizing of the manufacturing plant that lies at the heart of the community. Played by Zellweger, who was cast as Bridget Jones in the film adaptation of Helen Fielding's novel in 2001, Lucy is from the outset haunted by the ghost of the individualist, professional single girl. With her high heels, tight business suits and slick, corporate demeanour, 'city girl' Lucy is ill-equipped to deal with the freezing temperatures and the plain-speaking, god-fearing locals alike – a fact which becomes apparent within hours of her arrival, when she accepts an invitation to dine at the home of her secretary, Blanche (Siobhan Fallon). As she regales the party with tales of her urban adventures, Lucy's cosmopolitan liberalism clashes volubly with the conservative values of the other guests – not least those of the widowed union representative and father-of-one Ted Mitchell (Harry Connick Jr.), who equates her corporate success to the morbid exploitation of 'working folks'.

At the manufacturing plant itself, Lucy manages to raise the wrath of the employees by firing the foreman as a punishment for his perceived insubordination. Over time, however, Lucy begins to appreciate the comforts and intimacies of community living. When she gets stranded in a snow drift, the townswomen present her with a hand-stitched quilt that features names and telephone numbers to contact in case of another emergency; she is later visibly moved when Blanche presents her with a homemade scrapbook as a Christmas present. Just as Lucy is starting to make headway at work – and in her burgeoning relationship with Ted – she returns to Miami for a meeting with her boss, where she is told to abandon the restructuring programme and close the factory down. With her newfound place in the community and her romance with Ted in mutual jeopardy, Lucy concocts a plan to recalibrate the factory's machinery to mass-produce a 'power-packed protein pudding' according to Blanche's 'secret' tapioca recipe. Helped by Blanche, Ted and the soon-to-be-redundant factory workers, Lucy's plan is a rousing success and she is promoted to the role of Company Vice-President back in Miami. As the film draws to a close, Lucy returns to Minnesota to announce that she has brokered a deal for the factory workers that will enable them to become owner–operators of the facility – and to offer her services as the CEO of the new co-operative. By the end of the film, then, Lucy has swapped the cut-and-thrust of urban professionalism for the 'traditional' values and community-focused enterprise of the small town.[10]

In a contortion that is repeated in a number of contemporary retreatist narratives, *New in Town* refashions the concept of home so it is less a place of origin than the place where one is destined to belong. While different to *Sex and the City* in their focus on the small town, such retreatist texts also speak to postfeminism's intermittent tendency to erase the roots of the independent, city-dwelling, professional woman: we never find out where Lucy was 'from' before she arrived in the city. When Lucy 'retreats', then, she does not return to a remembered actual 'home', but withdraws instead from the progressive environs of the city to a setting that is

is this good for feminism?

coded as 'backward' (and thus historical), where traditional values and homespun wisdom hold sway over the relentless materialism and anonymity of late capitalism. While still a crucial, navigating principle within the postfeminist text, the home gives way to a nostalgic vision of the home*ly*. These texts thus succeed in gesturing towards the ongoing discordance of feminism and domesticity by implying that the 'feminist' heroine is so disarticulated from her own place of origins that these origins can no longer form the basis of the retreatist fantasy; indeed, they are so remote or irrelevant that they can scarcely be fathomed, let alone represented. Like the figure of the housewife, to which we will return in the next chapter, the formulation of home in these films and shows seems to represent a 'return of the repressed' in which the more cosy aspects of domestic life, which second wave feminism neglected to acknowledge fully, enact an uncanny return, shattering the stability of female identity in the process.

Owing to their remote settings, these retreatist narratives are linked inextricably with the fantasy of downshifting, which – as Hollows intimates in her useful analysis of this phenomenon – appears to 'resolve the problems of modern femininity through [the act of] geographical relocation' (108). Certainly, in films such as *Sweet Home Alabama*, *New in Town* and *The Proposal*, the movement from the city to the country affords each of the workaholic protagonists an opportunity to shed her hard, corporate skin, (re)discover her 'true' identity as a woman and, in the process, rectify the 'problem' of her moribund romantic life. Despite its apparently conservative trajectory, Hollows speculates that the downshifting narrative 'promises that one can give up [a career] (or at least minimize paid work) in order to spend more time at home without simply becoming "a housewife"'. This promise, in turn, raises the possibility that 'elements of feminism' might also 'be articulated within the transition from urban to rural femininities' (109). What, then, are these 'elements of feminism'? And how might we go about distinguishing a home-focused, rural, 'feminist' femininity from what is otherwise retrograde housewifery?[11]

If chick lit staples like Lauren Weisberger's *The Devil Wears Prada* (2003) and Sophie Kinsella's *The Undomestic Goddess* (2006) show how downshifting can rehabilitate the romantic life of the professional single woman, then Pearson's *I Don't Know How She Does It* demonstrates how it could likewise spell salvation for the equally ubiquitous and vexed figure of the working mother, providing a much-needed escape route from the precarious juggling of familial duty and professional responsibility. At the beginning of the novel, Kate Reddy is an over-committed working mother, endeavouring to balance her career in the city with her hectic home life. After a sequence of guilt-inducing incidents involving her 'neglected' husband and children, however, she leaves her job and moves her family to rural Derbyshire where she becomes a full-time housewife – albeit one who is poised to pursue new investment opportunities at the novel's close. Throughout the book, Kate's email correspondence with her female friends and colleagues, with its peppering of jokes and anecdotes, bears traces of recognition that they belong to a community of working women who have been weaned on the idea that they can have it all. 'Don't hate me if I stop work, will you?' pleads Kate in an email to another working mother. 'I know we said how we all need to keep going to prove it can be done. It's just I used to think that maybe my job was killing me and now I'm scared I died and didn't notice' (329). Kate's anxiety about her own potential ghostliness inverts the concerns that circulate around the ontological status of the housewife in *The Feminine Mystique*. Here, paid work is just as likely to deaden the souls of women as domestic labour; in this Gothic image, it is the professional woman who is imagined as 'empty', insubstantial and deathlike.

While Kate's decision to leave work appears to be purely personal, resulting from the desire to engage in more 'Mummy Time', Pearson does suggest that the situation is not necessarily this straightforward. When Kate's firm wins an award for 'Most Improved Company' for its commitment to diversity – due largely to the 'volume of business generated by Katharine Reddy' – the ensuing report in *Inside*

Finance features a revealing statement from the chair of a fictional organization named Women Mean Business: 'Equality for women remains a marginal issue for most City firms. It seems pointless for banks to spend vast sums of money training female recruits, only to lose them because they do not have flexitime or any of the things that could keep mothers on board' (337). Through this statement, Pearson identifies the extent to which existing labour practices might serve to push women out of work and back into the home. The world of work is defined as at once masculine and paternal; it is inhabited, observes Kate, by 'Daddy's Girls': 'Daughters striving to be the son their father never had, daughters excelling at school to win the attention of a man who was always looking the other way, daughters like poor mad Antigone pursuing the elusive ghost of paternal love' (157). Highlighting Judith Butler's 'sorrowful account of Antigone's life after death' in *Antigone's Claim* (2000), McRobbie suggests that her 'shadowy, lonely existence, suggests a modality of feminist effectivity as spectral; she has to be cast out, indeed entombed, for social organisation to once again become intelligible' (2009: 15). Thus, the summoning of the spectral figure of Antigone – the daddy's girl whose contestation of paternal law led to her entombment and death – in *I Don't Know How She Does It* remains somewhat ambivalent. Just as Freud, returning again and again to the same urban street, finds himself seized by a feeling he can only describe as 'uncanny', so the working woman finds herself returned to the disquieting, walled-up spaces of the home.

3

Haunted housewives and the postfeminist mystique

We are all haunted houses.
(H.D. 'Advent')

I do not know how I'm going to bake my way out of this one.
(Bree Van de Kamp, 'Not While I'm Around' 3.12, *Desperate Housewives*)

Jostled from the feminist stage by the worldly figure of the professional, market-savvy, single girl, the housewife has lingered as a shadowy presence in the wings; relegated to the role of prompt, she has tended to be deployed, within popular and feminist narratives alike, as a reminder to her feminist sisters of everything that feminism is not. As the default model of un-liberated domestic femininity, the housewife has functioned as a convenient cultural shorthand for oppressed womanhood since the first critical stirrings of second wave feminism in the late 1940s. From Beauvoir's doomed 'wife-servant' (473) to Greer's domestic 'slave' (327), she is routinely invoked within popular second wave discourses as an object of feminist pity and approbation. As the preferred object of feminist analysis, the housewife was necessarily integral to the process by which the second wave subject came to be defined; ironically, then, the housewife's centrality to the feminist project has been signalled through her apparent marginality.

Although her status as an object for feminist analysis persists, the housewife has enjoyed renewed visibility in the twenty-first century in texts which have sought to excavate the complexities of domestic femininities. This renewed interest in the housewife-as-subject is reflected in a range of recent television fictions, including *The Sopranos* (1999–2007), *Six Feet Under* (2001–05), *Desperate Housewives* (2004–12), *Brothers and Sisters* (2006–11) and *Mad Men*, in which the tensions between female identity and domestic space are traced and queried. The domestic focus of these fictions is replicated in contemporaneous reality programming such as Bravo's *Real Housewives of...* franchise (2006–) and VH1's *Mob Wives* (2011), which – like *The Sopranos, Desperate Housewives* and *Mad Men* in particular – focalize the personal and familial dramas of its key protagonists while generating a glossy, fetishistic spectacle out of their groomed appearances, luxurious homes and affluent lifestyles.[1]

Drawing on a combination of feminist polemical writing and popular fictions, this chapter explores the extent to which the housewife is marked by ambivalence; demonized and valorized by turns, she is routinely implicated in representations of domesticity which instrumentalize elements of second wave discourses in order to 'take into account' women's potential oppression within the home (McRobbie, 2009: 1). They do so, however, while simultaneously coding particular styles of (white, middle-class, suburban) domestic femininity as highly desirable.[2] Through the lens of the postfeminist mystique, we examine the housewife's myriad guises and trace the contradictory meanings that are ascribed to her, showing how the term 'housewife' has been transformed into an endlessly mobile descriptor that signifies not one but many potential subject positions. Noting sea-changes in the way the housewife has been constructed and understood across a range of cultural sites, we investigate how the 'housewife' epithet has been disarticulated from its etymological moorings, enquiring whether the term still applies exclusively to 'a woman who manages her own household as her main occupation' (*OED*), and considering the implications of Friedan's 'Occupation: housewife' in the context of postfeminism.

In light of these questions, and in the context of the domestic revivalism that has characterized the early years of the twenty-first century, we review the extent to which the housewife might be understood as a form of anachronism. Through reference to texts in which the housewife is evoked in terms of her 'pastness', we ask whether postfeminist culture mobilizes the mechanisms of history and nostalgia in order to re-naturalize or de-naturalize domestic modes of femininity. In doing so, we also consider how the putative 'pastness' of the housewife might problematize 'enlightenment' theories of feminist progress: to what extent do nostalgic evocations of the housewife '[take] feminism into account'? Alternatively, how do they excise feminism from the fictional narrative of women's history? How, moreover, is the housewife implicated in a counter-narrative that associates feminism not with progress but with social decline? In the pages that follow we explore the ever-expanding spectrum of domestic identities that span popular culture in an attempt to expose and unpack the (problematic) political messages that such identities might transmit. With reference to domestic goddesses and kitchen klutzes, we argue that the housewife – whether happy or desperate, glamorous or dowdy, sexy or saintly – is a prevailingly powerful symbolic presence whose increased cultural visibility allows us to reflect on the current state of feminist debates regarding women and the work they do within and beyond the home.

Feminism and the housewife

The polarization of the feminist and the housewife is a central axis of second wave feminism, and one which continues to motor contemporary configurations of women's relationship to the domestic. As Hollows reflects in 'Can I Go Home Yet?':

> Domesticity and the suburban 'home' were things associated with the feminist's 'other', and therefore needed to be kept at a distance. [...] While the politics of housework and suburban privatized domesticity

> could be objects of feminist analysis, they needed to be kept well away
> from the feminist subject. (101)

Echoing the vocabulary deployed by Freud in 'Repression' (1915), Hollows foregrounds the second wave's awkward relationship to domestic and suburban modes of femininity. Just as Freud notes that material which endangers the proper functioning of the individual subject must be 'turn[ed] [...] away' and kept 'at a distance from the conscious' (147), so Hollows contends that the functioning of the feminist subject has been historically contingent on the repression – at a cultural level – of her domesticated 'other'. As we go on to argue, this 'repression' of the housewife is the precondition for her many uncanny returns.

The awkward opposition between the feminist and the housewife is played out in a number of paradigmatic second wave texts which indicate that whatever else she might be, the feminist subject is *not a housewife*. Beauvoir, for one, dedicates large sections of *The Second Sex* to establishing housewifery as an obstacle to female independence, civic involvement and social usefulness. A 'woman's work within the home', she declares, 'gives her no autonomy; it is not directly useful to society, it does not open out on the future, it produces nothing. It takes on meaning and dignity only as it is linked with existent beings who reach out beyond themselves, transcend themselves towards society in production and action' (475). Brown in *Sex and the Single Girl* was equally sceptical about the contribution the housewife makes to society, casting her as 'a parasite, a dependent, a scrounger, a sponger or a bum' and setting her in stark contrast to the sexy, savvy figure of the working single woman who was out in the world, 'liv[ing] by her wits' (212). Eight years later in *The Female Eunuch*, Greer galvanized the status of the housewife as the absolute antithesis of liberated womanhood, citing her membership of 'the most oppressed class of life-contracted unpaid workers, for whom slaves is not too melodramatic a description' (327). Within such discourses, contented housewifery was at best diagnosed as a personal lack of ambition and at worst as

a persistent symptom of false consciousness. Either way, it was – as Ann Oakley declared – a worrying 'form of antifeminism', and thus one of the most troublesome hurdles that feminists would have to negotiate in the pursuit of gender equality (1974: 233).

As most recent scholarship acknowledges, contemporary accounts of the housewife – and her purportedly problematic relationship to the figure of the feminist – have been shaped profoundly by *The Feminist Mystique*. For Whelehan, Friedan's book 'appeared to herald the new dynamism of feminist thought' and installed Friedan as 'one of the pioneers of modern feminism' (1995: 9), while Lesley Johnson and Justine Lloyd remark upon its centrality to histories of women's liberation, emphasizing its articulation, to individual women, 'of a need to leave behind the housewife's role' and 'create a new life for themselves' (9). In another vein, Farrell views Friedan's book as awakening feminist activists to the power of the mainstream media, which 'had perpetuated stereotypical images of woman as housewives, mothers, and brainless consumers interested only in pleasing the men in their lives', but which might also be used to 'breathe life' into the women's movement 'by spreading its word over an entire nation' (21). Less laudatory in her reflections on Friedan's influence is bell hooks, who notes that *The Feminine Mystique* – though 'heralded as having paved the way for the contemporary feminist movement' – 'ignored the existence of all non-white women and poor white women' and is the source of 'certain biased premises about the nature of women's social status' that 'continue to shape the tenor and direction of feminist movement' (1–2).

As Friedan confidently proclaims, the 'feminine mystique says that the highest value and the only commitment for women is the fulfilment of their own femininity'. The mystique, she continues, 'makes certain, concrete, finite, domestic aspects of feminine existence – as it was lived by women whose lives were confined, by necessity, to cooking, cleaning, washing, bearing children – into a religion, a pattern by which all women must now live or deny their femininity' (38). This mystique is embodied, famously, in the fantasy figure of the 'happy housewife heroine'. The happy

housewife heroine reanimates elements of what Friedan recognizes, in the early 1960s, as 'the old image of glorified femininity [...] that trapped women for centuries and made the feminists rebel' (90). In Friedan's narrative, first wave feminism had already tried to '[destroy] the old image of woman' during the campaign for female enfranchisement, with the figure of the New Woman emerging in her wake. Once women's enfranchisement had been achieved, however, the New Woman was, in turn, displaced. Cast as a relic of 'dead [feminist] history' (88), she was laid to rest by the feminine mystique and 'replaced by the Happy Housewife', 'kissing [her husband] goodbye in front of the picture window, depositing [her] stationwagonful of children at school, and smiling as [she runs] the new electric waxer over the kitchen floor' (60, 16). Friedan's suburban housewife thus arises, ghostlike, from the stifled corpse of the first wave's independent 'New Woman', and becomes, herself, the target of repeated feminist exorcisms – not least Friedan's own in *The Feminine Mystique*. While Friedan's timeline risks rendering both feminism and femininity monolithic, it offers a suggestive model for considering the cycle of repression and return in which the housewife (as well as the feminist) is prevailingly caught, providing clues as to why representations of domestic femininity are so often accented by the uncanny.

If the Freudian uncanny is characterized by the 'return of the repressed', then feminism, in repeatedly seeking to displace the figure of the housewife, has inadvertently set the stage for her various returns. Marked nostalgically as belonging to the past, the housewife 'desynchronizes time', embodying the anachronistic ruptures with which Derrida is concerned in *Specters of Marx*; like the ghost of Hamlet's father, she gives rise to the idea that 'something in the present is not going well' (27), that 'the time is out of joint' and recourse must be taken to the past as a way of opening up possibilities for the future. This disjointed temporality is evinced in contemporary popular culture through a return to the historical figure of the 'happy housewife heroine' as a model for 'new', future-facing feminine – and feminist – identities. History

folds back on itself and, at the same time, projects forwards to the future. As we have already established, it is from this peculiar temporal fold that the postfeminist mystique emerges. Like the feminine mystique before it, the postfeminist mystique refreshes and re-enchants an old-style domestic femininity, though in its postfeminist configuration the mystique ensures that representations of this femininity are in some way cognizant of feminism.

If some first and second wave anatomies of housewifery undermined the potentially enjoyable elements of domestic and familial life by casting female homemakers as everything from 'house slaves' (Wollstonecraft 104) to 'parasit[es]' (Beauvoir 475), then it often seems as if postfeminist culture has gone into overdrive in its attempt to restore the twenty-first-century woman to her neo-mythic status at the heart of the home. As Susan Faludi argues in *The Terror Dream* (2007), these recuperative gestures have typified the nostalgic tenor of American culture in the aftermath of the 9/11 attacks on the World Trade Center and the Pentagon. For Faludi, this period was incongruously marked by the 'desire to rein in a liberated female population' that was somehow 'implicated in [the] nation's failure to protect itself' (20–1). Mobilizing against these 'subversive' sections of the population, she explains, the 'cultural troika of media, entertainment, and advertising declared the post-9/11 age an era of neofifties nuclear family "togetherness", redomesticated femininity, and reconstituted Cold Warrior manhood' (3–4). At the heart of this nostalgic portrait sat the beatified figure of the 'homebound' wife and mother, 'undemanding, uncompetitive, and, most of all, dependent' (131). Thus re-coded as acts of patriotism, marriage and pregnancy were no longer events that might be delayed in favour of the kind of 'feminist' careerism promoted by shows like *Sex and the City*, but the cornerstones of domestic security in a newly vigilant America. If, in the fallout of the attacks, cultural commentators predicted a rise in marriage rates and a post-9/11 'baby boom' that failed to materialize, the projected 'trend of a reconstituted "traditional" womanhood' continued to exist 'in the spectral realm of myth, where its relationship to the illusion

of security was symbiotic and self-perpetuating' (144). Faludi's patriotic re-coding of wifehood and maternity does, potentially, risk reducing complex and contradictory cultural phenomena to one traditionalist formula, but the re-prioritization of home, marriage and motherhood that she identifies in post-9/11 culture is readily discernible in 'the vast expansion in popular culture material devoted to the celebration of cooking, cleaning, childcare, and other activities that take place largely in the home' (Negra 118). This material, Negra argues, has an explicitly postfeminist cast, in that 'it presumes female managerial capacity and choice and remakes domesticity around these qualities'. In such a context, '[d]omestic practice gains a "value added" status as highly capable, managerially minded women are invited to devote themselves to home and family in a display of "restored priorities" after the social fracturing attributed to feminism' (118).[3]

From Cheryl Mendelson's *Home Comforts: The Art and Science of Keeping House* (1999) and Anthea Turner's *How to be the Perfect Housewife* (2007) to Nigella Lawson's *How to be A Domestic Goddess* (2000) and Kirstie Allsopp's recent suite of publications (*Kirstie's Homemade Home* [2010], *Craft* [2011] and *Kirstie's Vintage Home* [2012]), homemaking in the twenty-first century has been strategically rebranded as a professional exercise. Again and again it is presented not as the 'torture of Sisyphus' (Beauvoir 470), but as an 'art', a 'science', a form of 'business' undertaken by Negra's 'managerially minded' women, who luxuriate (sometimes guiltily) in the joys of domesticity. Featuring retro-chic images of cupcakes, flowers, feather dusters, gleaming cutlery and various ghostly reincarnations of Friedan's smiling, wide-skirted, bouffant-haired 1950s housewife, these books implicitly confer upon housekeeping, crafting and baking the status of endangered historical practices – potentially rewarding and creative enterprises that feminism has denied to women by consigning them to a gingham-draped (and distinctly un-liberated) version of the past.

Given that Friedan's *The Feminine Mystique* was such a flashpoint in feminist history, providing a useful set of co-ordinates around

which the women's movement could start to map out its terrain, it seems ironic that the figure of the 'happy housewife heroine' – rejected by Friedan as a key source of female oppression – should now figure so prominently in popular culture as a means of 'selling' domesticity to women. In its twenty-first-century recalibration of the 'happy housewife heroine' myth, the postfeminist mystique strives to incorporate elements of second wave feminism, primarily by co-opting the signifiers of choice and empowerment with which it is now associated. As a consequence, the postfeminist housewife heroine, who is represented in recent television fictions by Charlotte York in *Sex and the City*, Bree Van de Kamp (Marcia Cross) in *Desperate Housewives* and Betty Draper in *Mad Men*, is a peculiar amalgam of past and present, exemplifying retrograde styles of femininity that are inflected by elements of the 'ghost feminism' we describe in the first chapter. *Sex and the City*'s Charlotte, for example, evokes – through 'caste signifiers [including] her single strand of pearls, her Cartier watch and her Alice band' – what Stella Bruzzi and Pamela Church Gibson characterize as a 'full-skirted femininity' that recalls the styles of fifties' and sixties' icons including Grace Kelly and Jackie Kennedy (118–19). Charlotte's fashion choices are matched by her (usually) traditional views about love and relationships. When Charlotte gets married and decides to resign from her job as the director of a top Manhattan gallery, however, she invokes the women's movement to defend her right to be a housewife: 'The women's movement is supposed to be about choice. And if I choose to quit my job that is my choice. It's my life and my choice! I choose my choice! I choose my choice!' ('Time and Punishment' 4.7). While Charlotte accurately identifies 'choice' as a constituent of the second wave agenda, what she chooses is regarded by her friends – at least initially – as an anti-feminist retreat to the space of the home and the retroactive model of dependent, domestic femininity with which Charlotte is already sartorially associated.[4]

Desperate Housewives' Bree is similarly identified with the style and manners of a pre-liberation moment. Whether in preppy twinsets, Chanel-style suits or fifties-inspired eveningwear, Bree

cooks, cleans, sews, gardens and hosts elaborate dinner parties, mimicking the appearance and activities of the happy housewife heroine. She even extols the conservative value system of the 1950s, which, in her words, was a decade 'that had a lot to recommend it' ('City on Fire' 5.8). Just as Charlotte's retreat into housewifery is glossed by the 'feminist' rhetoric of choice, so Bree's seemingly anachronistic domesticity is veiled by layers of 'postfeminist' irony. As one of the strategies that the 'sophisticated media machine' adopts in order to 'anticipate objections to the content and images it uses', irony is identified by Whelehan as a staple feature of postfeminist culture (2004). In *Desperate Housewives* irony is used as a means of distancing Bree's domestic perfectionism from that of her pre-liberation prototype, the happy housewife heroine. Where Friedan's housewife was spiralling out of control under the pressure of the 'feminine role' (18), Bree's excessive (and camp) performance of this same role is the means by which she is shown, repeatedly, to retain control of herself and her environment.[5]

When in series 3, for example, Bree discovers that her daughter Danielle (Joy Lauren) is sleeping with her history teacher, she exploits her guise as 'the perfect wife and mother' ('Pilot' 1.1) in order to sabotage the affair. In the opening sequence of 'Nice She Ain't' (3.5), Bree politely coerces a motel manager into giving her the key to the room that Danielle and Mr. Falati (Anthony Azizi) have selected for their elicit rendezvous, telling him that she'd like him to unlock the room so she 'can enter unannounced'. As she does so, the camera remains trained on the motel door, so the exact content of the muffled shouts coming from inside the room remains mysterious. When Bree re-emerges (smiling and wiping the door handle with a handkerchief) there is no sign that anything untoward has taken place; she remarks to the manager that it went 'quite well', before complimenting him on the motel's 'beautiful' carpets. Later in the episode, when it becomes apparent that the affair has resumed, Bree visits Falati at his apartment under the pretext of giving the relationship her 'blessing'. Her 'blessing', however, is also a threat: 'I trust you to be discreet. You wouldn't want your

wife to find out about this and use it against you in your divorce.'
Spoken with faux-cheery animation, Bree's threat intimidates
Falati into agreeing to end his dalliance with Danielle. Although
she briefly steps out from under her guise as 'the perfect wife and
mother' in order to hiss at Falati that she will 'phone the police'
if he 'so much as mention[s]' to Danielle that they have spoken,
she defaults to her breezy disposition and mannered smile in order
to make her final demand: 'Danielle is applying to colleges; I do
hope she can count on you for a glowing recommendation.' In this
episode, and in the broader context of the series, the power of the
housewife is contingent on her ability to set aside the protocols of
suburban decency when the situation demands – but to do so while
still presenting (albeit uncannily) as 'the perfect wife and mother'.
It is through this strategy of 'ironic' distancing that *Desperate
Housewives* both co-opts and neutralizes Friedan's critique of the
'happy housewife heroine', implying that women who inhabit this
role in the twenty-first century do so playfully, with a knowing,
empowered, 'postfeminist' awareness of its social currency.

As we propose in the previous chapter, while *Mad Men* is set
in the early 1960s, its representation of housewifery is no less
shaped by the discourses of second wave feminism than shows like
Desperate Housewives, which inhabit a 'present' that clearly post-
dates women's liberation. Betty's experiences of domesticity are
clearly patterned on the 'problem that has no name', as diagnosed by
her namesake in *The Feminine Mystique*. Like Friedan's housewife,
Betty drifts around her attractive suburban home with little to
do, frustrated by the confines of her 'comfortable concentration
camp' (266). When she expresses her discontent to her husband
he pays for her to see a therapist. The viewer, then, looks back
on Betty's experiences through the lens of postfeminism, which
takes feminism 'into account' through this ghosting of the 'problem
that has no name'. Between Peggy and Betty, the show is inflected
by competing strains of nostalgia: nostalgia for a pre-second wave
moment in which the status of housewife was both respected and
desirable vies against an equally powerful nostalgia for the second

wave itself, when women's access to the workplace seemed to augur an exciting new era of gender equality in which women could 'have it all'. Betty thus emerges as a reminder of the danger of the housewife role, but does so while exemplifying many of the characteristics – beauty, wealth, style, femininity – that postfeminist culture most prizes.

Uncanny housewives

In order to trace the housewife's spectacular 'postfeminist' return, we must first account for her previous disappearances; as the historical *bête noire* of feminism, after all, she has been summoned up and dismissed with uncanny regularity in feminist scholarship and popular culture alike. From Woolf's 'Angel in the House' to Friedan's 'happy housewife heroine', the female homemaker is insistently positioned within feminist thought as the ghostly relic of a pre-feminist past; repressed as feminism's 'other', she embodies the logic of Derridean hauntology in that she '*begins by coming back*' (11; emphasis in original). In other words, her spectral re-emergences are both conditioned on and coterminous with fantasies (and anxieties) about her imminent extinction. While we here understand such re-emergences in relation to the anachronistic temporality of the postfeminist mystique, the housewife's identification with 'past' femininities predates the postfeminism of the late-twentieth century and is instead traceable to the 'postfeminist' moment that was supposed to herald the political successes of feminism's first wave.

In 'Professions for Women' Woolf imagines herself, as she writes, haunted by the phantom of that most exemplary of housewives, 'The Angel in the House'. Recognizing that the 'Angel' has been in partial exile since the 'last [days] of Queen Victoria', Woolf proceeds to trace her phantasmal contours for a 'younger and happier generation [who] may not have heard of her':

> She was intensely sympathetic. She was immensely charming. She was
> utterly unselfish. She excelled in the difficult arts of family life. She

sacrificed herself daily. If there was chicken, she took the leg; if there was a draught she sat in it – in short she was so constituted that she never had a mind or wish of her own, but preferred to sympathize always with the minds and wishes of others. (102)

Even in the 1930s, the housewife is invoked by Woolf as a ghost of femininity past – the stubborn remnant of a system that insisted on women's inferiority to men. Taunted by the Angel's meek whisperings, Woolf describes how she 'turned upon her and caught her by the throat'. 'I did my best to kill her', she admits: 'My excuse, if I were to be had up in a court of law, would be that I acted in self-defence. Had I not killed her she would have killed me' (103). Woolf's macabre vignette usefully characterizes the historically embattled relationship between the feminist and the housewife, and the related suspicion that the survival of either is contingent on the eradication of the other. At another level, though, Woolf's grappling with ghosts reveals the extent to which feminism is, and has always been, haunted by un-exorcized myths about feminine identity. In this way, it not only speaks suggestively to our concerns about feminism and its ghosts, but also foregrounds feminism's own haunted status. As Woolf discovers in the course of her unseemly wrangles with the Angel in the House, the image of the perfect housewife is surprisingly irrepressible. This is, argues Woolf, because of, rather than in spite of, her phantasmal essence:

> Her fictitious nature was of great assistance to her. It is far harder to kill a phantom than a reality. She was always creeping back when I thought I had despatched her. Though I flatter myself that I killed her in the end, the struggle was severe. (103)

Despite Woolf's murderous attempts, the 'Angel in the House' remains stubbornly indestructible; with an ever-changing wardrobe the phantom is forever returning to call women back to the home.

Just as Woolf's 'Angel in the House' has 'never had a mind or wish of her own', so her descendants exist in similar states of apparent

non-being. Second wave accounts of the housewife are marked by anxieties about her ontological status. Beauvoir and Friedan even query the extent to which she is 'alive', pointing to the deadening effects of the labour in which she is engaged. In *The Second Sex*, for example, Beauvoir argues that the work of the housewife proceeds from a 'negative basis'. Waging a 'battle against dust and dirt [that] is never won', the housewife 'wears herself out marking time: she makes nothing, simply perpetuates the present. [...] Washing, ironing, sweeping, ferreting out fluff from under wardrobes – all this halting of decay is also the denial of life; for time simultaneously creates and destroys, and only its negative aspect concerns the housekeeper' (470). This position and rhetoric is later echoed by Friedan:

> It is urgent to understand how the very condition of being a housewife can create a sense of emptiness, non-existence, nothingness, in women. There are aspects of the housewife role that make it almost impossible for a woman of adult intelligence to retain a sense of human identity, the firm core of self or 'I' without which a human being, man or woman, is not truly alive. For women of ability, in America today, I am concerned that there is something about the housewife state itself that is dangerous. (264)

In these accounts, being a housewife is tantamount to a voiding of the self: she has no mind of her own; she produces nothing; and her 'condition' predisposes her to feelings of 'emptiness, non-existence [and] nothingness' (Friedan 264). Like Woolf, who finds a murderous intent lurking behind the benign exterior of the Angel in the House, so Friedan detects danger in the 'very condition of being a housewife' (264). If, however, the 'housewife state' is indeed dangerous, then Friedan regards its danger as stealthily mobile, imperilling woman, home and family alike. As well as being the custodian of the home, then, the housewife is uncannily doubled as its potential destroyer.

As she is conjured by Woolf, Beauvoir and Friedan, the 'perfect housewife' performs traditional femininity so convincingly that she

presents as both an estranged and estranging figure. With varying degrees of subtlety, each of these accounts formulates the housewife as an uncanny – and potentially destructive – presence within the home. Her very existence hangs in doubt: she has 'no mind or wish of her own'; she leaves only ghostly traces of her activity around the home, in which she 'produces nothing' (Beauvoir 475); and, in Friedan's words, she is plagued by a sense of 'emptiness' that prevents her from being 'truly alive' (264). Even the compound noun by which she is described, 'housewife', weds woman to home, conjoining place and status in a way that implies an uncanny, reciprocal bleed between that which is alive (namely the 'wife') and that which is demonstrably inanimate (the 'house'). The housewife's questionable animism calls to mind Jentsch's description of the uncanny, quoted by Freud in his 1919 essay, as involving 'doubts whether an apparently animate being is really alive; or conversely, whether a lifeless object might not be in fact animate' (201). He proceeds to explain that 'one of the most successful devices for easily creating uncanny effects is to leave the reader in uncertainty whether a particular figure in the story is a human being or an automaton, and to do it in such a way that his attention is not focused directly upon his uncertainty, so that he may not be led to go into the matter and clear it up immediately' (202).

Likened routinely to dolls, automata and ghosts, the housewife has been implicated throughout the twentieth century in the solicitation of the 'uncanny effects' to which Jentsch draws attention. In episodes of *The Twilight Zone* from the late 1950s and early 1960s, the robotic woman is only barely distinguishable from her human counterparts. 'The Lonely' (1.7), 'The Lateness of the Hour' (2.8) and 'I Sing the Body Electric' (3.35) all show the robot woman discharging her domestic duties without fuss or objection and even growing to 'love' her adopted kin, despite the fact she is – in the words of the little girl from 'I Sing the Body Electric' – 'nothing but a machine'. Owned and controlled by men, these domestic robots are endlessly suggestive, epitomizing the parasitical nature of the housewife as outlined by Woolf, Beauvoir and Friedan.

As Corry (Jack Warden) in 'The Lonely' reflects, his robotic companion is 'simply an extension of me. I hear my words coming out of her, my emotions. The things that she has learned to love are the things that I've loved.' Similarly, in the American sitcom *My Living Doll* (1964–65), Rhoda (Julie Newmar), a gynoid placed in the charge of a male psychologist played by Bob Cummings, is programmed 'to do anything anybody tells [her]' ('Boy Meets Girl' 1.1). In the context of women's liberation and organized attempts to extricate women from the 'comfortable concentration camp' of the home, these 1960s representations of the programmable woman play overtly to male fantasies of female submissiveness, but they likewise draw out a line of argument that is implicit in first and second wave feminist critiques that the perfect human housewife is, in her robotic attendance to domestic duty, rendered not only strange, but also prone to dangerous malfunction.

It is, however, Bryan Forbes's 1975 film adaptation of Ira Levin's satirical novel *The Stepford Wives* (1972) that offers one of the most disturbingly resonant portrayals of the housewife in the wake of the second wave. While much has already been written about this text, it is such a vital point of reference for scholars of the domestic that it bears further consideration here – not only as a work that theatricalizes the awkward irreconcilability of the feminist and the housewife in the 1970s cultural imaginary, but also as a text that continues to haunt contemporary representations of docile, domesticated femininity in shows like *Buffy the Vampire Slayer* and *Desperate Housewives* – as well as in Frank Oz's 2004 re-imagining of Levin's novel itself.

The film follows Joanna Eberhart (Katharine Ross), a 'hopeful, would-be, semi-professional photographer' in New York City, as she moves with her husband (Peter Masterson) and two children to the exclusive, affluent suburb of Stepford, Connecticut. While not identified as a radical feminist, Joanna, like fellow new arrival and friend Bobbie Markowe (Paula Prentiss), 'messed a little bit with Women's Lib in New York' and is openly bewildered by the willingness with which the other Stepford wives submit to lives

of domestic and sexual servitude. As cigarette-smoking, trouser-wearing, whiskey-drinking women with messy homes, political opinions and florid sexual histories, Joanna and Bobbie are rendered distinct from the other Stepford women in terms of both appearance and sensibility. When the pair arrange a consciousness-raising meeting to help enlighten their seemingly downtrodden peers, they are dismayed when the discussion descends rapidly into an exchange about labour-saving household products. Joanna and Bobbie discover subsequently that Stepford was once a liberal enclave and 'had the first Women's Club to ask any of those liberation ladies to come lecture'. Further mystified by the wives' current political apathy, they confront Carol van Sant (Nanette Newman), the one-time president of the Women's Club, to ask why the group disbanded. 'We weren't accomplishing anything useful', she tells them, before ventriloquizing the principal tenets of the feminine mystique: 'I like to see my home looking nice. [...] Ted's doing really well in his scientific research now, and I give him a good home. I really think that helps. The kids are doing the best they've ever done in school and I'm here all the time. I, well, I know that helps, too. [...] It's none of your business, but our sex life is better, too. Look, I'm sorry to disappoint you, but I'm happy. I'm happy.' Like Friedan before them, Joanna and Bobbie regard the fact that 'the women in Stepford love housework' as the manifestation of a worrying collective pathology – so much so that they start to investigate the possibility that 'there might be something in the water'. When Bobbie herself succumbs to the life of cooking and cleaning about which she was once so cynical, Joanna makes an appointment with a female psychiatrist to whom she confesses her fears about her own future: 'There'll be somebody with my name, and she'll cook and clean like crazy, but she won't take pictures and she won't be me. She'll be like one of those robots in Disneyland.' Joanna's reference to robots could not be more prescient; at the climax of the film, she is lured to the headquarters of the local Men's Association, where she stumbles onto a stage set of her bedroom and comes face to face with her own large-breasted animatronic double. Already activated,

the new, negligee-clad 'Joanna' rises from her dressing table, wielding a twisted silk stocking in her hands, and looms menacingly towards Joanna before the shot blacks out. The film closes with a series of shots of the hollow-eyed wives – of which Joanna is now one – gliding vacantly through the bright, product-packed aisles of the local supermarket, exchanging banal pleasantries with one another as they load their trolleys with household merchandise.

Crystallizing Friedan's famous vision of the 'thing-buying' housewife as 'an anonymous biological robot in a docile mass' (267), Forbes's original adaptation of *The Stepford Wives* imagines a patriarchal dys/utopia in which all women are pre-programmed to conform to the strict script of the feminine mystique. Amongst the perfectly-coiffed, willingly obsequious wives of Stepford, then, there is no place for feminism; as Joanna and Bobbie discover to their cost, consciousness-raising groups are of limited effectiveness when the women involved are – quite literally – mindless automata. If Forbes's suburban Gothic dramatizes male fears about the rise of feminism in the 1970s, then the apparent status of feminism and domesticity as unhappy bedfellows is understood as the root of those fears; while the precise rationale for the murder and mechanization of the Stepford wives remains tantalizingly oblique, it appears that the men of Stepford take radical pre-emptive action against their 'liberal' wives in the belief that feminism is fundamentally anti-family, anti-home and anti-male. As the President of the Men's Association (Patrick O'Neal) explains to Joanna, 'it's perfect for us and it's perfect for you. [...] Think of it the other way around – wouldn't you like some perfect stud waiting on you around the house, praising you, servicing you, whispering how your sagging flesh was beautiful no matter how you looked?' According to the film, then, the ~~central work of~~ patriarchy (as it is represented through the conspiratorial machinations of the Stepford Men's Association) is to guard male interests, appetites and egos by brainwashing women into lives of domestic and sexual servitude, ensuring that they remain in the home and dependent on their husbands – ensuring, in short, that they are not feminists.

The film's narrative is, incontrovertibly, a response to 1970s feminism. At a moment when the women's movement seemed poised to re-script traditional gender roles entirely, it imagines a world in which feminism is rendered ineffective through the artificially coerced conformism of the white, middle-class women who would otherwise form its core demographic. More extremely, it offers a speculative vision of a society where patriarchy is brought to bear on bright, independent, professional women in ways that make them complicit in their own oppression.

Just as the profound injustices that drove the second wave are conveniently 'forgotten' or underplayed in many postfeminist narratives, so Frank Oz's 2004 remake of *The Stepford Wives* appears to disregard the biting critique of patriarchal power that lies at the heart of both Levin's novel and Forbes's adaptation. Where Forbes's film plays out a patriarchal fantasy in which men are able to neutralize the impact of women's liberation, Oz's Stepford is the venue of a post-liberation fantasy in which women are themselves released from the demands of feminism and the pressure to 'have it all'. In Oz's remake, it is a woman, Claire (Glenn Close), who

Figure 3
In Frank Oz's 2004 remake of *The Stepford Wives*, Claire
(Glenn Close) attempts to undo the progressive effects of
feminism by re-engineering her friends and neighbours as
gender-compliant robots.

engineers the automation of the Stepford housewives. In explaining her rationale for doing so, she articulates the anxieties about 'having it all' that are so central to postfeminist debate:

> All I wanted was a better world – a world where men were men and women were cherished and loved. [...] All I wanted was to make you – all of you – into perfect women. [...] I was just like you – overstressed, overbooked, underloved. I was the world's foremost brain surgeon and genetic engineer. [...] I was driven, exhausted, until late one night I came home to find Mike with Patricia, my brilliant, blonde, twenty-one-year-old research assistant. It was all so ugly. I decided to turn back the clock, to a time before overtime, before quality time, before women were turning themselves into robots.[6]

By casting Claire in the role of engineer, Oz reverses the original denouement in order to reflect the way that liberation has changed relations between men and women.

As well as exposing the mythical plight of emasculated men like Walter (Matthew Broderick), the husband of Joanna (Nicole Kidman), who complains that his wife's 'Wonder Woman' accomplishments have made him (like the other Stepford men) into 'the wuss, the wind beneath your wings, your support system, the girl'. Oz seeks to foreground women's own weariness with equality and imply their self-willed complicity in the maintenance of patriarchal interests. Although her critique – with its references to 'overtime' and 'quality time' – is in part a critique of the relentless demands that capitalism places on the individual worker, Claire chooses to believe that women's untenable predicament is a product of their own (feminist) making, rather than a fault of the (enduringly patriarchal) capitalist system. In Claire's view, it is women – and those 'overstressed, overbooked, underloved' working women in particular – who are responsible for their own unhappy state: they are the ones who are 'turning themselves into robots'. Interestingly, the figure of the robot is invoked by Claire as the exemplum par excellence of the postfeminist woman, striving

to juggle her personal and professional responsibilities in a blank state of routinized hyper-efficiency. When Claire does actually transform the over-achieving women of Stepford into automata, however, she does not endeavour to adapt them to the competing demands of domesticity and paid work, but instead elects to re-anchor them to the space of the home. Even robotic women, it seems, must limit their aspirations to the domestic sphere and abandon the expectation that it is possible to be anything other than good wives and mothers. As Claire explains, personal and professional contentment are mutually exclusive for even the most talented women; the only way for women and men to be happy is to return to a world where women's responsibilities are exclusively domestic. Despite her representation as a well-coiffed lunatic, Claire usefully articulates the post-liberation challenges with which so many postfeminist texts are engaged. She also, of course, arrives at the same conclusion as these texts: it is time to give up on having it all and go back home.

With its evocative portrayal of a picture-perfect suburbia populated by erotically compliant robots, *The Stepford Wives* provides a useful context for thinking about subsequent representations of domestic femininity. While fantasy fictions like *Buffy the Vampire Slayer* and *Dollhouse* (2009–10) have toyed with versions of the 'reprogrammed' woman that demonstrate a debt to the sexually submissive wives of Levin's original novel, its influence is nowhere more apparent than in the nostalgic stylings and dark suburban themes of Marc Cherry's *Desperate Housewives*. So clear is this debt that *The Stepford Wives* is referenced directly in the pilot episode. As Bree Van de Kamp serves up an elaborate dinner to her family, her teenage children respond with little more than 'cold indifference', identifying her domestic perfectionism as abnormal rather than praiseworthy: 'Tim Harper's mom gets home from work, pops open a can of pork and beans, and boom! They're eating. Everybody's happy. [...] [D]oes every dinner have to be one of Martha Stewart's greatest hits?' These despairing words, spoken by Bree's son, Andrew (Shawn Pyfrom), bring about a further exchange in which he lays the blame for the

family's unhappiness at his mother's feet: 'I'm not the problem here. You're the one always acting like she's running for the mayor of Stepford' ('Pilot' 1.1).

If Stepford has become an easy shorthand for a pre- or anti-feminist world in which women remain ineluctably identified with the home, then Fairview, the fictional Connecticut suburb in which *Desperate Housewives* is set, presents as a similarly candy-hued and conservative environment. Ultimately, the show performs a double gesture in which domestic perfectionism is mocked and glamorized simultaneously. It offers a version of domesticity which, if not without difficulty, is nonetheless highly desirable – undertaken, as it is, by women in luxurious homes, wearing designer clothes, with access to paid help and no shortage of leisure time. If such materialism does not necessarily make these women happy in their domestic roles, then it at least enables them to look good while performing them.

Princess housewives and idle hands

In the twenty-first century, popular representations have focused increasingly on the housewife as an agent of excess; departing from the 'downshifting' model described in the previous chapter, being a housewife seems to be about consuming more, not less. Indeed, since the success of *Desperate Housewives*, with its slick depiction of glamorous, suburbanite domesticity, representations of the housewife within popular culture have demonstrated an increased interest in this figure as an emblem of leisure and luxury. Despite their relative scarcity within the population, it is those housewives who embody the kind of sexy, supercharged materialism associated with contemporary celebrity culture who have attracted a disproportionate amount of media coverage in recent years. From the British WAG to the Beverly Hills gold-digger, the first decades of the twenty-first century have witnessed the rise of what might be termed the 'princess housewife'. Freed from the pressures of paid work and thus empowered through her 'choice' to stay at home,

the princess housewife has become a revered and reviled symbol of modern femininity. With her hyper-groomed appearance and rigorous fitness schedule, she has been instrumental in repositioning the housewife as a desiring and desirable being.

This is nowhere more apparent than in Bravo's *Real Housewives of...* franchise. Created by branding consultant Scott Dunlap, the original series, *Real Housewives of Orange County* (2006–), follows the moneyed women of Coto de Caza, an affluent gated community in Southern California. Riding on the *Desperate Housewives* zeitgeist, to which its title is a knowing reference, the success of the *Real Housewives of Orange County* led to the commissioning of sister series in New York City, Atlanta, New Jersey, Beverly Hills and Miami. Despite its titular proclamations, one of the most interesting things about the *Real Housewives of...* franchise is the virtual absence of any women whose daily activities might conform roughly to those of a conventional housewife. Not only do many of the women run their own businesses, but – with housekeeping and childrearing outsourced to low-paid professionals – they are seldom, if ever, shown engaging in housework. Indeed, they are seldom, if ever, at home. In addition to this, a handful of the women featured in the shows are either divorced or unmarried. What claim, then, do these women have on the 'housewife' label? With schedules revolving around shopping expeditions, cosmetic procedures, luxury holidays and work, the art of 'keeping house' is all but invisible in this show. Through this aggressive rebranding of 'housewifery' as an extended exercise in self-indulgence, Friedan's 'Occupation: Housewife' is deftly transformed from a curse into a privilege.

In celebrating these models of privileged 'housewifery' popular culture repeats a fairy-tale idealization of feminine idleness and indulgence that has long been a source of frustration within feminist discourses. Over two centuries ago, Wollstonecraft dismissed as 'mere dolls' the women who, 'rendered weak and luxurious by the relaxing pleasure which wealth bestows', rid themselves of all domestic responsibility by delegating their wifely and motherly duties to paid employees (262–63). Mocking the 'idle princes and

princesses [that] pass with stupid pomp before a gaping crowd, who almost worship the very parade that cost them so dear', she laments that women 'all want to be ladies. Which is simply to have nothing to do, but listlessly go they scarcely care where, for they cannot tell what' (265–66). While Wollstonecraft notes that 'the woman who earns her own bread by fulfilling any duty' is 'much more respectable' than she who resides in a 'giddy whirl of pleasure', she also bemoans 'how few women aim at attaining this respectability' (268). According to Wollstonecraft, then, these idle princesses – like their postfeminist descendants – do have access to some lifestyle choices as a consequence of their wealth. The problem, for Wollstonecraft at least, is that these women of privilege insist on making the 'wrong' choices, prioritizing the pursuit of empty pleasures over the 'respectability' of paid work. Over a century and a half later, Beauvoir worried that the indolence of the wealthy wife had now infected her less privileged counterpart: 'Middle-class women who employ help [...] are almost idle; and they often multiply and complicate their domestic duties to excess, just to have something to do' (473). Friedan, too, reflected that the mass manufacturing of new domestic technologies had left the housewife with too much time to fill – time which she could all too easily dedicate to the neurotic monitoring of her offspring (249).

Friedan's anxiety about the idle housewife, and the danger her indolence poses to her family, is anticipated in a 1960 episode of *The Twilight Zone* entitled 'The Lateness of the Hour' (2.8). As Rod Serling explains in his narration, modern engineering – in the form of advanced robotics – has enabled Dr. Loren (John Hoyt) and his family to 'make comfort a life's work'. This 'life's work' is rendered obscene from the outset through the figure of Mrs. Loren (Irene Tedrow), whose sensuous moans provide the incongruous soundtrack to the opening scene, in which the Lorens' daughter, Jana (Inger Stevens), is shown gazing longingly out of the drawing room window onto a dark, stormy vista. The camera then follows Jana across the room as she passes the sedentary figure of her father, before panning out to reveal Mrs. Loren, in the foreground,

groaning rapturously in response to her maid's shoulder massage. This grotesque portrayal of wifely overindulgence is oddly discomfiting. As the traditional responsibilities of the happy housewife heroine are delegated to an assortment of humanoid robots, Mrs. Loren's role as housewife is evacuated of all its nurturing elements, and her ability to mother effectively is cast into question. While the robots fulfil the functions for which they were designed, the same cannot be said of Mrs. Loren; she is a wife and mother who performs none of the duties associated with these roles, the literal embodiment of Beauvoir's housewife, who does nothing, makes nothing and produces nothing (475). Mrs. Loren's inactivity disgusts Jana, who asks: 'Haven't you had enough of that yet?'. This disgust fuels Jana's ultimate discovery that she, too, is a robot – a discovery that leads first to her deactivation and then to her father's decision to reprogram her as a maid. While Dr. Loren is responsible for constructing the robots that facilitate the couple's slothful lives, it is Mrs. Loren who seems most accountable for the destruction of the 'family' he has made; a housewife lounging about the home is an anomaly, an abomination, an indication of a house not in order and a family made vulnerable. *is this sarcasm?*

In *Mad Men*, the disintegration of the Drapers' marriage is concomitant with Betty's decision to hire a black maid, Carla (Deborah Lacey). Recalling hooks' critique of *The Feminine Mystique* as a lament for white, privileged 'housewives, bored with leisure, with the home, with children, with buying products, who wanted more out of life' (1), *Mad Men* fixates on Betty's discontent, while offering little insight into the plight of the black woman to whom she outsources her domestic labour. This is typical of a show in which non-white identities are only made visible when they make incursions into the 'white' spaces (of the suburban home and the Manhattan office) that it takes as its key settings. With Carla rallying the children for school, vacuuming the carpets, cooking the meals and washing the dishes, Betty's hands become increasingly idle. She listens to the radio, reads bestselling novels, watches television and starts attending a riding club where she meets a young man with

whom she begins a flirtation ('The Benefactor' 2.3). Once Betty's domestic usefulness is undermined, her home, quite literally, begins to fall apart. In 'Three Sundays' (2.4) the Drapers' son, Bobby (Aaron Hart), breaks the bed and the stereo, then burns himself on the stove. In the same episode, the car breaks down when Betty is driving and Don smashes up Bobby's toy robot at the dinner table. The Draper residence, once desirable, is here transformed into an architectural facsimile of the 'broken home'. As the series progresses, any sense of domestic order that Carla imposes is countervailed by Betty's increasingly chaotic behaviour within the home: she drinks during the day, sleeps in her clothes and smashes a dining chair to pieces as her children watch television in the next room. Her body, too, is a site of disorder: she cuts her foot open on a broken glass; she bleeds through her trousers onto the sofa; and she eventually discovers, unhappily, that she is pregnant with a third child.

Without an effective housewife-superintendent, the home is rendered vulnerable to collapse; it is not just that Betty is ineffective as a housewife, but that her reluctance to fulfil the duties associated with that role is actively destructive. In addition, it is impossible for Betty to imagine a life for herself beyond home. When she goes into labour with her third child, she experiences a hallucination which reveals the narrowness of her horizons and her psychological inability to dream her way out of domesticity. A close-up of Betty's labouring face dissolves first into a moving shot of the fluorescent lighting in the hospital corridor, then into sequential shots of various body parts – her feet, her left hand (complete with a hospital tag identifying her, no doubt, as 'Mrs. Draper'), her head and shoulders – before cutting to a long shot in which she shuffles languidly towards the dazzling light of the exit. The use of dissolves here implies a peculiar convergence of woman and space – a convergence that is further confirmed when Betty finds herself not outside, as the spatial logic of the hospital would dictate, but returned instead to the familiar enclosure of the Draper kitchen, which is now haunted by the ghosts of both her parents and a wounded civil rights campaigner. The claustrophobic plight

of the 'happy housewife heroine' is here dramatized through her surreal transitioning between maternity ward and kitchen: the two places where she ought to be most at home. Clearly not 'at home' in this white suburban tableau is the black campaigner, who – as well as implicitly connecting racist and sexist modes of oppression – makes visible what *Mad Men* tends to otherwise render invisible: black and non-white identities. As a ghostly symbol of what has been 'cast out' of the series in order to enable its sustained and glamorous investigation of white privilege, the martyred black man comes back to haunt the intimate spaces of white suburbia as both a reminder of (past and present) injustices and as a portent of sacrifices yet to come. Gesturing towards the wounded campaigner with the bloody rag she holds in her hand, Betty's mother (Lou Mulford) asks her if she 'see[s] what happens to people who speak up? Be happy with what you have', while her father (Ryan Cutrona) tells her '[y]ou'll be okay. You're a housecat: you're very important and you have little to do' ('The Fog' 3.5). Thus haunted by the myth of the 'happy housewife heroine', as ventriloquized by her dead father, Betty is encouraged to view her indolence as an achievement, the ultimate reward for her successful performance of domesticated femininity.[7]

You're gonna die in here!

If the idle housewife is often represented as being uncannily estranged from the domestic sphere, then she is elsewhere rendered uncanny as a consequence of her over-identification with the home. It is through these housewives that popular culture has endeavoured to represent the potentially toxic (and deadly) effects of domesticity on the postfeminist subject. As the term 'housewife' encrypts the uncanny interconnectedness of woman and home, Gaston Bachelard's *The Poetics of Space* (1958) offers a more sustained evocation of the home as a feminine zone. Making special reference to its 'maternal features', Bachelard's home is a 'large cradle' with 'arms' to envelop and a 'warm bosom' to

nurture. It is the place of 'original fullness' which 'we were born in', a 'material paradise' where we are 'bathed in nourishment' and to which we return, over and over again, in daydream (7–8). Calling to mind Freud's reflections on the space of the womb and the maternal *imago*, Bachelard describes how 'the house we were born in is physically inscribed in us': it is the psychic blueprint for an 'oneiric house, a house of dream-memory, that is lost in the shadow of a beyond of the real past' (15–16). While Bachelard's 'topoanalytical' tour of 'the sites of our intimate lives' hinges on an insistent anthropomorphization of the home that reveals its peculiar sensitivity to its inhabitants, he views its responsiveness as purely benign; in his eyes it is a 'felicitous space' into which no harm can come, a bricks-and-mortar 'mother' who offers protection from the storm (45).

Shades of the home's maternal reactivity also emerge from the pages of *The Second Sex,* where it becomes a 'refuge, retreat, grotto, womb, [which] gives shelter from outside dangers'. For all its cosy charms, however, the home is also working against the homemaker, who must engage in an endless and impossible 'war against dust, stains, mud, and dirt' as 'provisions attract rats' and 'moths attack blankets and clothing'. Like the world, the home 'is not a dream carved in stone, it is made of dubious stuff subject to rot; […] it seems inert, inorganic, but hidden larvae may have changed it into a cadaver' (471–74). Beauvoir's ambivalent description of the home as both a sanctuary and site of decay echoes Freud's reminder in 'The Uncanny' that benignity and malevolence are close bedfellows: what is *heimlich* can very quickly become *unheimlich*. Indeed, it is the womb, that most homely of places 'which had originally nothing terrifying about it', that Freud regards as 'the most uncanny thing of all' (220). Freud's delineation of the uncanny fosters an intentional confusion between rooms and wombs, in which the distinctions between the two break down and the spaces of the home begin to converge with those of the female body.

This unsettling over-identification of women with the home is one of the principal motifs of Ryan Murphy and Brad Falchuk's

television series *American Horror Story*. In the first of the present-day scenes from the opening episode, Vivien Harmon (Connie Britton), a middle-aged housewife recovering from a late miscarriage, undergoes a routine vaginal examination. As she lies, feet in stirrups, the male gynaecologist couches his discussion of her ageing body in architectural euphemisms: 'Your body is like a house. You can fix the tiles in the bathroom and the kitchen, but if the foundation is decaying you're wasting your time.' While Vivien is quick to remind him that she is 'not a house', the doctor's analogy becomes retrospectively prescient when the series starts to collapse the clear-cut division between woman and home upon which Vivien insists ('Pilot' 1.1).

If Vivien's ageing body was too leaky to provide a secure home for the son she could not carry to term, then her house proves to be a similarly inhospitable environment for its occupants. Like her body, which is raped, impregnated, assaulted, threatened and hijacked, the 'classic L.A. Victorian' home into which she moves with her husband, Ben (Dylan McDermott), and their daughter, Violet (Taissa Farmiga), is vulnerable to frequent and unsolicited intrusions by various interlopers. Initially, it is Adelaide (Jamie Brewer), the grown-up daughter of the Harmons' eccentric neighbour, Constance Langdon (Jessica Lange), who keeps appearing uninvited to issue her stock warning, 'You're gonna die in here', to an increasingly impatient Vivien. As Adelaide is repeatedly discovered within the Harmon home – running through the kitchen, playing in the basement, loitering in the dining room ('Home Invasion' 1.2), hiding under Violet's bed ('Halloween: Part 1' 1.4) – Constance's early advice to Vivien, that 'Addy will always find a way in' ('Pilot' 1.1), takes on the character of a prophecy. As harmless as Adelaide is, Ben views her presence within the Harmon home as a worrying sign of its vulnerability: 'if that little freak can get in, anyone can' ('Home Invasion' 1.2). As Adelaide can 'always find a way in', so too can Constance herself, whose clandestine trespassing is usually accompanied by her pilfering of portable items from Vivien's jewellery box or cutlery collection. Throughout the

series, repeated reference is made to the fact that the house is not secure: 'You left your back door open', Constance tells Vivien in the opening episode, while Violet, cutting her wrists in the bathroom, is warned by one of her father's psychiatric patients to 'try locking the door' if she's going to kill herself ('Pilot' 1.1). Shots of the home's interior reveal a place in which doors are rarely closed, where occupants and visitors wander between rooms as they please and in which privacy, as a consequence, is perpetually effaced.

Although what is outside the Harmon home can always get in, the reverse is less often the case: what is inside cannot always get out. Known locally as the 'Murder House' and billed as the star attraction on a macabre bus tour of Los Angeles' most notorious crime sites, Vivien's house plays host to the ghosts of everyone who has ever died within its perimeters. These ghosts are destined to remain trapped within the boundaries of the property for all eternity, giving in to their earthly impulses and repeating their earthly mistakes ad infinitum. If this destiny speaks on one level to the historical plight of the housewife, doomed to repetition within the walls of the home, then it speaks on another to anxieties about property ownership in the wake of the subprime crisis. The safety, and threatened loss, of the home is a constant source of concern in *American Horror Story*; the real horror is not that the house is haunted, but that the Harmons could suffer the same fate as their ghostly cohabitants and be forced to dwell indefinitely in an undesirable property that they are unable to sell.

In many respects, the show recalls Eugenia C. DeLamotte's characterization of the Female Gothic as a subgenre in which 'women [...] just can't seem to get out of the house' (10). Even though the house is not inhabited exclusively by women, it is women – particularly Nora, Constance, Vivien, Violet and the maid, Moira (Frances Conroy/Alexandra Breckenridge) – who are most closely identified with its structures. Certainly, *American Horror Story* seeks to locate itself within a venerable tradition of haunted house narratives about female entrapment, including Charlotte Perkins Gilman's *The Yellow Wallpaper* (1892) and Shirley Jackson's

The Haunting of Hill House (1959). Repeating the key manoeuvres of these earlier fictions, *American Horror Story* explores the end-limit of the postfeminist mystique, showing what happens when women start to identify themselves too closely with the domestic spaces in which they move. When Moira makes specific reference to *The Yellow Wallpaper* – not as a fiction, but as a historical example of how 'men find excuses to lock women away' ('Rubber Man' 1.8) – Vivien's earlier attempts to strip back the wallpaper in one of the reception rooms ('Pilot' 1.1) become portentous post factum, foreshadowing her own perceived insanity and eventual imprisonment within the home.

Vivien, however, is far from being the first woman to develop an unhealthy psychic affinity to the house. Originally built for the moneyed Philadelphian socialite Nora Montgomery by her surgeon husband, the house is modelled on her tastes and features. 'Look at the blue', says the ghost of Nora to Vivien as she admires the Tiffany stained glass window against which she is standing, 'matches my eyes doesn't it? Your eyes are a beautiful blue, too.' While delighted by the home's original features, Nora begins to shake nervously when she enters the kitchen, which Vivien – mistaking her for a potential buyer – advises her 'has been modernized quite a bit' ('Murder House' 1.3). In another episode, Nora is similarly agitated by the 'cheap, vulgar' tastes of the home's latest inhabitants, interpreting their alterations to the decor as a posthumous assault upon a once-living being: 'they picked the flesh off my beautiful home and left the skeleton, the bare bones' ('Rubber Man' 1.8). Nora's understanding of the home as both lived in and living is also shared by Moira, who warns Vivien in the first episode that the 'house has a personality. Mistreat it and you'll regret it' ('Pilot' 1.1). This 'personality' is inferred through the purposeful use of free-camera techniques and point-of-view shots that suggest the house is able to observe its inhabitants as a subjective entity, shifting position and perspective in response to their movements. Dutch angles, fast zooms and tracking shots generate a similar sense of voyeuristic unease, as if the house is watching itself, monitoring its

own interiors from a range of different (and unusual) perspectives, between which it can switch at speed. Despite the housewives' ongoing claims to ownership ('*my* house'), the house belongs, resolutely, to itself, with the insistent use of frequent jump cuts likewise implying that the house has its own temporality, distinct from that of the outside world.

Like the housewives who lived there before her, Vivien's relationship to the home is uncannily sympathetic. When she becomes pregnant with twins, she is 'racked with violent morning sickness' every time she leaves the house ('Piggy Piggy' 1.6), suffers a vaginal bleed which stops as soon as she gets back inside ('Murder House' 1.3), then ultimately gives birth within its walls ('Afterbirth' 1.12). Vivien's curiosity about the property's troubled history leads her to the 'Eternal Darkness' bus tour in which it features as an advertised highlight. Bookended by the sensationalizing narration of the tour guide, a flashback to the 1920s reveals that Dr. Charles Montgomery, the husband of Nora, performed illegal abortions in the basement at his wife's behest. When the action returns to the present, the camera zooms in slowly on Vivien's horrified face as she stares into her home from the open-top tour bus outside, before looking down into her lap. A series of aerial shots, focusing in on Vivien's crotch, reveal what she has just noticed: that she, in response to the tour guide's gruesome narration, is bleeding from between her legs. Via a sequence of disorientating cuts between different tracking shots, the camera follows Vivien as she runs towards the front door, screaming 'This is my house' ('Murder House' 1.3).

With its layers of accumulated history and its ghostly traces of the past, the home functions as an architectural palimpsest, where the decor and detritus of the present cover, without fully erasing, what lies beneath. In Bachelard's words, the '[p]ast, present and future give the house different dynamisms, which often interfere, at times opposing at others stimulating one another' (6). The kinds of interruptions, conflicts and synchronicities to which Bachelard here draws attention demonstrate his attentiveness to the home as a site of compressed temporality, a place where the past is often

peculiarly proximate to the present. While Bachelard views this proximity as being either benign or productive, his account of the home demonstrates its predisposition to the uncanny, a place where the past that lies buried within it is always on the verge of discovery, threatening to revisit itself upon the unsuspecting inhabitants.

The strange temporal dynamisms to which Bachelard draws attention in *The Poetics of Space* are discernible in the trope of endless haunting that comes to define *American Horror Story*. The show's many ghosts are not the ineffectual apparitions of most gothic fictions, rendered tragic by their inability to effect change in a world where something is going wrong; rather, as long as they are 'at home', the house gives them all the tangibility and agency of live humans. This peculiarly embodied existence allows the dead to enact their erotic and violent fantasies upon the living in ways that imply the potential subordination of the present (and the future) to the past, while electrifying the relationships that are forged across the show's various temporal dimensions. At a formal level, flashbacks and flashforwards repeatedly rupture the continuity of the unfolding present, suggesting the extent to which it is inhabited by both the past and the future.

While *American Horror Story*, like many contemporaneous fictions, does much to reinforce the uncanny inextricability of women and the home, it also carries a message to women that contradicts postfeminist valorizations of feminine re-domestication: get out of the house before it kills you; or, as Adelaide warns, 'You're gonna die in there'. Just as the ghostly occupants of the house in *American Horror Story* are destined to remain there forever, playing out the same tired roles and re-enacting the same doomed scenarios, so popular culture returns again and again to the same retrograde configurations of female identity. Despite the changes that feminism has made to women's working lives, they continue to be represented as custodians of the home and judged in accordance with their effectiveness in this role.

4

Who's that girl?
Slayers, spooks and secret agents

[H]er body is getting away from her, it is no longer the
straightforward expression of her individuality; it becomes
foreign to her; and at the same time she becomes for others a
thing: on the street men follow her with their eyes and comment
on her anatomy. She would like to be invisible; it frightens her to
become flesh and to show her flesh.
(Simone de Beauvoir, *The Second Sex*)

What's more real? A sick girl in an institution or some kind of
super girl chosen to fight demons and save the world?
(Buffy Summers, 'Normal Again' 6.17, *Buffy the Vampire Slayer*)

'It will take a while', writes Gloria Steinem in the foreword to *To Be
Real* (1995), 'before feminists succeed enough so that feminism is
not perceived as a gigantic mother who is held responsible for almost
everything, while the patriarchy receives terminal gratitude for the
favors it bestows' (xix). Just as Virginia Woolf detected murderous
intent in the tormented relationship between the feminist and the
housewife, so too is the mother–daughter relationship – that seems
always to beset the progress of feminist history – inflected by deadly
desire. In an article for *Harper's Magazine*, entitled 'American Electra:
Feminism's Ritual Matricide', Faludi proclaims that a generational
breakdown underlies 'so many of the pathologies that have long

disturbed American feminism – its fleeting mobilizations followed by long periods of hibernations; its bitter divisions over sex; and its reflexive renunciation of its prior incarnations, its progenitors, even its very name' (2010: 29). The contemporary women's movement, she speculates, 'seems *fated* to fight a war on two fronts: alongside the battle of the sexes rages the battle of the ages' (29; emphasis added). Feminism's volatile relationship with its history suggests, then, that its future might inescapably be always already inscribed by the past.

These repetitive patterns and re-enactments speak to the ambiguous temporality of the spectre which 'presents itself only as that which could come or come back' (Derrida, 48). Undecided if it comes from the future or the past, the spectre, in Derrida's articulation, 'is the *frequency* of a certain visibility. But the visibility of the invisible. And visibility, by its essence, is not seen [...]. The spectre is also, among other things, what one imagines, what one thinks one sees and which one projects – on an imaginary screen where there is nothing to see' (125; emphasis in original). The notion of the spectre as an imaginative projection onto the screen of the future offers a suggestive way of thinking about the figure of the girl who, in contemporary accounts, is presented as an image of the future that is always pre-emptively haunted by femininities and feminisms of ages past. Girlhood, as we argue in this chapter, has in turn been posited as a locus of ambiguous temporality – not just of the in-between (the transition from childhood to adulthood), but also of a strangely haunted futurity.

The visibility of the girl as a harbinger of change and transformation has been a long-standing fascination in popular culture. In *Girls* (2002), her seminal analysis of the category of girlhood, Catherine Driscoll maps the increasing visibility of girls and young women in late modernity and the ways in which girlhood functions as an index of cultural change and continuity (2–3). In so doing, she not only anatomizes the various forms of girl culture, but also telegraphs the relationship between the public visibility of girls and the expansion of theoretical discourses of feminine adolescence. The visibility of

girls and young women in popular culture has been the subject of a vast and dynamic body of scholarship and debate, from field-defining texts such as McRobbie's *Feminism and Youth Culture: From 'Jackie' to 'Just Seventeen'* (1991) and Valerie Walkerdine's *Daddy's Girl: Young Girls and Popular Culture* (1997) to more recent work by Sarah Projansky, Kathleen Rowe Karlyn, Anita Harris, Diane Negra and Jessica Ringrose.[1] This obsession with girls – and the operations of girlhood as a site for the exploration and resolution of a variety of cultural anxieties – persists at the end of the twentieth century and into the twenty-first. 'Girlhood and daughterhood', avers Driscoll, 'are consistently articulated in relation to a future role – who or what the girl will be or do as a woman' (108). In *Future Girl* (2004), Anita Harris similarly argues that

> in a time of dramatic social, cultural, and political transition, young women are being constructed as the vanguard of a new subjectivity. [...] Power, opportunities, and success are all modelled by the 'future girl' – a kind of young woman celebrated for her 'desire, determination and confidence' to take charge of her life, seize chances, and achieve her goals. (1)

Focusing, like Driscoll, on the 'visibility' of girls, Harris proposes that young women have 'become a focus for the construction of an ideal late modern subject who is self-making, resilient, and flexible' (6). She attributes this investment in young women to changes in economic and work conditions, combined with the achievement of feminist goals in the spheres of education and employment.

The language of flexibility, malleability and change that marks discussions of the 'future girl' posits the girl as a figure in transition – both as a subject moving from juvenility to maturity, and as a hinge between old and new, present and future. In *A Thousand Plateaus: Capitalism and Schizophrenia* (1980), Gilles Deleuze and Félix Guattari use the 'girl' as a privileged figure in their discussion of 'becoming'. Rejecting an understanding of subject and object as binary oppositions, they turn their attention to the theft of the body

that enables the fabrication of what they describe as 'opposable organisms':

> The body is stolen first from the girl. Stop behaving like that, you're not a little girl anymore, you're not a tomboy, etc. The girl's becoming is stolen first, in order to impose a history or prehistory upon her. The boy's turn comes next, but it is by using the girl as an example, by pointing to the girl as the object of desire, that an opposed organism, a dominant history is fabricated for him too. The girl is the first victim, but she must also serve as an example and a trap. (305)

The little girl, then, must shed her body to enable the little boy's individuation. In place of the unified body as a functional organism, Deleuze and Guattari envisage the 'body without organs' as a 'body populated by multiplicities' (33) and distinguish between molar and molecular flows, as well as minoritarian and majoritarian modes. A 'molar entity is, for example, the woman as defined by her form, endowed with organs and functions and assigned as a subject' (304); it seeks to stabilize and fix form by asserting identity categories, such as class, race and sex. Molecular energies are, in contrast, dispersed and flowing. They 'traverse, create a path, destabilize, energize instabilities, vulnerabilities of the molar entities' (Grosz 172). 'Becomings' are thus always molecular and minoritarian; they are a moving away and an escape from binaries and clear demarcations. All becomings, Deleuze and Guattari suggest, 'begin with and pass through becoming-woman' (306) because of women's subordinated position in the existing social order.

It is, tellingly, not the woman herself, but the little girl who is the privileged example of 'becoming-woman'. Associated with a state of openness and becoming, the little girl is 'defined by a relation of movement and rest, speed and slowness, by a combination of atoms, an emission of particles: haecceity' (395). An 'abstract line, or a line of flight' (395), she does not represent a fixed stage of life; rather, girls 'do not belong to an age, group, sex, order or kingdom; they slip in everywhere, between orders, acts, ages, sexes: They

produce *n* molecular sexes in the line of flight' (395). In Deleuze and Guattari's analysis, the girl functions, in the words of Elizabeth Grosz, 'as the site of a culture's most intensified disinvestments and recasting of the body' (175). Stripped of bodily specificity, she is rendered 'a generalized and indeterminate in-betweenness, a transgressive movement in itself' (175).[2] This 'decorporealization' of the little girl makes of her a rather ghostly figure, always on the cusp of a trans-formation (a movement between states).[3] Hovering across boundaries and surfaces, this 'fugitive being' (Deleuze and Guattari 299) is, according to Taru Elfving, a 'haunting figure [who] troubles the economy of visibility' (109). It is perhaps owing to her spectral transitions that the girl often appears in the guise of a 'spook' – as both an apparitional presence and a double agent. It is with this notion of the girl's ghostly becoming in mind that this chapter will examine the spooky visibility of the girl in popular culture. Beginning with an analysis of the transformative potential of the super girl, exemplified by Buffy the Vampire Slayer in the 1990s, it calls attention to a recent shift in cultural representations of the girl's fugitive identity as a site of disorder and a threat to the body politic.

Sign of the times: girl power

The 1990s was the decade of girl power. From the Spice Girls' clamorous celebrations of the virtues of Thatcherism and the Wonderbra to the brigade of strong and stylish action heroines, glamorous witches and sassy detectives who fought, enchanted, spooked and talked their way on to film and television screens, images of girls and girliness permeated popular culture. According to Susan Hopkins, writing at the turn of the twenty-first century, the 'girl of today's collective dreams is a heroic over-achiever – active, ambitious, sexy and strong. She emerges as an unstoppable superhero, a savvy supermodel, a combative action chick, a media goddess, a popstar who wants to rule the world. Popular culture has never been so pervasively girl-powered' (1). For Hopkins, 'girl

power' is 'a postfeminist movement, in the sense of coming after and perhaps overcoming feminism. [...] The Girl Power of the 1990s and beyond marks a generational shift in feminist-inspired thinking toward more optimistic but individualistic positions and perspectives' (2). In this popular configuration, then, 'girl power' posits a simultaneous replacement and displacement of second wave feminism. While 'girl' represents the secession of the insurgent daughter, 'power' offers an alternative to an ostensibly outdated 'victim feminism'.

Although the term 'girl power' is identified most readily with the Spice Girls, it had been coined earlier in the 1990s by members of US Riot Grrrl, an underground movement that mobilized girl – or, rather, *grrrl* – identities to bring together feminist politics and punk aesthetics. The DIY ethos of early Riot Grrrl (for example, the production and circulation of girl-centred zines and the creation of all-female record labels, most notably Ani DiFranco's Righteous Babe Records) challenged conventional representations of girlhood and the role of girls in consumer-orientated culture.[4] In this respect, Riot Grrrl's call for 'Revolution Girl Style Now!' offered a response to dominant representations of patriarchal girlhood by forging spaces in which girls and young women were empowered to resist and, moreover, to produce their own self-representations. In her Deleuzean reading of Riot Grrrl, Hilary Malatino proposes that Riot Grrrl culture can be understood as a 'definite and defiantly queer realm that establishes counter-norms and alternative, resistant community by way of rituals that evade majoritarian/hegemonic logics' – in other words, a 'process of becoming-otherwise' (para. 26). Still, in spite of its movements and resistances, Harris points out that Riot Grrrl's 'punk philosophy of DIY [...] and individual responsibility for social change lent itself easily to its transformation into a discourse of choice and focus on the self' (17). In the popular cultural imagination 'girl power' comes to signify 'a unique category of girls who are self-assured, living lives lightly inflected but by no means driven by feminism, influenced by the philosophy of DIY, and assuming they can have

(or at least buy) it all' (17). In the context of mainstream popular culture, this individualistic and commodified model of girl power is one harnessed by, and inherited from, Madonna, the material girl par excellence whose 'postmodern feminism' exemplified notions of the fluid and mobile self. Madonna, as suggested in chapter one, not only 'taught young women to be fully female and sexual while still exercising control over their lives' (Paglia 4), but also educated them in new modes of desire and empowerment located in the body as a highly-sexualized site of power.

One of the pre-eminent examples of this new, highly-sexualized mode of female agency is the female action heroine. From *Buffy the Vampire Slayer* and *Xena: Warrior Princess* (1995–2001) to *La Femme Nikita* (1997–2001) and *Dark Angel* (2000–2002), the 1990s saw an eruption of quality television series offering representations of the girl hero. Charged with saving the world from various terrestrial and supernatural forces, these super girls emerge from a longer tradition of female action heroism, one that has its roots in television series such as *The Avengers* (1961–69), *Charlie's Angels* (1976–81), *The Bionic Woman* (1976–78) and *Wonder Woman* (1975–79), as well as the 'women warriors' and 'aggressive gun-toting' cinematic heroines of the 1980s and early 1990s, anatomized by Tasker in her seminal *Spectacular Bodies* (1993).[5] If the physically powerful heroines of 1960s and 1970s television series married images of toughness with the conventional trappings of glamorous and sexualized femininity, then the cinematic action heroines emerging from the 1980s – exemplified by Ripley (Sigourney Weaver) in *Aliens* (1986) and Sarah Connor (Linda Hamilton) in *Terminator 2* (1991) – represented an aesthetic shift towards what Tasker describes as 'musculinity' (3), a new inscription of the female body in relation to traditional masculinity. Images of the active heroine in the 1980s, writes Tasker, 'disrupt the conventional notion [...] that women either are, or should be, represented exclusively through the codes of femininity' by mobilizing a 'symbolically transgressive iconography' that draws on codes of masculinity (132). What is most striking about the

girl hero of the 1990s, therefore, and what distinguishes her from the 'hard bodied' action heroine of the 1980s, is that she is heavily coded in terms of traditional femininity.

At once tough and independent, sexy and stylish, the physical prowess of the late-twentieth-century super girl is mobilized rather than hindered by the trappings of traditional femininity. From Buffy Summers (Sarah Michelle Gellar) kicking ass in her 'stylish, yet affordable boots' ('Once More, with Feeling' 6.7) to *Alias*'s Sidney Bristow (Jennifer Garner) employing multiple, high-glamour disguises as a double agent for the CIA, these young women are dressed to kill. A spectacular deployment of fashion underlies the representation of the action heroine and a model of postfeminist agency that is both grounded in and delimited by the girl hero's 'killer body'. The postfeminist re-appropriation of fashion works too, then, to establish a distance from second wave feminism by relocating the trappings of traditional femininity as part of, rather than antithetical to, a 're-fashioned' politics of sexual agency and confidence. Still, as many commentators have noted, the girl hero of the 1990s proliferates in a cultural context that is irrevocably shaped and influenced by second wave feminism – even if, as Elyce Rae Helford observes, the word 'feminism' is hardly ever given air time (5). Mobilizing the postfeminist mystique, however, many of these shows engage with, or respond to, the political goals and achievements of second wave feminism while working to distance themselves from an earlier political agenda – not least through their reconfiguration of the relationship between female power and traditional femininity in the form of 'new' feminist subject positions.

The series that perhaps best encapsulates this phenomenon is *Buffy the Vampire Slayer*. Notable for its representation of physically and intellectually exceptional young women, *Buffy the Vampire Slayer* has, since its television debut, functioned as a locus for academic discussions of popular feminism and its configurations of girlhood. This cult American series follows the trials of Buffy Summers, an ex-cheerleader who is charged with the sacred responsibility of

protecting the world against the forces of darkness that curiously congregate over the 'hellmouth' in the fictional town of Sunnydale. Buffy, the voiceover at the beginning of early episodes announces, is the 'chosen one' who 'alone will fight the demons, the vampires, and the forces of darkness. She is the Slayer.' Director Joss Whedon's oft-cited announcement that he was tired of horror films in which 'bubblehead blonds wandered into dark alleys and got murdered by some creature' and wanted to see instead 'a movie in which a blond wanders into a dark alley, takes care of herself and deploys her powers' (see Bellafante, 1997: 82) are well realized in *Buffy the Vampire Slayer*, which plays persistently with the conventions of the horror and Gothic genres, taking to task their image repertoires of persecuted and victimized femininity.[6]

Patricia Pender outlines how Buffy's fight against the forces of evil (including the oppressive structures of the patriarchal 'Watcher's Council') has been interpreted as a dramatization of several second wave feminist struggles – including the battle against sexual violence, the negotiation of personal and professional life, and girls' attempts to establish their sexual and social autonomy (226). According to Karlyn, the series might also be read as a 'dramatization of the tensions between feminism's Second and Third Waves' (122). Concerned with the burgeoning powers of the insurgent daughter – powers that are also negotiated in contrast to, or in conflict with, older women – *Buffy the Vampire Slayer* exemplifies the contradictions and paradoxes shaping young women's dual negotiation of the spectres of feminist and patriarchal discourses, combining 'second wave [feminist] critique of beauty culture, sexual abuse, and power structures' with 'the pleasure, danger and defining power of those structures' (Heywood and Drake 3). Buffy has, accordingly, been variously hailed as 'a post-feminist heroine' (Daugherty 148–49) and 'the third wave's final girl' (Karras 2002); glamorous, fashion-conscious and always girlish, she is a Girlie feminist in the Gothic mode.[7] If, as Juliann E. Fleenor suggests, '[t]he Gothic world is one of nightmare, and that nightmare is created by the individual in conflict with the values of her society and her prescribed role' (10),

then the Buffyverse exemplifies the recasting of this conflict within the spectral spaces of postfeminism.

Elfving argues that, in the horror genre, 'the boundaries of female characters and, notably, the borderline that distinguishes women and girls are continuously under negotiation. The girls in horror dwell in the threat and fascination of collapsing boundaries' (112). In *Buffy the Vampire Slayer*, this negotiation of collapsing boundaries is often played out through Buffy's at times fraught relationship with her mother Joyce (Kristine Sutherland), as well as the series' more general ambivalence about maternal figures. Mother–daughter conflict provides a stark focus for 'Gingerbread' (3.11), an episode from the third series, which takes place soon after Joyce has learned of her daughter's superpowers. After discovering the bodies of two dead children, who have what appear to be occult symbols on their hands, Joyce sets up Mothers Opposing the Occult (MOO) with other parents concerned about the supernatural powers of the 'bad girls' in the community, including the mother of fellow Scooby Gang member Willow (Alyson Hannigan), Sheila Rosenberg (Jordan Baker). Willow's relationship with her mother is specifically framed in terms of intergenerational feminist antagonism. When confronted about her interest in witchcraft, Willow places the distance between them in the context of an alienating, second wave feminist discourse: 'The last time we had a conversation over three minutes it was about the patriarchal bias of the *Mr. Rogers* show'. The members of MOO, led by Joyce, also initiate a programme of censorship in Sunnydale High, removing all 'dangerous' and 'unsuitable' books from the library in a move that echoes the censoriousness of anti-pornography discourse. On the instruction of the dead children (who are in fact a projection of a male demon), MOO resolve to 'kill the bad girls' by burning them at the stake. Blaming her daughter for assuming a new mode of unsanctioned power, Joyce chastises Buffy, telling her: 'You did this. You toyed with unnatural forces. What kind of mother would I be if I didn't punish you?' Thus, the mother–daughter relationship plays out in terms of the 'war of the ages' identified by Faludi – a war that, in this

instance, foregrounds a maternal desire to drive out the daughter's emergent and unruly power. Here, however, generational conflict is staged in order to pathologize the figure of the mother (in both her domestic and academic feminist incarnations), whose authority is destabilized and discredited owing to her susceptibility to the spectral effects of demonic suggestion.

The dramatization of mother–daughter conflict in 'Gingerbread' bespeaks postfeminism's anxieties about the feminist 'mother' as an outmoded, even morbid, body. Camille Nurka suggests that, for 'postfeminists, it is the redundant mother, the bearer of the unfecund body, the ageing body, the body of "liberation feminism", who ironically *denies* women their liberatory sexual potential' (187; emphasis in original). In contrast, the agency of the super girl is primarily located in her body. Powerful, resilient and self-healing, Buffy exemplifies the 'postfeminist body', which is 'posited primarily as a *sexy* body, in opposition to the dowdy, menopausal body of the mother' (187; emphasis in original).[8] The transformative power and potential of the girlish body is foregrounded in series five, in which Buffy fights one of her strongest and most glamorous opponents. Glory (Clare Kramer) is a stylishly dressed, tremendously strong and seemingly invulnerable god who desires to return to her hell dimension by opening the gateway to all dimensions (a task she is unable to achieve until she locates the 'key', which has taken the form of another girlish body in the guise of Buffy's sister, Dawn). Suffering from episodes of incoherence and manic disturbance owing to the mental and physical inadequacy of the human body in which she resides, Glory self-medicates for her surfacing insanity by feeding on the mental energy of humans. A magnified image of Buffy's strength and physical resilience, the aptly-named Glory offers a terrifying image of the girl in transition spiralling out of control. In the end, it is only by 'gifting' her own body and throwing herself into the portal where temporal and spatial boundaries collapse that Buffy is able to close the gateway to the hell dimensions that Glory has opened and reaffirm the restorative promise of the girlish body ('The Gift' 5.22).

Set against these ambivalent images of postfeminist bodies moving across spectral zones is the static and immobile image of the dead mother. Earlier in series five, Buffy's mother Joyce dies of a brain tumour (a somatic inflection of the psychic infection she suffers in 'Gingerbread'). In 'The Body' (5.16), Buffy comes back to the family home to find her mother's cold and pale corpse reclined on the sofa. One of the most stylistically striking episodes of the series, 'The Body' unfolds without ambient sound and deploys intense, almost luminous, lighting to emphasize the surface of Buffy's glistening body. This *mise-en-scène* creates the impression of a kind of vacuum or 'negative space' into which Joyce's dead body is repeatedly returned through the fitful camera shots. Buffy's confrontation with the abject body of the mother marks a vital moment in her transition into womanhood. In *Powers of Horror* (1980) Julia Kristeva describes the abject as that which 'disturbs identity, system, order. What does not respect borders, positions, rules' (4); the abject, she proposes, threatens the borders of the subject's 'own and clean' self (53). According to Kristeva, the mother is the first body that must be abjected in order for the subject to become autonomous. The abject, she suggests, 'confronts us [...] within our personal archaeology, with our earliest attempts to release the hold of *maternal* entity even before ex-isting outside of her [...]. It is a violent, clumsy breaking away, with the constant risk of falling back under the sway of a power as securing as it is stifling' (13; emphasis in original). It is little wonder, then, that the text is reluctant to give up the maternal corpse, reanimating it firstly in the form of a zombie ('Forever' 5.17) and secondly as a manifestation of the resoundingly patriarchal First Evil ('Conversations with Dead People' 7.7). Thus, while *Buffy* challenges dominant representations of adolescent femininity within the horror genre, it deploys iconographies of the monstrous-feminine that reaffirm conventional Gothic representations of the maternal.[9]

This Gothic iconography is especially pronounced in the depiction, in series four, of Maggie Walsh (Lindsay Crouse). A psychology professor at University College Sunnydale, Walsh is

positioned from the outset as an aberrant woman, introducing herself to her students as 'the Evil Bitch-Monster of Death' ('The Freshman' 4.1). Outside of the classroom Walsh works for the Initiative, a covert government organization investigating demon life. Deploying the 'latest in scientific technology', this military operation represents a hyper-rationalization of the supernatural through its rigorous and rigid classification, experimentation and neutralization of 'hostile sub-terrestrials'. Walsh, in contrast, is engaged in a top-secret operation to hybridize soldiers from the body parts of humans, demons and machines to create an army of demonoid super-soldiers. This Gothic inflection of maternal creativity is, however, interrupted when Adam (George Hertzberg), Walsh's prototype cyborg and hideous progeny, turns on his creator and murders her. Operating in the subterranean passages beneath the academic institution, Walsh's scientific practice is codified as monstrous in terms of both its location and its methodology. On one hand, its underground location is reminiscent of the cave or 'grotta' as an archetypal space of the grotesque which, as Mary Russo describes, functions metaphorically in correspondence with 'the cavernous anatomical female body' (1–2).[10] However, this female Frankenstein, working in the surrogate womb-space of the laboratory, commits Gothic crimes against nature in her transgression of traditional, maternal femininity. Walsh is not only a 'bad scientist', but also a 'bad mother'. It is only in death that she comes to signify properly as 'Mother' when Adam (reasserting his position as the monstrous 'first man') reanimates her corpse, restraining the dangerous mind of the Promethean academic and scientist by returning her to her body.

The representation of Walsh betrays a broader anxiety about the representation of intellectual women as disruptive, aberrant figures in popular culture.[11] Analysing the emergence of the female graduate student in prime-time television culture, Michele Byers proposes that the female academic, and by implication the intellectual woman more generally, is often represented as 'both grotesque and deficient; unable to be a real woman (wife, mother) [...] and at the

same time endowed with an intellectual power which enables her to access the masculine/phallic order of things' (112).[12] *Buffy the Vampire Slayer*'s most sustained articulation of the monstrous excesses of the intellectual woman is its representation of Willow. Willow's 'superpower' initially manifests in her exceptional technology skills as a geeky schoolgirl, though she later develops supernatural powers as a practising witch. While the combination of Willow's technological insight and witchcraft play a vital role in the Scooby Gang's fight against the 'big bad', series six sees her unable to either contain or manage her superpowers. Having brought Buffy back from the grave after her death at the end of the previous series, Willow is depicted as a volatile subject whose power is forever on the verge of running out of control. She is, in other words, a subject for whom the prospect of 'becoming-otherwise' is fraught with danger and risks undoing her identity altogether.

Willow's abandoned and irrepressible use of magic is cast as an addiction – a pathology that works to position her as an abject body, monstrous and excessive in its 'spellbound' transfiguration. Fuelled by anger and grief when Warren (Adam Busch) murders her girlfriend Tara (Amber Benson), Willow embarks upon a journey of vengeance and devastation. Placing her hands on top of the pile of witchcraft volumes and magic books she assembles in the Magic Shop, she absorbs their power: the text flows through her body like blood moving through her veins ('Villains' 6.20). Transformed into a body-text, Willow comes to represent a monstrous embodiment of knowledge and a hyper-destructive and unruly femininity; moving through spatial and temporal zones, she uses her telekinetic powers to reconfigure molecular systems in a Gothic re-imagining of Deleuze and Guattari's 'becoming-girl'. Here the girl's openness and becoming is articulated in terms of the 'abhuman subject', described by Kelly Hurley as 'a not-quite-human subject, characterized by its morphic variability, continually in danger of becoming not-itself, becoming other' (3). As Hurley highlights, the 'prefix "ab-" signals a movement away from a site or condition, and thus a loss. But a movement away from is also a

movement towards – towards a site or condition as yet unspecified – and thus entails both a threat and a promise' (4). This threat of Willow's becoming (other) is only undone when Xander (Nicholas Brendon) attempts to reignite her capacity to 'feel' over her capacity to 'know', restoring her proper 'feminine' attributes and halting her potentially apocalyptic lines of flight.

The tension between the threat and promise of the 'becoming' girl that permeates *Buffy the Vampire Slayer* is realized most fully in 'Normal Again' (6.17). In this episode Buffy is poisoned by a demon conjured up by the Trio (three geeky boys with 'evil' world-conquering ambitions); as the deadly, hallucinogenic venom infects her body it brings about a state of psychosis. The moment when the demon instils his poison into Buffy's body cuts into a shot of her being injected with a sedative in a mental institution where, the doctor informs us, she has been for six years, diagnosed with an 'undifferentiated type of schizophrenia'. Throughout the episode, Buffy's two realities are violently and abruptly cut into one another. In one reality, she is a vampire-slaying super girl; in the other, she is a psychiatric patient suffering from the self-aggrandizing 'delusion' that 'she is some type of hero [...] the central figure in a fantastic world beyond imagination' ('Normal Again' 6.17). In the world of the mental institution, Buffy's strong and resilient body exists only in her mind; it is rendered frail and vulnerable as she shrinks into the chair in the psychiatrist's office and, later, into the corner of a padded cell. Buffy is also returned to her proper daughterly role in the nuclear family (her parents' divorce and her mother's death are both undone in this reality). In its shifts between Buffy's realities, 'Normal Again' asks the question posed by Buffy herself: 'What's more real? A sick girl in an institution or some kind of super girl chosen to fight demons and save the world?' In the end, Buffy's loyalty to her friends and rejection of the role of 'sick daughter' give her the strength to re-enter the vampire-slaying world of Sunnydale, asserting the 'reality' and promise of the girl hero. However, the episode ends on a disquieting note. The final shot offers a view of Buffy in a catatonic state in her padded

cell, signalling the 'fugitive' identity of the girl as one always and inevitably marked by pathology.

Homeland insecurities

The speculative positioning of Buffy as a pathological subject in 'Normal Again' presages the rise of a new model of girlish heroism threatened by the reality or prospect of mental illness. A number of recent fictions – including *The Bridge* (2011–), *The Killing* (2007–), *The Girl with the Dragon Tattoo* (2009) and *Dexter* (2006–) – feature female spies or detectives whose investigative skills are peculiarly heightened by either psychic trauma or psychological disorder. If the girl hero of the 1990s was a symbol of the future, at the beginning of the twenty-first century she seems strangely haunted by the past. Anxieties about the potentially disordered or disorderly female subject provide a particular focus for *Homeland* (2011–), one of the most compelling contemporary representations of the girlish secret agent. Co-created by Howard Gordon and Alex Gansa, who worked together on *24* (2001–10), *Homeland* is based on Gideon Raff's Israeli series *Hatufim* (2009–12) and was first broadcast on Showtime in the US and Channel 4 in the UK to critical acclaim and multiple awards. *Homeland* centres on Carrie Mathison (Claire Danes), a brilliant and astoundingly intuitive, if unorthodox, CIA operations officer who, it is later revealed, suffers from bipolar disorder inherited from her father. *Homeland* plays with the idea of moral uncertainty that characterized post-9/11 shows like *Alias* and *24*.[13] At a far remove from her *Sex and the City* namesake, Carrie shares more perhaps with *24*'s Machiavellian Jack Bauer (Kiefer Sutherland), the Counter Terrorist Unit's most skilled and unpredictable agent, than she does with the athletic and guarded Sidney Bristow. Although Carrie is an adult woman who has already established herself in her professional position, she is repeatedly coded as a girlish or daughterly figure, both in terms of her bodily and psychological vulnerability and her dependence on her sister's family home.[14]

In the pilot episode's tense opening scene, Carrie learns from one of her assets (during an unauthorized operation in Baghdad) that an unidentified American prisoner of war has been 'turned'. The sleeper agent soon appears in the guise of Nicholas Brody (Damian Lewis), a US Marine who, having been held prisoner by al-Qaeda commander Abu Nazir (Navid Negahban) for eight years, is pulled bearded and bewildered from Nazir's compound. Set in 2011, the series has already been heralded as 'the most compelling and incisive television or film narrative ever to address 9/11 and its aftermath' with its female protagonist 'embodying a lot of the psychological demons that still haunt many Americans more than 10 years after the terrorist hijackings' (Edgerton and Edgerton 92, 89). If, as this description suggests, Carrie's bipolar condition functions as a metaphor for the traumatic scars of a nation (casting the girl once again as a 'sign of the times'), then *Homeland* makes explicit that, in the contemporary context, it is not just the female body, but also the female mind, that is inscribed as a conflicted site for the mutually implicated operations of memory and amnesia.

Homeland's spectral effects are played out through representations of states of sleep and awakedness. Its opening credits begin with the flickering image of Carrie as a young girl, asleep, while archival news reports of terrorist activity, including the 9/11 broadcast, play across the soundtrack of dissonant jazz trumpets. Using a vertiginous combination of splicing, jump cuts and dissolves, the credits offer a sequence of static images of Carrie, as a child, positioned in a labyrinth wearing a lion's mask, standing in front of a piano and watching television, as well as a moving image of her playing a trumpet trill that is synchronized with archival footage of Louis Armstrong. These images are, in turn, interspersed with newsreel footage, including speeches by Ronald Reagan, George H. W. Bush, Bill Clinton, Colin Powell and Barack Obama. In the second half of the sequence, adult Carrie opens her eyes, awakening in a world irrevocably shaped by a 'war on terror' that has been fought since her early childhood. The freneticism of the opening credits communicates both the instability of the

traumatized – or 'spooked' – individual and national body, as well as the erosion of the boundaries between private and public spaces signalled by television's relentless projections of the outside world within the supposedly secure walls of the home. The credits convey that Carrie's is a consciousness shaped by the percussive rhythms of post-9/11 American life, with its attendant emphasis on suspicion and surveillance, terror and trauma – the notion that, in the words of Fredric Jameson, 'History is what hurts' (88; qtd in McCabe 81).

The spooked turned spook, Carrie is a haunted subject who, as Gary R. Edgerton and Katherine C. Edgerton describe, 'has internalised the deeply felt psychological trauma emanating from the 9/11 attacks and seeks to redeem herself by assuming full responsibility for "making sure we don't get hit again"' (91). In a telling exchange with her mentor Saul Berenson (Mandy Patinkin), who also acts as a kind of paternal guardian, Carrie contextualizes her suspicions about Brody as part of her guilt at having overlooked something in the past:

> CARRIE: I missed something once before. I won't – I can't – let that happen again.
> SAUL: It was ten years ago. Everyone missed something that day.
> CARRIE: Everyone's not me. ('Pilot' 1.1)

This fragment of dialogue is given ghostly status as it echoes prior to every episode in the opening credits. Carrie may think of herself as exceptional but, unlike Buffy Summers and the girl heroes of the 1990s, whose supernatural powers enabled them to save the world, Carrie's look to the future is always inscribed by her sense of culpability for the past. Treated as a kind of savant by Saul, Carrie must turn her prodigious intuition to making visible the apparently invisible – to see in the chaos and confusion what others cannot.

Thus, although Brody is immediately treated as a war hero by the CIA, and swiftly targeted by the Vice-President as a potential candidate for Congress, Carrie suspects immediately that he is the turned POW and sets up an unauthorized illegal surveillance system

in his home with the help of the appositely-named Virgil (David Marciano), another paternal guardian figure. Yet, in spite of Carrie's obsessive moves to surveille Brody's every move, the cinematography repeatedly frustrates any clear delineation of the surveillant and the surveilled. In the early episodes of *Homeland*, Carrie is regularly depicted close-up in her house, wearing circumaural headphones and installed in front of surveillance screens, as she avidly watches and listens to Brody's most mundane as well as his most agonizing private moments, including his first, aggressive sexual contact with his wife Jessica (Morena Baccarin), his nightmares and his moments in front of the bathroom mirror.

Carrie is also subject to cinematic intrusions into her private bodily routines. The first present-time shot of Carrie in 'Pilot' (1.1) depicts her returning in the morning from a night out, undressing to her black lingerie and high heels from the previous night. Filmed from behind as she stands in front of her bathroom mirror, she is shown wiping her crotch and then taking an unidentifiable tablet which the viewer later discovers is anti-psychotic medication (a fact, tellingly, revealed when she is in the back of Virgil's surveillance van). The camera works, then, to make visible Carrie's most private moments, and to capture evidence of her disorderliness and lack of regulation; her cursory hygiene is an indication of both her professional lateness (her inability to 'keep time') and her personal promiscuity (just as she is about to leave the house she remembers to remove the wedding ring she wears to 'weed out men who are looking for a relationship'). Ordered to remove the surveillance equipment after she fails to produce any evidence that Brody is a sleeper agent, Carrie contrives to bump into him at a support group, setting in motion an affair that further complicates and obscures the boundaries between her professional and private life. As she goes off-script in her investigation of Brody, she is increasingly filmed using high-angle shots, which create the impression that her own movements are being captured by a diegetic surveillance camera. Having watched, through a viewing window, Brody lie (undetected) on a polygraph test about being unfaithful to his wife,

she is subsequently observed, through a high-angle shot, getting into his car outside Langley. The implication, then, is that at the very same time as she is surveilling Brody's moves, Carrie's own behaviour – especially her sexual behaviour – is being surveilled. The girl as spook is cast here as a 'haunting figure' who, as Elfving suggests, 'troubles the economy of visibility' (109); in need of regulation, she must remain visible, her unregulated movements always kept in view.

The doubling of Brody and Carrie that ripples through the early episodes of the series – both are filmed in front of the mirror using similar shots, and both are hiding pathologies (post-traumatic stress disorder and bipolar disorder respectively) – serves to suggest Carrie's potential as a disruptive agent. Brody may appear to be the 'enemy within' who endangers homeland security, but his threat is mirrored back by another sleeper agent, the awakened, liberated and independent single woman – the embodiment of a liberal feminist legacy – who terrorizes the security of the suburban American home.[15] The potential threat that the unruly girl poses to the integrity of the home and the family is signalled early on in the series by the disruptive behaviour of Brody's daughter Dana (Morgan Sayler). While playing 'Hearts' with Mike (Diego Klattenhoff) and her brother Chris (Jackson Pace), Dana announces that the marines call the card game 'hunt the cunt' – a comment that is observed by Carrie and Virgil, who are watching the family's activities on the surveillance screens. Virgil's seemingly innocuous remark that 'maybe the daughter's the terrorist' ('Grace' 1.2) does not only reflect Dana's anarchic attitude towards family life and cultural anxieties surrounding the emergent sexuality of the girl. It also betrays an embedded anxiety about the real disruptions that the liberated sexuality of the uncoupled, non-maternal 'girlish' woman may bring into the family home and the domestic sphere.

Carrie's disorderliness is repeatedly located in her body. Early episodes of the series are punctuated with remarks about her poor diet and lack of sleep. Her irreverent attitude towards marriage and openness to casual sex are mirrored in Carrie's inability to keep

domestic space in order. She tells her father, for example, that 'it's a good time to avoid household appliances' when on anti-psychotic medication ('Blind Spot' 1.5). This representation of Carrie's disordered (and 'unhygienic') body runs counter to the idealized image of the 'homebound wife', exemplified by Jessica Brody. A stock figure of the postfeminist mystique, the 'homebound wife' is identified by Faludi as key to the 'terror dream' that holds feminism (and by implication independent, single women) responsible for the country's vulnerability and susceptibility to attack. Faludi writes that 'efforts to bring back the "new traditional" woman had been launched periodically since the rise of modern feminism. But 9/11 seemed to provide the best opportunity yet to bring her out of dormancy – and the media's first responders rushed to rouse Sleeping Beauty from her slumber' (2007: 131). Jessica similarly 'awakes' abruptly back into her role as 'virgin of grief' (2007: 104) when she receives the phone call from Brody announcing that he is alive and coming home (a phone call that interrupts her sexual intercourse with her husband's best friend, with whom she has been romantically involved in his absence). The moment of Brody's return thus shocks Jessica back into her 'proper' wifely role, forcing a denial of her sexual desire and the reinstatement of a 'gauzy vision of resurrected femininity, dedicated to home, family, domesticity' (Faludi, 2007: 115).

Jessica's obedient retreat into domesticity offers a stark contrast to Carrie's insistent unorthodoxy. Carrie's unconventional methods, unruly behaviour and willingness to operate outside of official systems – her propensity for improvisation – are coded through her association with jazz: jazz plays in her home and car; pictures of jazz artists, including Miles Davis, bedeck her walls; she goes to jazz clubs to pick up men; and she bets Saul her signed copy of Thelonius Monk's *Monk's Dream* that Brody will fail a polygraph implicating him in the suicide of a captured al-Qaeda operative (Monk was known for his unique improvisational style and there is speculation that he too suffered symptoms of bipolar disorder).[16] We learn in 'The Vest' (1.11) that Carrie's bipolar disorder was diagnosed when

she was at college and wrote 'a 45-page manifesto declaring [she'd] invented music' before being despatched to student health. Carrie's obsession with improvisational jazz is thus suggestive of her own movements – or abstract 'line[s] of flight' (Deleuze and Guattari 395) – outside of fixed structures (schizophrenia is identified in *A Thousand Plateaus* as a potentially revolutionary line of flight).

Crucially, jazz not only enables Carrie to move differently, but also to see differently. For example, it is watching the finger movements of musicians playing the trumpet, piano and cello in the jazz bar where she goes to pick up men that allows her to read Brody's rhythmic hand movements when he is on television as a sign that he is sending a message to a handler: 'It's a pattern; it repeats like a musical phrase', she tells Saul ('Pilot' 1.1). It is, nonetheless, Carrie's own identification with the anarchic, dissonant and improvised language of jazz that aligns her girlish extemporizations with a wider field of suspicious, insurgent activity. Rob Wallace, for example, describes how the term 'improvised' has been used frequently since 9/11 with reference to Improvised Explosive Devices. He argues that

> the appearance of the word 'improvisation' in descriptions of the events of 9/11 and after is only the most recent variation on an underlying theme. Improvisation – largely due to its connection with African American cultural practices such as jazz – has historically been perceived in the West as a suspicious activity. (79)

The language of jazz, closely aligned with Carrie's sexual as well as her emotional and intellectual life, works here to designate her chaotic and volatile movements; but it also signals once again the threat posed by the independent young woman to the security of the home(land).

Later injured and hospitalized (without the medication that her sister has been surreptitiously dispensing to her) in the explosion that occurs as part of a thwarted attempt to capture Tom Walker (Chris Chalk), another turned POW working for Abu Nazir,

Carrie wakes up from her physical shock and descends into a manic episode which sees her becoming brilliantly insightful but increasingly erratic in her behaviour. The injuries on her body (caused by the explosion) portend her psychological unravelling and the visibility of the bipolar symptoms she has kept hidden. Her language becomes excessive and repetitive as she riffs on particular alliterative sequences; her 'musical phrases' are improvised to the extent that they make little sense to her auditors. Behaving in what is perceived to be an unpredictable and discordant manner, Carrie is told by Saul, her closest confidant, that she is 'not herself'; when, after being fired from the CIA, she attempts to get into the State Department after Walker has opened fire, he tells a member of the security detail that '[t]here's a woman outside – she's one of ours. She's unstable and you need to contain her' ('Marine One' 1.12). Once again, the dangerous 'becoming-otherwise' of the girlish woman needs to be halted – or 'contained'. If, as Mary Douglas suggests, 'the body is always treated as an image of society' and 'bodily control is an expression of social control' (70), then the sexually liberated body, 'with the threat it poses to the stability of the family, represents what Douglas would understand as weakness in the social fabric – a weakness that must be plugged or eradicated if the integrity and security of the US body politic is to remain intact' (Waters, 2012: 42). In *Homeland*, this eradication comes in the form of Carrie's shocking decision, convinced that her suspicions about Brody are paranoid delusions, to undergo electroconvulsive therapy (ECT) voluntarily. She elects, in other words, to be wiped clean and to forget what has gone before.

As Elaine Showalter points out in *The Female Malady* (1987), electroconvulsive therapy – or 'electroshock' as it was first called – has 'strong symbolic associations with feminization and the female role' (205). Invented by Ugo Cerletti, ECT was used widely in the 1940s and 1950s as a physical treatment for schizophrenia and depression. The practice involves anaesthetizing the patient, placing electrodes on her temples and passing an electrical current across the brain to induce a short seizure. One of the most common side

127

effects of ECT – which is referenced on *Homeland* – is short term and usually temporary amnesia. The mind of the patient is not only subdued but, in the words of Dr. Cyrill J.C. Kennedy and Dr. David Anchel in 1948, transformed into a 'clean slate' (qtd in Klein 25). This notion of 'cleaning' – or erasing – the mind has particular implications for the female subject. Both Friedan in *The Feminine Mystique* and Naomi Wolf in *The Beauty Myth* (1990) use images of brainwashing and electroshock to explore women's enculturation in traditional definitions of femininity as a kind of mind manipulation. Discussing young women's 'education' in the 'beauty myth', Wolf announces that

> [e]lectric shock is not just a metaphor. It has been part of the control of women since electricity was in use. Victorian invalids were subjected to galvanic shocks. Electroshock therapy is used typically on women asylum patients, and bears a strong resemblance to the death-and-rebirth ceremonial of cosmetic surgery. (250)

Likening electroshock therapy to cosmetic surgery, Wolf envisages beauty thinking as 'an anaesthetic, with the ability to make women more like objects by cauterizing sensation'. Women have come to act as their own 'electroshock operators' to survive the beauty myth; in the 'surgical economy', she suggests, we need to 'keep ourselves from knowing what we feel' (249). Employing a similar line of argument three decades earlier, Friedan envisages the work of the feminine mystique in trapping women in housewifery as a kind of 'brainwashing' (160). Pursuing this logic, she goes on to suggest that women who have been 'deluded or cheated by the feminine mystique' might also be reconditioned and re-educated (323). Towards the end of the book, she advocates that those women who did not go to university, or who were not interested in education, undergo 'a sort of intellectual "shock therapy"'. This 'educational shock treatment', she avers, would 'bring the housewife back into the mainstream of thought' and 'awaken able women' (324).

Friedan's call for a collectivized 'shock treatment' for housewives bears consideration alongside Naomi Klein's exposition of the links between the psychiatric practice of electroconvulsive therapy and forms of economic 'shock therapy' enacted by advanced capitalist societies to exploit crises in developing nations. In *The Shock Doctrine: The Rise of Disaster Capitalism* (2007) Klein argues that '[t]he history of the contemporary free market [...] was written in shocks' (19); she proposes that 'countries are shocked – by wars, terror attacks, coups d'état and natural disasters. And then [...] they are shocked again – by corporations and politicians who exploit the fear and disorientation of this first shock to push through economic shock therapy' (25–26). The 'shock doctrine' bespeaks global capitalism's exploitation of cataclysmic events to wash away or wipe clean previous social conditions and limitations to make way for a 'clean slate on which to build a reengineered model society' (20).

The synonymy that Klein sets up between the body in crisis and the nation in crisis resonates in *Homeland*, which uses images of brainwashing, electroshock and amnesia to analogize the state of the nation under siege. Brainwashing is at first used to account for the terrorist activities of the turned POWs ('Achilles Heel' 1.8). In the video he makes before his (aborted) suicide bombing, however, Brody (who has endured electric shock as a mode of torture during his imprisonment) assures his projected viewers that he was not 'brainwashed', but is acting instead, as an American marine, to remove domestic terrorists – and, specifically, the Vice President who ordered the drone attack on a school that killed Isa, Abu Nazir's son, whom Brody had been tutoring ('Marine One' 1.12). This announcement, combined with his ability to cheat the polygraph test, suggests an image of the male psyche as impervious and resilient – especially when set against the representation of Carrie, whose depressive phases see her become increasingly girlish and childlike. Anxieties regarding being 'wiped clean' are articulated in Saul's description of the redacted records of the drone attack, which are 'wiped clean [...] expunged, like it never happened' ('Marine One' 1.12). The first series of *Homeland* ends

with the deeply disturbing spectacle of the girlish woman paralyzed and in shock – her line of flight arrested. Carrie's projected amnesia becomes, then, a mirror for this erasure of history and the site of trauma, providing an image of the feminized nation under siege by both 'domestic' and 'foreign' terrorists.

The dramatic staging of Carrie's 'shocked' body has a particularly sinister resonance in light of the 'war on women' that has emerged from, and become a disturbing outgrowth of, the 'war on terror'. Just as the homebound woman is roused in the figure of Jessica Brody, the intellectually exceptional woman is put back to sleep in a Gothic inversion of Friedan's proposed programme of the 'intellectual' shock therapy that might awaken the 'able woman' from housewifery. Nevertheless, while losing consciousness after she has been anaesthetized in preparation for the ECT, Carrie remembers (amongst other moments of her love affair with him) that Brody called out the name of Nazir's son Isa in his sleep. This memory does not just prove that Carrie was right in her suspicions about Brody; her last words before going under – 'Don't let me forget' – also represent a refusal to take up the position of amnesiac subject.

Figure 4

Electroconvulsive therapy has become a powerful motif in shows such as *Homeland*, where it is used as a means of reconditioning problematic female identities ('Marine One' 1.12).

Homeland is not the only example of contemporary prime-time television series to use images of electroshock and electroconvulsive therapy as metaphors for reconfiguring and re-scripting women and girls. In *American Horror Story: Asylum* (2012), journalist Lana Winters (Sarah Paulson), after being wrongfully admitted to Briarcliff Manor mental institution, is subjected to a grotesque deployment of ECT to erase her memory of the sinister goings on in the asylum and to 'cure' her homosexuality ('Tricks and Treats' 2.2). The spectre of ECT, as already suggested in chapter two, also hovers over *Mad Men*'s representations of femininity in the Cold War period. While watching the secretaries test lipsticks as part of the Belle Jolie campaign from behind a one-way mirror, Pete Campbell asks when they will 'start running electricity through the chairs' ('Babylon' 1.6). Campbell's jocular remark betrays the series' persistent fascination with femininity as a 'hysterical' condition. This fascination is consolidated in *Mad Men*'s fifth series in the figure of Beth Dawes (Alexis Bledel), one of the show's haunted housewives. First introduced in the episode 'Lady Lazarus' (5.8), Beth is quite explicitly identified with Sylvia Plath, who famously underwent electroshock therapy, an experience she explored in such work as 'The Hanging Man' (1960).[17] In the fittingly titled last episode of the series, 'The Phantom' (5.13), Beth is sent for electroshock treatment by her husband because of her tendency to get 'really blue'. Afterwards, she is left completely blank, unable to remember her affair with Pete Campbell; she is shocked back into 'faithful' domestic femininity by the postfeminist mystique.

It is in contrast to such conservative evocations of electroconvulsive therapy, then, that *Homeland* refuses to re-invest the fantasy of the female subject as a 'clean slate' to be rebuilt or re-inscribed in the image of 'proper' femininity. At the beginning of series two, Carrie appears to have been 'wiped clean' and re-educated into orderly, domestic femininity (recovering in her sister's home, her engagement in domestic activities such as cooking and gardening is posited as key to her recovery and rehabilitation). However, by the end of the first episode, it becomes clear that Carrie is

amnesiac subject who has forgotten her liberation and
dence as a professional woman, than a subject haunted by
her relationship to the past. Co-opted to a secret CIA mission to
assassinate Nazir, who is apparently planning a terrorist attack on
US soil, Carrie is at first unsettled by her relocation to Beirut and
alias identity. On her way to meet Saul, however, she is followed
by a Lebanese secret service agent whom she leads into a crowded
market and immobilizes. It is the exhilaration of this encounter that
brings to the surface a trace of her previous identity in the form
of the gratified smile that gives the episode its title ('The Smile'
2.1). Carrie's emergent smile offers a glimpse of a trace identity
that withstands re-conditioning. In its representation of Carrie,
Homeland presents what Grosz would describe as a 'metaphorics of
body writing' that posits the body as a palimpsest 'as complicated
and indeterminate as any literary manuscript' (117). Carrie's
amnesia – the condition of the postfeminist subject who forgets her
(secret) agency – is, in the end, undermined by the resurfacing of
memory. Carrie is positioned instead as a palimpsestic subject, with
the attendant potential for recovery and recuperation, but also for
indeterminacy, flexibility and the possibility of new lines of flight.

5

The return of the repressed
Feminism, fear and the postfeminist gothic

[Gothic novels] are about women who just can't seem to get out of the house.
(Eugenia C. DeLamotte, *Perils of the Night*)

People came here to escape their past. There are no more virgin plots – we live on top of each other. You're building on top of someone else's life. You should stop unearthing while you're ahead. It only brings a haunting. We have a responsibility to the caretakers of the old lands...to show some respect.
(Constance Langdon, 'Open House' 1.7, *American Horror Story*)

As a figure of 'becoming', poised to open up different 'lines of flight', the girl exerts an electrifying influence over the Gothic text, returning again and again to recharge its old generic circuitry through the galvanic potential of her transitional body. The Gothic itself, of course, also recedes and re-emerges with remarkable tenacity, providing a suggestive site at which feminist anxieties – particularly those which circulate around girlish and womanly bodies – can be symbolized and contested. From Ann Radcliffe's *The Mysteries of Udolpho* (1794) to the dark erotics of shows like *True Blood*, the conventions of the Gothic have been

deployed repeatedly across a range of popular forms in ways that have 'attracted mass audiences and intellectuals alike' for more than two centuries (Becker 1). As a result of this enduring popular and academic currency, there are moments at which the Gothic – and the fraught formulations of feminism and femininity by which it is haunted – seems destined less to 'always come back', than to never go away in the first place. Like Derrida's 'revenant', then, the Gothic *begins by coming back* (11; emphasis in original). Providing a (dysfunctional) home for what has been cast out of mainstream discourses, it offers the expression par excellence of the 'return of the repressed', marking the moment at which knowledge – in this case feminist knowledge – that 'ought to have remained hidden' revisits itself upon those who tried to deny its existence (Freud, 1997: 207).

The Gothic constitutes what Eve Kosofsky Sedgwick describes as 'a carceral sublime of representation, of the body, and potentially of politics and history as well' (1986: vi). If Freud's *Studies in Hysteria* (1895) stresses the ways in which the 'foreign body' of repression wreaks its twisted influence upon the individual body proper, then Sedgwick's approach explores a model of repression (and return), in which the repressed foreign bod*ies* of 'politics and history' start to resurface within the body of the Gothic text.[1] Thus envisioning repression as a collective cultural mechanism, as well as an individual psychic phenomenon, Sedgwick emphasizes the Gothic as a political category, suggesting that the body of the Gothic text is itself as pregnant with political meaning as the physical bodies it describes. Via this conjuring, the Gothic is invested with a spectral quality; haunted by the 'repressed' spectre of feminism which has been turned away and kept 'at a distance' from the collective consciousness (Freud, 1957: 147), it returns to popular culture that which postfeminism once appeared to have consigned to the past.

As we have already suggested, this species of haunting is not confined to the Gothic, but has also been a feature of popular feminist discourse for more than two centuries. As an attempt to

draw attention to issues and injustices which might otherwise pass unheeded, feminism – like the Gothic – has repeatedly turned its attentions to what goes on behind closed doors, in women's private lives. This is especially discernible in the second wave's use of personal experience as the basis for collective action. Through consciousness-raising and related feminist activism, the second wave positioned abortion, contraception, the family, domestic violence, rape and the sexual division of labour squarely within the popular purview, redefining the parameters of politics to include 'not only the domestic sphere, the places where we lie down with lovers, but all activity not carried on within existing parties, previously institutionalized forms, [...] the whole question of power', which is 'left invisible' in conventional definitions (Rich, 1993: 23–24). Thus seeking to intervene in the legislation of women's choices and experiences, feminism necessarily trespasses on the dark 'Gothic' territories of power, sex and violence, demonstrating the mutual investment of the two discourses in narratives of female victimization, sexual violation and domestic abuse. This sense of shared territory is notably amplified in popular and critical accounts of the second wave alike. As Helene Meyers puts it,

> [s]econd-wave feminists in general and cultural feminists in particular have chronicled the horrors that women routinely face: economic dependence and vulnerability, sexual victimization, psychological battering from an androcentric culture. Feminist writers such as Susan Brownmiller, Andrea Dworkin, Mary Daly, Susan Griffin, and Dale Spender argue that women are at risk when they roam the street, when they make love in their bedrooms, when they enter their gynecologists' offices, when they consume or produce culture. Taken together, such accounts of women's lives suggest that the world is a Gothic place for the second sex. (118)

Conjuring up an army of angry, fear-mongering Dworkinian spectres – the same spectres which are routinely invoked in popular discourses as metonyms for all feminism – Meyers shows how

particular elements of the second wave have hewn the female subject into the archetypal Gothic victim, shoring her up in the intestinal passages of a patriarchal labyrinth from which there is no escape, where she will inevitably fall prey to one disaster or another. In light of such critiques, the Gothic suggests itself as a *heimlich* venue for 'ghost feminism', playing congenial host to debates about the family, reproductive rights and sexual violence that remain unresolved – and perhaps more tangled than ever – in the wake of postfeminism. Returning afresh to the gallery of ghostly mothers and disinherited daughters that occasioned our earlier discussion of intergenerational legacies and tensions, we find in the Gothic's narrative attempts to repress the past – and mother figures in particular – a rehearsal of tendencies within contemporary popular culture to 'forget' or misremember feminist histories and debates. While 'forgotten' at one level, however, we explore how these histories continue to encroach on the 'now' of the Gothic, re-emerging in the fearsome, uncanny figurations of femininity with which the genre is inextricably identified. In doing so, we focus on some of the stock female characters from the Gothic's colourful dramatis personae, asking why seemingly anachronistic feminine 'types' should continue to be such objects of fear and fascination in the twenty-first century.

The postfeminist Gothic

Our attempts to dissect these symbolic formulae focus on recent capitulations of what is often termed the 'Female Gothic'. However, while we do recognize the ground-breaking influence of Ellen Moers' avowedly straightforward identification of the 'Female Gothic' in 1976 as 'the work that women writers have done in the literary mode that, since the eighteenth century, we have called "the Gothic"' (90), we also acknowledge – along with the likes of E. J. Clery, Susanne Becker, Paulina Palmer and Diane Long Hoeveler – the limitations inherent in a definition that takes the gender of the author as its basis.[2] As a result, we retain with

Moers an investment in those examples of the Gothic mode that encode women's fears about entrapment within the home and the body, but reject the idea that such texts must always be the product of female authorship. With regard to this particular chapter, the texts with which we are primarily concerned utilize and adapt Gothic conventions in ways that speak to women's experiences in the contemporary world. Just as the women's liberation movement provided the context for Moers' excavation of the Female Gothic, our discussion here is shaped directly by ideological shifts in the contemporary landscape.[3] In accounting for these shifts, we draw special attention to the postfeminist mystique's rhetoric of choice and its implications for Gothic renderings of female enclosure and entrapment.

Benjamin Brabon and Stéphanie Genz have already designated the term 'postfeminist Gothic' as 'a new area of study [that] moves beyond the Female Gothic with its historical associations with second wave feminism and female/feminine victimisation'. Situating 'postfeminism' and 'Gothic' as 'categories [that] are characterised by a multi-focal and contradictory spectrum of meaning that gives rise to their many permutations and manifestations', they posit their conjunction in 'postfeminist Gothic' as 'a point of interrogation and a locus of struggle that operates in the gap between dualities and undermines their either/or antithesis'. In this way, the postfeminist Gothic is advanced by Brabon and Genz as 'a site for the construction of meaning, a contentious location that cannot be fixed or contained as it is "in process", exploring more than defining' (1). We likewise acknowledge the need for critical discourses that are flexible rather than fixed, but are fascinated by the extent to which the patterns of 'female/feminine victimisation' which Moers identified in her 'second wave' account of the Female Gothic remain operable in the postfeminist Gothic – especially at a time when feminism is once again the target of much negative political campaigning and media coverage. Using existing criticism of the Female Gothic as a fulcrum for our discussions, we here deploy the term 'postfeminist Gothic' to refer to texts that mobilize the tropes of supernaturalism

(especially haunting, vampirism and telepathy) to respond – in ways that are both subtle and overt, positive and negative – to the gains made by second wave feminism.

If the past decade has seen a significant rise in the number of female-centred television shows, then this has also been the period in which the postfeminist Gothic has established itself as one of the most ubiquitous and popular television subgenres. Beginning with *Buffy the Vampire Slayer*, the twenty-first century has augured a steady stream of small-screen Gothic fictions that are haunted by anxieties about the legacy of second wave feminism and its impact on the rights and freedoms of individual women. While the early generation of postfeminist Gothic heroines in *Xena: Warrior Princess*, *Buffy the Vampire Slayer*, *Dark Angel* and *Alias* are marked by second wave critiques of the family, reproductive rights and sexual violence, more recent fictions – especially those produced in the years following 9/11 – tend to fantasize about re-domesticating women along the lines that Faludi describes in *The Terror Dream*, as discussed in chapter three. This shift is registered in a number of ways, but not least in the shows' representations of marriage and the family. For some of the second wave's most outspoken campaigners, including Kate Millett, Germaine Greer and Shulamith Firestone, the family had played an instrumental role in women's subjugation for centuries. 'Patriarchy's chief institution is the family', proclaimed Millett in *Sexual Politics* (1970). 'It is both a mirror of and a connection with the larger society; a patriarchal unit within a patriarchal whole' (33). Firestone, in *The Dialectic of Sex* (1970), argues that the family is 'directly connected to – even the cause of – the ills of the larger society' and marriage 'consistently proves itself unsatisfactory – even rotten' (224). The second wave conjecture that marriage and the traditional nuclear family would come to occupy anachronistic positions in a post-liberation age is interrogated repeatedly in the postfeminist Gothic, where empowered heroines – struggling with conventional domestic arrangements – investigate alternative systems of support that might be more accommodating of female independence.

Marriage is the focus of sustained suspicion in *Buffy the Vampire Slayer*, where the failed wedding plot becomes a metaphor for the series' anxieties about the sustainability of the heterosexual family unit: Buffy's mother barely gets to discuss engagement with her salesman boyfriend, Ted (John Ritter), before he is exposed as a robot from the 1950s who has murdered his previous 'wives' ('Ted' 2.11), and Xander, in response to his parents' dysfunctional marriage, backs out of his wedding to Anya (Emma Caulfield) just prior to the ceremony ('Hell's Bells' 6.16). In 'Something Blue' (4.9), a spell causes Buffy herself to start planning her wedding to Spike (James Marsters), though her temporary recasting as a giddy bride-to-be plays purely as parody. Even in fantasy, marriage seems doomed: when Angel (David Boreanaz) dreams about marrying Buffy, his imagined happiness is short-lived. Following the solemnization of their vows and the couple's emergence from the church, he looks on helplessly as his new bride bursts into flames ('The Prom' 3.20). While Angel understands the dream as portent of the threat he poses to Buffy and a sign that their relationship must end, it speaks more generally to the dangers that marriage poses to the postfeminist Gothic heroine, feeding into the series' overarching scepticism about institutions that circumscribe female autonomy. As becomes clear when the series draws to a close, it is through non-nuclear living arrangements – organized around 'the ideal of sisterhood, the rallying cry of the Second Wave' (Karlyn 123) – that *Buffy the Vampire Slayer*'s powerful women are best able to flourish. Returning to and modifying second wave blueprints of the cooperative, self-regulating 'organic family' (Greer 232), the show's liberal vision of communal living is abandoned rather than developed by the next generation of postfeminist Gothics, which have tended to investigate more stable, settled and 'familiar' versions of femininity. Where Buffy's nuptials are part of a nightmarish vision that ends in her death, a somewhat different inflection of marriage opens the 2005 premiere of *Ghost Whisperer* (2005–10). The series begins at the wedding reception of Melinda (Jennifer Love Hewitt), the eponymous 'ghost whisperer', and her new husband, Jim (David Conrad). Through a slow-motion

AMC

montage bringing together images of the couple's 'delirious' faces, Melinda's wedding is presented as a dreamy affirmation of her life as a woman – a moment so transformative that its significance is comparable only to her first, life-defining encounter with a ghost.

As is demonstrated in these differing portrayals of marriage, the postfeminist mystique operates with ambidextrous versatility in contemporary Gothic fictions, sometimes rekindling the sisterly idealism of the second wave that postfeminism pronounced 'dead', sometimes reviving models of femininity that the second wave had declared outmoded by the 1970s. The shifting focus of the postfeminist mystique is further demonstrated in the types of power that are accorded to the heroines of the Gothic. While the early generation of postfeminist heroines in *Xena: Warrior Princess*, *Buffy the Vampire Slayer*, *Dark Angel* and *Alias* were physically formidable as well as mentally astute, subsequent convolutions of the Gothic have tended to re-inscribe women as possessors of psychic – rather than somatic – power. Nomadic models of female heroism have thus been supplanted by those which might be more readily reconciled to the demands of home and family. From psychic insight, clairvoyance and telepathy to telekinesis, witchcraft and other associated 'dark arts', the powers attributed to the post-9/11 Gothic heroine are typically presented as supernatural extensions of her maternal function, which trade on, or appeal to, the 'feminine' capacity for sympathetic nurture.

The institution of motherhood has long occupied a contentious position in feminist thought. Alongside marriage, it was viewed by a number of prominent second wave thinkers as patriarchy's most effective means of 'ensuring that [...] all women shall remain under male control' (Rich, 1977: 13).[4] While Firestone imagined a time in which new reproductive technologies would liberate women 'from the tyranny of their biology', outsourcing the roles of 'childbearing and childrearing [...] to society as a whole' (270), Greer lamented the mother's unseemly demise, defining her as 'the dead heart of the family', whose only legitimate role in modern consumer society was that of scapegoat (251). If the *institution* of motherhood was

the target of feminist ire, then the practice of mothering, argued Oakley, could still be 'a valid and valuable aspect of being a woman, a resource to be drawn on rather than a burden to be disposed of' (1981: 23). The ambivalent position of the mother in second wave accounts of patriarchal motherhood is anticipated by the eighteenth-century Gothic, where mothers are presciently encoded as powerful and victimized, the loci of daughterly fears and fantasies.[5]

The supernatural abilities which the heroines of the postfeminist Gothic possess are, almost invariably, part of a disquieting matrilineal legacy that speaks to the ambivalent position occupied by the mother in second wave feminism: *Ghost Whisperer*, as we have already indicated, follows a young wife and mother whose 'ghost whispering' can be traced back through five generations of women to her great-great-great grandmother; Allison Du Bois (Patricia Arquette) in *Medium* shares her psychic abilities with her grandmother and her three daughters; and *Tru Calling* features a mortician, Tru (Eliza Dushku), who – like her mother before her – attempts to assist those who request her help from beyond the grave. This tendency not only to feminize, but also maternalize, psychic sensitivity is similarly insistent in shows like *True Blood*, where telepathic waitress Sookie Stackhouse (Anna Paquin) at one point uses her powers to 'become' her dead mother ('Somebody That I Used to Know' 5.8), and *The Secret Circle*, in which the young protagonist, descended from a long line of powerful witches, is able to witness key episodes from her dead mother's life through the 'psychic imprints' left on an enchanted crystal ('Prom' 1.21). In each case, the ability that the girl-child inherits is both a gift and a curse: her power is always tempered by the danger it brings to herself and to those around her.

Women's apparent predisposition to feats of magical intuition is hardwired into some feminist and psychoanalytic accounts of maternity, in which the intimacy of the mother–daughter bond is routinely configured as both powerful and uncanny. According to Adrienne Rich in *Of Woman Born* (1976), 'mothers and daughters have always exchanged with each other – beyond the verbally

transmitted lore of female survival – a knowledge that is subliminal, subversive, preverbal: the knowledge floating between two alike bodies, one of which has spent nine months inside the other' (220). Luce Irigaray, too, places '[s]upernatural mother–daughter encounters' at the heart of her Elysian description of pre-Socratic society, or the 'time of women's law, [when] the divine and the human were not separate' (1994: 11). These numinous accounts of maternity and femininity echo early psychoanalytic theories of the mother–infant relationship, from D. W. Winnicott's intuitive mother, with her 'magical understanding of [her child's] need' (50), to Dorothy Dinnerstein's investiture of 'the magically powerful goddess mother of infancy' as the organizing principle of the daughter's 'inner world' (85). More recently, books like Carl Jones's *The Secret Life of the Expectant Mother* (1997) and Judith Orloff's *Second Sight* (2010) have presented the 'scientific' case for 'mother's intuition' and suggested ways of honing or developing this putative form of insight. Specially connected to nature and divinity, capable of telepathic communication and subliminally attuned to the needs and desires of others, the mother is regularly evoked as innately and uncannily perceptive. As solicitous of deflation as these myths are, the fantasy/horror of the 'magic mother' remains stubbornly persistent within the postfeminist Gothic. In text after text, the origins of female power are perpetually rerouted back into cycles of female biology, foregrounding the prevailing interconnectedness of body and mind.

Like the body of the mother, the mind of the psychic is intruded upon and burdened by the needs of another being. At one level, then, the psychic

> becomes a powerful metaphor for feminine identity and the tensions by which it is beset. Torn between fulfilling her own needs and carrying out her responsibilities to others – both living and dead – her condition speaks to the increasingly complex negotiations that women are required to undertake as they try to balance personal, familial, domestic, and professional obligations (Waters, 2011: 70).

Ministering to the demands of the restless souls by whom they are assailed in the same way that they tend to their children, the protagonists of shows like *Medium* and *Ghost Whisperer* are transformed into 'über-mothers', extending the remit of their custodial roles as wives and mothers beyond the domestic realm and into the zones of the supernatural. In *Medium*, Allison's husband, Joe (Jake Weber), even suggests that the dreams and visions by which his wife is plagued are little more than the hallucinatory products of her maternal status, having 'more to do with the stress associated with being a mother of three while trying to get into law school and work an internship at the D.A.'s' than any genuine ability to communicate with the dead ('Pilot' 1.1). The maternal dimensions of Allison's 'gift' are further accentuated in the course of her work as an advisor to the District Attorney's office, where she is routinely tasked with using her psychic abilities to find daughters who are 'lost'. As well as dealing with the cases which are assigned to her officially, Allison is specially enlisted to investigate cases involving her boss's daughter ('Dear Dad...' 6.12), Joe's boss's daughter ('To Have and To Hold' 4.3) and, on two separate occasions, the daughters of her boss's friends ('Sweet Dreams' 2.5; 'A Taste of Her Own Medicine' 5.5). In addition, Allison's own daughters are often presented as potential targets for male violence: convicted sex offenders move into the neighbourhood ('Bring Your Daughter to Work Day' 7.1); neighbours are murdered ('Sal' 6.19); a stalker, who has threatened Allison's children, gains entry to the DuBois home ('The Devil Inside: Part 1' 5.11); and a serial rapist and murderer tells Allison, in a dream, that her 'little girl' is 'in the trunk of [his] car', and that he has 'come for the other ones' ('Coming Soon' 1.6). This recurrent motif of 'daughters in danger' insists upon Allison's status as a mother, but also underlines the limits of her maternal power; she cannot usually 'save' these young women, but only ensure that those who perpetrated crimes against them are identified and prosecuted.

If shows like *Medium* demonstrate the recuperative power of memory, with the figure of the psychic remembering and recovering

the experiences of other people (and dead women in particular), then they also foreground the danger of forgetting. Anxieties about forgetting have long loomed large within feminist criticism and were intimately connected with the work of the second wave, which engaged in a colossal act of remembering through its attempts to establish a female tradition out of women's 'lost' contributions to history and culture. Moers' definition of the 'Female Gothic' was itself a product of this remembering, being 'not only central to the recovery of a submerged tradition of women's writing, but to broader feminist interrogations of the cultural refusal of female subjectivity' (Munford 59). Just as Huyssen characterized the postmodern age as one in which a proliferation of memory is set against a countervailing culture of amnesia, the postfeminist Gothic stages a similar tension, recuperating particular kinds of memory, while partaking in an equally particularized species of forgetting.

As we noted in chapter three, Ira Levin's *The Stepford Wives* is a narrative about a group of women who are programmed to forget about feminism. With only the barest recollection of the successful, professional careers that they had prior to their modification, the women of Stepford surrender the boardroom for the feminized precincts of the supermarket and the home, floating around in an artificially-manufactured cloud of ignorance about their own oppression. Haunted by anxieties about women's liberation, *The Stepford Wives* conjures up a world in which feminism does not survive and in doing so satirizes the dangers of forgetting to powerful effect. In its dramatization of forgetting, *The Stepford Wives* is somewhat prescient, anticipating the amnesiac dimensions of the postfeminist Gothic. Recapitulating historical characterizations of hysterical amnesia as a woman's affliction – evident in everything from the etymology of hysteria itself (from the Greek 'hystera', meaning 'womb'), to Freud's exclusive referencing of cases involving female patients in his seminal *Studies in Hysteria* – the postfeminist Gothic is insistently concerned with what is inaccessible to female consciousness. An enduring symbol of Gothic uncertainty, the amnesiac or forgetful woman is unable to access her own memories;

hovering on the periphery of self-knowledge, she is forever on the verge of uncovering (and revealing) information that will both empower her as an individual and assist her in overturning existing systems of authority.

Episodes of hysterical amnesia and related instances of forgetting are frequent features of female experience in the postfeminist Gothic, and are part of the genre's more sustained investment in certain kinds of remembering and misremembering. Allison's ability to 'remember' on behalf of others is often accompanied by bouts of forgetfulness: she regains consciousness after being 'possessed' by the spirit of a murdered woman, but remembers nothing about the preceding days ('The One Behind the Wheel' 3.12); she wakes up in an alley, having been missing for six hours, and cannot recall how she got there ('About Last Night' 5.4); and she forgets simple facts about her life after passing out on the kitchen floor ('A Changed Man' 2.14). It is Ariel (Sofia Vassilieva), Allison's eldest daughter, however, who suffers the most prolonged and affecting episode of amnesia in the show. In 'Time Keeps on Slipping' (6.20), Ariel is projected further and further into her own future after falling asleep in the car of her would-be boyfriend, Liam (Michael Rady), during a free period at school. Losing first hours, then years of her life, Ariel 'awakens' to find herself married to Liam, with whom she appears to have a five-year-old daughter, before being jettisoned into a disturbing future where her mother is dead. It is only when Ariel recognizes the role that Liam has played in the murders of her teacher and her mother that she is returned to the present, where her 'memory' of the future enables Allison to intercept Liam's attempt on the teacher's life. Again and again, the figure of the amnesiac girl resurfaces as a symbol through which the processes of repression (and possible return) that structure the narrative of the Gothic ur-text are enacted. In *Tru Calling*, too, Tru must remember what she has 'seen' of the future in order to change the present. In 'Haunted' (1.5), the importance of remembering – over and against misremembering – is dramatically foregrounded when Tru attempts to save a young medical student, Paige (Alaina Huffman),

who believes she was sexually abused by her father. In an attempt to remember, Paige and her colleagues engineer a dangerous experiment in which subjects are clinically put to death in order to unlock repressed memories. When Paige cannot be resuscitated by her fellow medical students, it is Tru who first shocks her back to life with the cardiac defibrillator and then saves her from strangulation at the hands of the neighbour who perpetrated the abuse that Paige had formerly misremembered. It is only by remembering correctly that Paige can take the 'first step' towards 'liv[ing] in the present'.[6]

Through the disorienting effects of the time-slip motif, both *Medium* and *Tru Calling* replicate the vagaries of memory, investigating the (negative) ways in which failing to remember – or remember *correctly* – impacts on the formation of postfeminist subjectivities. By conjuring up speculative futures to which only the heroine is privy, these series foreground the status of the young woman as the caretaker of the future. It is the young woman, then, who is haunted by horrors yet to come. Like the girl, she is a figure of possibility; in her Gothic guise, however, she is not only identified with the promise of the future, but is also responsible for safeguarding it from threat – a feat which she can only accomplish when she uses her 'memories' of the past and the future to negotiate the awkward terrain of the present.

Magical wombs and monstrous pregnancies

When Todd Akin, the Republican senatorial candidate for Missouri, was asked by Charles Jaco in August 2012 whether he believed abortion should be available to victims of rape, his response was as enigmatic as it was uninformed: 'from what I understand from doctors [pregnancy as a result of rape is] really rare. If it's a legitimate rape, the female body has ways of shutting that whole thing down' (see Jaco). While Akin later retracted his remarks about 'legitimate rape', acknowledging that his views about pregnancy were 'medically wrong', his comments reveal something about the extent to which current debates about rape and abortion

rights in the United States are mired in myths about women and their bodies. Certainly, Akin's fable of the magical uterus rests on antiquated characterizations of the female body as an enchanted space, where inscrutable biological mechanisms safeguard women and men against the establishment of unwanted pregnancies. Indeed, the medical historian Vanessa Heggie has traced Akin's theory back to 1290 and a clause in one of the earliest documents in English law, which states that 'without a woman's consent she could not conceive' (para. 1). In the case of Akin, his recourse to biological mysticism provides a conveniently magical solution to the awkward questions about cases of rape and incest that have beset Republican calls to overturn Roe vs. Wade and introduce new 'no abortion, no exception' legislation (McVeigh paras. 5–9). According to Akin, after all, abortions are not necessary in cases of rape, as pregnancies do not result from 'legitimate' rapes: if a woman falls pregnant as a result of rape, then she was not 'forcibly' raped.[7] Akin's sketchy grasp of the female reproductive system is not without its political precedents: in 1995 the Republican Representative Henry Aldridge claimed that women who are 'truly raped' do not get pregnant because 'the juices don't flow', while the Republican pro-lifer Stephen Freind argued in 1988 that the female body, when subject to unsolicited violation, 'secrete[s] a certain secretion' that destroys sperm, precluding the possibility of fertilization (Baker paras 4–5). Even those pro-life discourses that countenance the idea of pregnancy-by-rape are so entangled with Christian dogma that the female body is understood exclusively in terms of its miraculous life-giving properties. According to Sharon Barnes, a member of the Missourian Republican central committee who was invited to comment on Akin's claims, a woman only gets pregnant 'because God has chosen to bless this person with a life'. Women who suffer rape are not unlucky targets of male violence, but 'chosen' and 'bless[ed]' (qtd in Weisman and Eligon para. 15). In accordance with time-honoured prejudices, women's bodies are the loci of various antitheses: they are both sacred and profane, pure and unclean. Encircled by centuries-old myths and superstitions,

the female body lies at the core of debates about abortion and rape but does so while remaining ultimately (and necessarily) mysterious.

Abortion has long been at the heart of women's battles for reproductive freedom and has shaped portrayals of feminism in popular culture since the 1960s. Reflecting on the political agenda of radical feminism between 1967 and 1975, Ellen Willis avers that abortion, 'more than any other issue, […] embodied and symbolized our fundamental demand – not merely formal equality for women but genuine self-determination' (vii). With the rise of second wave feminism, abortion came to be understood increasingly as a 'collective problem for all women' (Reagan 217), and in 1967 the National Organization of Women (NOW), presided over by Friedan, controversially opted to include legal access to abortion in its Bill of Rights for Women. In a different vein, activists led by Kathie Sarachild interrupted the New York state hearings on abortion reform in February 1969 to object to the panel's composition (14 men and one nun); in doing so they generated a storm of media coverage that identified the legalization of abortion as a feminist demand. Capitalizing on this mainstream interest in the movement's political aims, the Redstockings – a radical feminist group founded by Willis and Firestone in 1969 – went on to hold a series of 'speakouts' in the same year, where women were invited to make public their experiences of abortion in an attempt to 'confront the spurious personal-political distinction' (Echols 142). Steinem, who reported on the speakouts for *New York* magazine, would later be part of the editorial team that published Barbaralee Diamonstein's article, 'We Have Had Abortions', in the first issue of *Ms.* in July 1972. When Roe vs. Wade legalized abortion in 1973 (six years after the passing of the UK Abortion Act in 1967), it was hailed as a feminist victory.

Though freighted with controversy, abortion had been addressed in early twentieth-century novels such as Jean Rhys's *Voyage in the Dark* (1934), Fryniwyd Tennyson Jesse's *A Pin to See the Peepshow* (1934) and Rosamond Lehmann's *The Weather in the Streets* (1936), which emerged alongside the organized campaigns for abortion

rights in Europe, the UK and the US. It was only at the start of the 1970s, however, that abortion became 'a commonplace of women's and feminist fiction', featuring in Joan Didion's *Play As It Lays* (1970), Dorothy Bryant's *Ella Price's Journal* (1972), Rita Mae Brown's *Rubyfruit Jungle* (1973), Margaret Laurence's *The Diviners* (1974), Marge Piercy's *Woman on the Edge of Time* (1976) and *Braided Lives* (1982) and Alix Kates Shulman's *Burning Question* (1979) (Hogeland 62). In 1972, only two months prior to the Roe vs. Wade ruling, abortion made a watershed small-screen appearance on the sitcom *Maude* (1972–78). In a double episode, the liberal-minded Maude (Bea Arthur), reminded by her daughter that abortion has recently been made legal in New York, decides to terminate an unwanted pregnancy on the basis that she and her husband are too old to raise another child. Although *Maude* is perhaps the most famous example of 'prime-time abortion', Celeste Michelle Condit has identified plotlines in shows that aired in the decade following Roe vs. Wade, including *St. Elsewhere* (1982–88), *Buffalo Bill* (1983–84) and *Spenser for Hire* (1985–88), in which central female characters obtain terminations. According to Condit, these plotlines, and those in other shows involving more minor characters, present 'a fairly unified depiction of the practice of abortion in American mainstream culture' during this period; with the horror of backstreet abortions still in recent memory, network television appeared to reach a brief and uneasy consensus that abortion, however 'morally undesirable', was – and had to be – 'a woman's choice' (139).

By the millennium, abortion had all but disappeared from the horizons of popular culture. In the very few mainstream texts that have dealt with unwanted pregnancy in recent years, abortion has scarcely been referenced. In *Knocked Up* (2007), a film about a career-minded woman (Katherine Heigl) who becomes pregnant as a consequence of a one-night stand with an unemployed stoner (Seth Rogen), abortion is only mentioned in passing: once, by Alison's feminist-identified mother, who brusquely advises her to 'take care of it. Take care of it and move on', before reminding her

that her stepsister had an abortion and 'now she has a real baby'; and once by the father-to-be's roommate, who asks if he's 'thought about something that rhymes with smushmortion'. In *Juno* (2007), too, the teenage protagonist's more serious attempt to 'procure a hasty abortion' is depicted fleetingly as she very quickly resolves to go through with the pregnancy and have her baby adopted instead. This strategy of referencing and rejecting abortion as a possible option (or, in the case of *Knocked Up*, not even that), is a typical feature of unplanned pregnancy plotlines in popular television shows like *Beverly Hills 90210* (1990–2000), *Dawson's Creek* (1998–2003), *Sex and the City*, *Desperate Housewives* and *Mad Men* – shows which ultimately seem to valorize women who decide against abortion.[8] The rhetoric of choice, appropriated here in relation to women who choose *not* to have abortions, is haunted by the language of the second wave. Inextricable from 'pro-choice' campaigns for abortion rights and the vocabulary of post-Roe feminist works such as Beverly Wildung Harrison's *Our Right to Choose* (1983) and Rosalind Pollack Petchesky's *Abortion and Woman's Choice* (1984), 'choice' is instrumentalized in these fictions as part of the discussion that takes place around unwanted pregnancy, but it is reframed in ways that empty that rhetoric of its original political import.

In the twenty-first century it is the Gothic – the genre of secrets, shadows and unwelcome returns – that has managed to tackle the thorny issues of reproductive rights and sexual violence without attracting the censure reserved for realist fictions. A strange and sustained engagement with abortion is found in *American Horror Story*, which – in keeping with the series' tendency towards narrative and stylistic excess – features two abortion storylines, as well as multiple depictions of failed maternity in the form of miscarriages, doomed pregnancies, child abuse and infanticide. Abortion is used here as a strategy for signposting female monstrosity and expressing anxieties about women who should not be mothers; tellingly, the women who countenance abortion are those who are elsewhere revealed to be incapable of effective maternity. As Constance remarks to Vivien with reference to Adelaide, her daughter with

Figure 5
Feminist debates about abortion have resurfaced in a number of
recent Gothic fictions like *American Horror Story* ('Murder House 1.3).

Down's Syndrome, 'that girl is a monster. I love and I'm a good
Christian, but Jesus H. Christ, if they'd invented some of those tests
a few years ago I would have…' ('Pilot' 1.1). This coded overture
to abortion establishes a slippage between abortion and infanticide
that is sustained throughout the series. Crucially, it is the spoken
invocation of abortion, and not even the act itself, which serves to
foreground the threat that certain women pose to their children.
Constance never terminates a pregnancy, but she urges her husband
to smother her deformed son, Beau, who is chained up in the attic
('Open House' 1.7), and is identified by the ghost of her son Tate
(Evan Peters) as the cause of his high-school murder spree and his
subsequent death at the hands of an armed response unit.

Of all the women who get pregnant in *American Horror Story*,
not one of them is deemed a 'suitable' mother: Nora 'doesn't have
a maternal bone in her body' ('Afterbirth' 1.12); Constance, who
loses four children, 'should have stopped after the first' on account
of her 'cursed' womb ('Home Invasion' 1.2); Vivien suffers two
stillbirths, has a teenage daughter who commits suicide (without
her noticing) and a surviving son who appears to be the Antichrist;[9]
and Hayden (Kate Mara) – a graduate student made pregnant by
Vivien's husband – not only schedules a termination for herself, but

also threatens to perform an impromptu abortion on Vivien, telling her 'I'm going to cut it out' ('Halloween: Part 2' 1.5). In 'Murder House' (1.3) the traumatic history of the Harmon home is sourced directly to the illegal abortions that the original owner, Dr. Charles Montgomery, performed in the basement during the 1920s. While Montgomery wields the surgeon's knife, it is his money-hungry wife, Nora, who is ultimately held accountable for the devastation that ensues. As the grim story of the house springs to life through various flashback sequences, it is Nora, intent that her husband 'is going to support [his] family one way or another', who is shown to take the initiative in procuring the clients and drugging them (and herself) to 'make [them] forget' ('Murder House' 1.3). Embedded within the imagery of the flashbacks are visual references to the present day; the shot of a young Hollywood starlet, with her feet in stirrups in the Montgomerys' basement recalls the first image of Vivien in the gynaecologist's surgery, identifying both as women who should not – or will not – reproduce.

As is implied through its engagement with abortion, *American Horror Story* is curiously informed by the discourses of second wave feminism. 'I'll always win against the patriarchal male', says Sister Jude (Jessica Lange) anachronistically as she challenges the physician who runs the medical unit of the 1960s asylum over which she presides in the show's second season ('Welcome to Briarcliff' 2.1). Ventriloquizing the language of the second wave, the series flirts with parody in its treatment of feminism. As well as informing the dialogue, feminism is positioned as the real source of horror in the show. It is to the 1920s, and the figure of the newly enfranchised, sexually liberated woman, that the home's problems are traced. As we observe in chapter one, this transitional moment is the focus of flashbacks in popular television Gothics including *Buffy the Vampire Slayer*, *Charmed* and *True Blood*. Following the twisted historical logic of *American Horror Story*, the increasing deregulation of female sexuality at this time and the ensuing rise in unwanted pregnancies generates a gap in the medical market that Nora first identifies and then – through her hapless husband – exploits. As Nora's

'secret side business' eventually results in the kidnap, murder and dismemberment of her son, her husband's ghoulish reanimation of the corpse and her own eventual suicide, the abortions – understood as a product of feminist liberation – are clearly identified as the root of all evil ('Halloween: Part 1' 1.4): 'We're damned, Charles', Nora says, 'because of what we did to those girls – to those poor innocent girls and their babies' ('Open House' 1.7). It is only after Vivien gives birth in the house that it can be restored to its proper function as a home for the nuclear family. In the final shot of the house, Ben, Vivien, their baby son, Violet and Moira – all now dead – are shown happily dressing the Christmas tree, the posthumous embodiment of recuperated domestic order ('Afterbirth' 1.12).

Abortion has likewise provided a focus for an adjacent – and highly specific – subgenre of Hollywood films that deal explicitly with possession and exorcism. If the release of *The Exorcist* in 1973 coincided with the landmark ruling of Roe vs. Wade, reflecting contemporaneous anxieties about the female body and its ability to harbour life, then the recent raft of films about demonic possession might invite consideration alongside the aggressive resurgence of these anxieties in the face of calls to overturn the US Supreme Court's decision. In the rituals of exorcism, after all, the female body is a site of conflict through which opposing – and invariably patriarchal – forces engage in a battle for authority. As in debates about abortion, these forces routinely reduce the female body to the status of insensible matter, invoking scripture and medical discourses in order to diagnose the body's condition and determine its ultimate fate. The possession/exorcism motif represents a nightmarish scenario in which women are denied choice: they do not choose to be 'possessed'; they do not choose to be pregnant; and they do not have any agency in determining the final fate of their own bodies, nor those to which they play host. This privilege belongs exclusively to the men to whom they are entrusted.

The Exorcism of Emily Rose (2005), *Exorcismus* (2010), *The Last Exorcism* (2010), *The Rite* (2011), *The Devil Inside* (2012) and *The Possession* (2012) speak to fears about the vulnerability of the

post-pubescent female body to unsolicited forms of intrusion, as well as to related concerns about its ability to play host to foreign bodies – foreign bodies that have the power to annihilate its biological and psychic integrity. In line with Deleuze and Guattari's account of the 'girl' as a highly unstable and destabilizing category, these narratives select the 'girlish', rather than the womanly, body, as the logical host site for demonic activity. As a 'fugitive being', vitalized by molecular flows that are yet to harden into the fixed form of 'molar' woman, Deleuze and Guattari's 'becoming-girl' suggests a nexus of possibilities yet to be realized. As we note in the previous chapter, however, this state of openness and possibility is purely temporary, as the little girl's body is 'stolen' from her in order to facilitate the subjective individuation of the little boy. These patterns of theft and becoming are important features of the exorcism plotline, in which the body of the girl is 'stolen' not only by the satanic hoards who 'become' in her and through her, but also by the male authority figures who seek to define themselves through the spectacle of her transitioning body.

In *The Last Exorcism*, *The Rite* and *The Devil Inside*, the symbolic links between demonic possession and pregnancy are rendered gorily apparent through the double coding of the host bodies as girls and (potential) mothers. Nell (Ashley Bell) in *The Last Exorcism* and Rosaria (Marta Gastini) in *The Rite* are both 16, while Isabella (Fernanda Andrade) and Rosa (Bonnie Morgan) in *The Devil Inside* are slightly older, in their twenties, but are 'girled' insistently throughout: home video footage of Isabella as an infant is spliced into the documentary; she is referred to repeatedly as a 'daughter' and a 'little girl'; and she sings nursery rhymes with her mother during the latter's exorcism. Rosa, too, is introduced not as a woman, but as the daughter of a concerned mother, being first presented to the viewer in an awkward gymnastic contortion on a child's bed in the basement. This girling is not only significant but critical, in that it identifies the girl explicitly as the weak link in the social fabric. Patterning Deleuze and Guattari's understanding of the girl as a 'fugitive being' or a 'becoming', the twenty-first-

century exorcism narrative casts her both as 'the first victim', whose body is stolen from her (in this case quite literally), and as an agent of dangerous, uncontrollable excess who must serve 'as an example and a trap' (Deleuze and Guattari 305).

The Last Exorcism is a mockumentary-style film that follows Cotton Marcus (Patrick Fabian), an evangelical minister who has lost his faith, as he travels out to a remote Louisiana farm in order to assist a farmer who believes his 16-year-old daughter, Nell, is a victim of demonic possession. While Nell appears to be a devout young woman, suffering as a consequence of her repressive, remote upbringing and the loss of her mother, Marcus misleads her father into believing she is possessed by a demon that 'defiles the flesh of the innocent' so he can 'exorcize' her and claim his bogus fee. Following the smoke-and-mirrors theatrics of the fraudulent ritual, Marcus claims his salary and leaves, but is drawn back into the case after Nell – now demonstrating genuine signs of disturbance – is hospitalized. Once discharged, Nell's strange behaviour starts to escalate: she attacks her brother with a knife; she makes crude paintings; and she kills a cat. When a message from the hospital reveals that Nell is pregnant, Marcus and the documentary team start to understand her bizarre actions as signs of trauma, symptomatic of the systematic sexual abuse that they assume she has suffered at the hands of her overprotective father. While Marcus remains convinced that Nell requires urgent psychiatric attention, he agrees under duress to perform another exorcism, after which Nell again appears recovered. As Marcus and the film crew are driving out of town, however, they grow increasingly suspicious of Nell's story and return to the farmhouse to find Nell and her father missing. At the film's climax, Marcus, looking for Nell, stumbles across a hooded congregation in nearby woodland. At the centre of the congregation, splayed on an altar, lies Nell. With Marcus and the crew looking on, Nell gives birth to something 'not human', a blood-slicked, writhing mass, which the local pastor, now adorned in his diabolical garb, casts into a towering pyre.

While *The Last Exorcism* is more or less conventional in its narrative manoeuvres, the pregnancy subplot serves to focus concerns about promiscuity and consent on the reproductive body of the girl. The failure of both Marcus and Nell's father to determine the paternity of her 'baby', or to unravel the mysterious circumstances in which it was conceived (was she raped, or did she consent?), speaks to the threateningly enigmatic nature of pregnancy, while the fact that Nell goes into labour when she is not visibly pregnant, giving birth to a bloodied mass that is destroyed by the authority who presides over the delivery, mobilizes a metaphorics of abortion, with Marcus's claim that Nell's progeny is 'not human' ventriloquizing anxieties about the ontological status of embryos and their potential 'right to life'.

Drawing on comparable systems of ideas and imagery, both Mikael Håfström's *The Rite* and William Brent Bell's documentary-style film *The Devil Inside* demonstrate a similarly vested interest in the violated body of the girl. Both set in Rome, in the shadows and interiors of the city's imposing religious architecture, the films are each concerned with problem pregnancies and dead babies. *The Rite* follows Michael Kovak (Colin O'Donoghue), a troubled priest, as he undertakes a course on exorcism run by the Vatican in order to fulfil the terms of his proposed abdication from the priesthood. The first case of possession he witnesses involves Rosaria, a pregnant 16-year-old who is brought to the home of Father Lucas (Anthony Hopkins) by her aunt during Michael's first visit. Like Nell, Rosaria will not initially identify the father or her unborn child, though the 'demon' who speaks through her later claims to have entered her 'with her father's seed'. Despite the incestuous provenance of the baby, Rosaria does not seek to obtain an abortion, but after withstanding repeated exorcism attempts under the aegis of Father Lucas she does attempt to drown herself, ending up chained to a bed in a hospital room overlooked by the Vatican, the seat of Canon Law. It is here, within sight of the institution that holds abortion to be an 'abominable crime', impermissible even in cases of rape and incest, that Rosaria and her baby die. Despite Rosaria's

own demise, the death of her baby is regarded as suspicious, with at least one character querying whether Rosaria could have harmed it prior to her death.

If abortion casts a spectral presence over *The Rite*, invoked indirectly through the film's setting and references to implied infanticide, then *The Devil Inside* is more categorical in its condemnation of the procedure. Bell's film follows Isabella Rossi as she travels to Rome to investigate the circumstances surrounding her estranged mother's incarceration in a psychiatric hospital, where she is being held at the Vatican's behest. Although Isabella knows that her mother, Maria (Suzan Crowley), committed a triple homicide in the 1980s, she has only recently discovered that she was undergoing an exorcism at the time. In an attempt to 'understand [her] mother's condition' and prepare for seeing her again, Isabella sits in on an exorcism seminar run by the Vatican, where she views footage of 'possessed' individuals and listens to medical explanations of apparently demonic phenomena. Like Michael in *The Rite*, Isabella remains sceptical, but when she visits Maria she is startled by the few words that her mother does speak to her: 'you shouldn't have killed your child. It's against God's will.' Isabella later discloses that she terminated a pregnancy years earlier, after a doctor told her she would not be able to carry the baby to term. During another attempted exorcism on Maria – already established as possessed and homicidal – the 'demon' again addresses Isabella's abortion, calling her a 'baby killer' and warning her she'll 'burn for the child'. Emanating from this devilish source, such judgement implies not that abortion is demonic, but that it is somehow *beyond* demonic, that even the devil would think twice before terminating a pregnancy.

If viewers were to be left in any doubt about the condemnatory stance that *The Devil Inside* adopts in relation to 'baby killer[s]', its position is clarified by scenes which consolidate the implied connection between devilry and abortion. When a priest by whom Isabella is befriended attempts to drown a baby during a baptism it is a clear sign that he, too, has been infected by the demon, while

Rosa, another 'possessed' woman – similar in age to Isabella – starts to haemorrhage between her legs during the exorcism ritual, in what seems to be an embodied gesture towards Isabella's 'secret'. There are similar attempts to augment the equation between abortion and infanticide in *The Last Exorcism*, most notably when Nell is found submerging an infant-shaped form under water, which – though only a doll – serves to foreshadow the ambiguous act of destruction with which the film concludes.

In one way or another, these exorcism narratives each identify girls as vulnerable – not only as a consequence of their maternal biology, which appears to make them ambiguously susceptible to demonic possession, but also through the disappearance of reliable mother figures and/or their own (poor) sexual choices. For Faludi, the girl has enjoyed heightened visibility in the wake of 9/11, in part as a consequence of her proneness to violation by malevolent forces. The 'girl in jeopardy', she argues, has long played a vital role in defining American masculinity: 'Without the girl [in jeopardy], the cowboy president had no one to hug, the buckskin pol had no one to protect, the urban outsider no one to rescue' (2007: 199). Given the conservative impulses that appear to be at work in these films, it is not surprising that girls are understood as 'weak links', vulnerable to forms of corruption that could destroy the world, and as the means by which the compromised ('feminized') American male can reassert his authority and seal up the fortress.

In *Gothic Romanced* (2008), Fred Botting uses Deleuze and Guattari's 'lines of flight' to analyse the 'desiring geographies' that are mapped out through the figure of the Gothic heroine (160). As Deleuze and Guattari describe it, the line of flight, or *ligne de fuite*, is not a line of escape, but a deterritorializing flow, which – in its unpredictable, 'nomadic' course – cuts across borders, unsettling organized structures, systems and spaces:

> [L]ines of flight, for their part, never consist in running away from the world but rather in causing runoffs, as when you drill a hole in a pipe;

there is no social system that does not leak from all directions, even if it makes its segments increasingly rigid in order to seal the lines of flight. (226)

Deleuze and Guattari's designation of the girl as a 'line of flight', 'the in-between, the border', which 'carrie[s] us away [...] across our thresholds, towards a destination that is unknown, not foreseeable, and not pre-existent', seems especially apt in the context of a discussion about representations of female possession. Following Brian Massumi's gloss in his Translator's Note to *A Thousand Plateaus* that 'fuite' (as in *ligne de fuite*) is 'not only the act of fleeing or eluding but also flowing, leaking, and disappearing into the distance' (xvii), the possessed girl emerges as the woefully incontinent embodiment of the 'leaky' line. Whether sweating, swearing, spitting, bleeding, blaspheming, or giving birth, her body – like the social system for which it is a metaphor – appears to 'leak from all directions'. Just as Botting discerns in his Deleuzean reading of the eighteenth-century Gothic novel a vacillation between the deterritorializing gestures enacted through the 'flight of the heroine [...] beyond the structures of paternal power' and the 'processes of reterritorialization' that accompany her eventual recuperation to 'bourgeois and domestic femininity', so the twenty-first-century exorcism narrative demonstrates a similar movement between the 'wild zone' of the girlish body, 'where femininity encounters the possibility of becoming something other' and the imposing structures of paternal authority that seek to restore order (160). Ultimately, it is the girl, through the elaborate staging of her transitioning body, who is required to facilitate the spectacle of order lost and (partially) regained on which these exorcism narratives pivot. Significantly, the nature of the order which these films seek to restore is very specific; by appearing to confirm the existence of demonic phenomena – either through the use of the 'documentary' medium (in *The Last Exorcism* and *The Devil Inside*), or through the renewed belief of a doubting priest (*The Last Exorcism* and *The Rite*) – these films also

THE RETURN OF THE REPRESSED

159

reassert the need for strong religious authorities who are willing to do battle with evil, in whatever (girlish) form it takes.

Postfeminism in peril

Like abortion, rape has been a major focus of feminist debate since the second wave's attempts to draw attention to sexual violence against women. 'From prehistoric times to the present', claims Susan Brownmiller in her landmark study *Against Our Will: Men, Women and Rape* (1975), 'rape has played a critical function. It is nothing more or less than a conscious process of intimidation by which *all* men keep *all* women in a state of fear' (15; emphasis in original). Like the spectral zones of the Gothic, permanently electrified by cross-currents of threat and apprehension, Brownmiller's world – at least as it is viewed from a postfeminist perspective – is a place of fearsome predations and unremitting peril. As one of the issues through which postfeminism developed its myopic vision of the second wave, and articulated its divergence from it, rape looms large in key works by Katie Roiphe, Naomi Wolf and Rene Denfeld. Brownmiller's fixed characterization of rape as 'the central mechanism of oppression[,] [...] something originary, something that defines relations between men and women' was famously interpreted by Roiphe in *The Morning After: Sex, Fear, and Feminism* (1993) as part of a dangerous legacy of fear that the second wave had imparted to its inheritors, a legacy which teaches young women 'to be afraid', that 'there's something out there trying to get [them]' (56, 28). In Wolf's *Fire with Fire* (1993), too, Brownmiller's inference that 'all men are rapists' is held accountable for 'clos[ing] down discussion between men and women, cloud[ing] feminist thinking about men and sexuality, and do[ing] men and women a grave injustice' (133). With another sleight of hand, Wolf argues that second wave critiques of rape exemplify the insidious strategy of 'victim feminism', which 'casts women as sexually pure and mystically nurturing, and stresses the evil done to these "good" women as a way to petition for their rights' (xvii). Situating rape

as 'a gray area' in which 'someone's rape may be another person's bad night', Roiphe uses Mary Koss's survey of sexual harassment to argue for rape as a kind of feminist chimera, claiming that 'most of the women in [Koss's] own study didn't recognize [...] they had been raped' (54–55).[10] These constructions intersect frequently with neoconservative discourses which reposition men in terms of their vulnerability to 'false' accusations of rape. As Faludi notes in *The Terror Dream*, this was made especially clear in the lurid redeployment of the feminist rhetoric of rape to discredit feminists who petitioned for reflection and calm in the aftermath of the 9/11 attacks: *Newsweek*'s Jonathan Alter found it 'ironic [that] the same people urging us not to blame the victim in rape cases are now saying Uncle Sam wore a short skirt and asked for it', while Katha Pollitt was compared by radio host Andrew Sullivan to 'someone who refuses to help a rape victim and blames her for wearing a short skirt' (28–30). Once again, then, the violation of the sexualized female body is read as a metaphor for the violation of the national body politic.

The rape motif is mobilized with predictably elaborate gratuity in postfeminist Gothic fictions like *True Blood*, *Dollhouse* and *American Horror Story*, where the violent, coercive, or extraordinary circumstances in which sex takes place compromise the individual's ability to give full or informed consent. In Joss Whedon's ill-fated *Dollhouse*, Eliza Dushku plays Echo, a young woman whose memory is wiped by a secret organization that undertakes highly-specialized 'engagements' for wealthy clients. With no recollection of who she is, Echo exists in a state of infantile, somnambulistic dependency; only when she is selected for an assignment is she reprogrammed with a personality that is tailored to suit the client's niche requirements. When the assignment is completed, Echo is returned to the 'Dollhouse' headquarters by her handler, where she undergoes a 'treatment' that erases any recollection of where she has been, who she has met and what she has experienced. Like her mythical namesake, who is doomed to speak the words of others, Echo's various identities are not forged autonomously, but are mere

imprints of other, 'real' personalities that the Dollhouse has on file – personalities which are selected and modified for use by the Dollhouse's head (male) programmer, Topher Brink (Fran Kranz).

As is clear from even the briefest description, the politics of *Dollhouse* are incredibly fraught: a young woman is entrapped by a shadowy branch of a large-scale multinational corporation and then coerced into signing a contract in which she not only agrees to have her personality wiped, but also surrenders control of her body for use in whatever schemes that corporation should choose. While *Buffy the Vampire Slayer*, Whedon's earlier show, set out to overturn the conventions of the horror movie by transforming the default 'victim' of that genre – the 'little blonde girl' – into a 'hero', *Dollhouse* appears to do the reverse by transforming its 'hero' into a 'victim'.[11] This shift is likewise registered in the distinction between the titles of the two shows: *Buffy the Vampire Slayer*, which emphasizes the agency and autonomy of its heroine, and *Dollhouse*, which focuses on the oppressive structures by which the heroine is contained. In episode after episode, Echo is hired out to men with whom she has sex. As she has been programmed to respond to, and even invite, the romantic advances of the client, this sex gives the impression of being consensual, though this 'consent' is only a chimera. Where Buffy enacted a (feminist) fantasy of female agency and autonomy, *Dollhouse* explores a murkier world of misogyny in which Echo, programmed (by a man) to follow masculine-devised scripts, engages in fantasy play (with men) that gives body to (male) fantasies about women; Echo's enslaved body is valued, but only insofar as it is a lucrative source of income for those who 'own' it.

The motif of the 'unheeded' rape, or the rape which is not (initially) identified as such, is not exclusive to *Dollhouse*. One such rape also occurs in the first episode of *American Horror Story*, when Vivien, having just had sex with Ben, her husband, for the first time since her miscarriage and his infidelity, is preparing for bed. Startled briefly by the sight of a male figure standing at the threshold to the bedroom, wearing the latex gimp suit which they earlier found in the attic, Vivien – reasonably assuming the figure to be Ben – strips

off her gown and invites the disguised figure to 'go for Round Two'. As the scene cuts to the kitchen, however, and a head-and-shoulders shot of a somnambulistic Ben holding his hand over the lit hob, it becomes apparent that Vivien's bedfellow is someone – or something – other than her husband. Returning to the bedroom, the scene unfolds with a sequence of blurry point-of-view close-ups of both Vivien and her assailant as they have sex, interspersed with shots of Ben (as Vivien imagines him in the place of seducer) and shock cuts to images of dead babies and horror-stricken faces from the grotesque mural that Vivien has been uncovering in the reception room. Though clearly out of the ordinary, this kinky sexual encounter is not mentioned again until the closing stages of the series when Vivien realizes that Ben was not the 'rubber man' with whom she had sex ('Rubber Man' 1.8). Only when it is too late does Vivien recognize that she has been raped, and even then it is dismissed as a sign of her delusional paranoia and used as a pretext to have her committed to a mental institution. When the rapist assaults Vivien for a second time, it is at the urging of Hayden, Ben's mistress, who – repeating Vivien's own words – states that the 'rubber man' wants to 'go for Round Two'. In this instance, Hayden's attempt to punish Vivien demonstrates the younger woman's troubling complicity in the violating and divisive patriarchal fantasy of generational conflict.

Where texts like *Buffy the Vampire Slayer* enacted the mode of 'free-thinking, pleasure-loving and self-assertive' (181) power feminism endorsed by Wolf in *Fire with Fire*, subsequent fictions have conformed more closely to the anxious ethic of 'victim feminism', re-identifying young women as vulnerable and in urgent need of protection. Gothic models of feminine fragility are a playful point of reference in *The Vampire Diaries* (2009–) and *True Blood*, each of which traces the supernatural adventures of an (initially) virginal protagonist, but these models are reanimated with a chilling earnestness in Stephenie Meyer's *Twilight* saga (2005–08). Meyer's series of bestselling books charts the love affair between Bella Swan, a young woman who goes to live with her father following her

mother's remarriage, and Edward Cullen, a centagenarian vampire with the appearance of a 17-year-old boy.

If, as we propose in the previous chapter, the body of the girl is regularly configured as a text, then the virginal heroine of the postfeminist Gothic is a *tabula rasa* awaiting inscription. Conforming to Sedgwick's anatomization of the eighteenth-century Gothic heroine, Bella – like Sookie Stackhouse in *True Blood* and Elena Gilbert (Nina Dobrev) in *The Vampire Diaries* – is evoked in terms of 'the white, the innocent, the pristine', beginning life as a 'blank' (1981: 261). From the opening chapter of *Twilight* (2005), the first instalment of Meyer's quadrilogy, Bella's whiteness is emphatic: her name is 'Swan'; her favourite shirt is 'white eyelet lace' (3); she is 'ivory-skinned', 'pallid' (9), 'white as a ghost' (246). In *New Moon* (2006), when Edward ends his relationship with her, Bella literally whites out into the (almost) blank pages of her diary, which are marked by nothing other than the names of the passing months (75–82). Through her whiteness, Bella renders visible the model of 'unsullied femininity (not dirtied by sex)' that Richard Dyer links to the 'cult of virginity' and the associated fantasy of the intact body (76–77). Bella is so pure, in fact, that when, in *Twilight*, Edward is required to suck vampire venom from her hand, he remarks that even her blood 'tastes clean' (398).

While shows like *True Blood* invoke the spectacle of bleeding, plundered, violated and promiscuous bodies as a means of communicating concerns about the 'leakiness' of the American body politic in the wake of 9/11, *Twilight* is less interested in exploring the body's leaks and fissures than in fetishizing its impregnability (Waters, 2012: 37). In narrative and symbolic terms, then, these books hinge on an obsessive valorization of (female) virginity; the 'power' that Meyer ascribes to Bella in the books is primarily a consequence of her unwitting attractiveness to men and the fact she maintains her status as a *virgo intacto* – albeit largely at Edward's insistence – until she is married. Thus inclined towards a strict patrolling of the female body and its borders, *Twilight* enacts a peculiarly sustained erotics of abstinence in

which sex and blood-drinking are alike notable by their relative invisibility.

The fantasy of the sealed, abstinent body is writ especially large in Meyer's re-scripting of the vampire as a creature that thrives during the day. Where most vampires are incinerated by the rays of the sun, Meyer's vampires are reflective surfaces: Edward does not combust in daylight but presents instead as the crystalline embodiment of his chaste refusal to discharge his vampiric impulses on the human population. With his 'white' skin 'sparkl[ing], like thousands of tiny diamonds were embedded in the surface', Edward is 'glistening', 'incandescent', a 'perfect statue, carved in some unknown stone, smooth like marble, glittering like crystal' (228). His 'perfection', as it is referenced across the four novels in the saga, is tethered inexorably to the apparent imperviousness of his anatomy; his body is a smooth, white, impenetrable surface, a carefully guarded, unbreachable boundary.[12] The emphatic hardness of Edward's disciplined body is thrown into relief by Meyer's insistent signalling of Bella's weak, girlish flesh. In contrast to Edward, Bella – as he keeps telling her – is eminently 'breakable' (271). By the end of the first novel, she has suffered 'a broken leg, four broken ribs, some cracks in [her] skull, bruises covering every inch of [her] skin, and [has] lost a lot of blood' (400). It is, in part, by insisting upon Bella's weakness that Edward is made strong. Suffering frequent bouts of dizziness and fainting fits, Bella is the direct descendent of the eighteenth-century Gothic heroine, whose delicacy is implicitly naturalized through its twenty-first-century recapitulation (279).

Although a textual shroud is drawn over the consummation of Bella's marriage to Edward in *Breaking Dawn* (2008), her body is used as a surface through which the sullying effects of sex might be registered. After their first sexual encounter Bella notes the 'large purplish bruises' that were 'beginning to blossom across the pale skin of [her] arm', before 'follow[ing] the trail they made up to [her] shoulder, and then down across [her] ribs' (81). During another moment of post-coital contemplation, Bella regards her naked body in the full-length mirror, apprehending first 'a faint

shadow' across her cheekbone, then her 'swollen' lips. 'The rest of me', she reveals, 'was decorated with patches of blue and purple. I concentrated on the bruises that would be hardest to hide – my arms and my shoulders. They weren't so bad. My skin marked up easily [...] I'd look even worse tomorrow' (87). Bruised rather than bleeding, Bella's body absorbs and contains the violence that is inflicted upon it. Where Grosz's discussion of the 'textualized body' proposes that the 'body's blank page' is 'incise[d]' by 'social, surgical, epistemic, [and] disciplinary' tools of inscription, Bella's body is marked from the inside out (117). Through this form of subcutaneous branding, Bella's body – no longer a 'blank page' – is overdetermined as a site of victimhood.

This victimhood, moreover, is shown to be both solicited and sanctioned by Bella herself. By agreeing to marry Edward, she is positioned as a willing victim of male violence. She appears, in fact, to not only consent to violence, but also desire it. Despite the bruises that Edward has inflicted upon her as a result of his superhuman strength, Bella basks in a 'glowing sphere of happiness' (79), later pleading with him to have sex with her again (97). Ultimately, the screened-out violence of Edward's lovemaking pales in comparison to what happens when Bella gives birth to Edward's child. Indeed, Bella is so incapacitated that the whole second section of the fourth novel, *Breaking Dawn*, is narrated by her friend, Jacob Black (whose own name inscribes his 'non-white' racial heritage). He is the one who witnesses 'Bella's body streaming with red' (320) as her half-vampire child is violently extracted:

> I heard the soft, wet sound of the scalpel across her stomach. More blood dripping on the floor. The next sound jolted through me, unexpected, terrifying. Like metal being shredded apart. [...] I glanced over to see Edward's face pressed against the bulge. Vampire teeth – a sure fire way to cut through vampire skin. [...] Edward had snatched the warm bloody thing out of [Bella's] limp arms. My eyes flickered across her skin. It was red with blood – the blood that had flowed from her mouth, the blood smeared all over the creature, and fresh

blood welling out of a tiny double-crescent bite mark just above her
left breast. (323–24)

Once deflowered, Bella's body is opened up to the vagaries of
masculine violence. Cut, bitten and torn apart by her husband in
order to deliver their child, Bella dies, leaving behind a 'broken,
bled-out, mangled corpse' that Edward 'seal[s] shut' and which
later rises again as a vampire body (326).[13] In accordance with
the nostalgic turn of post-9/11 politics, the Gothic – through its
recent resurrection of the dizzy, swooning, imperilled naïf of the
eighteenth-century romance – has retreated back into its oldest
formulations of gender identities. Still, although in this particular
permutation the postfeminist mystique appears to return the Gothic
heroine to her endangered state, as ever, its shifts and swirls present
the possibility of different re-enchantments and inscriptions,
implying – through what appears to be absent – what might one
day return.

Ghostscript

Don't let me forget.
(Carrie Matheson, 'Marine One' 1.12, *Homeland*)

'A question of repetition', writes Derrida, 'a specter is always a revenant. One cannot control its comings and goings because it *begins by coming back*' (11; emphasis in original). We have traced in this book the peculiar gusts of amnesia that sweep across the cultural landscape as well as the anachronistic models of femininity that are the lifeblood of the postfeminist mystique. Resuscitating and reanimating images and styles of femininity that belong to the past, the postfeminist mystique speculates readily and obsessively on the death of feminism. But, as Derrida conveys, '[s]peculation is always fascinated, bewitched by the specter' (57); indeed, '[s]peculation always speculates on some specter, it speculates in the mirror of what it produces, on the spectacle that it gives itself and that it gives itself to see' (183). Feminism may have lost some of its visibility in popular culture's house of mirrors, but its unsettling and unexpected ghostly returns suggest that this remains a haunted house. While the postfeminist mystique's haunting often presents as an extended exercise in nostalgia (part of an elegiac lament for a past that feminism threatened with extinction), its temporal shifts make possible a process of endless cultural recovery that might, at other times, rescue and revivify feminism itself. If the spectre is indeed the spirit of the 'future-to-come as much as a

past' (Derrida 19), then the wraithlike movements and manoeuvres of the postfeminist mystique indicate that we are not in a moment where the 'post' of postfeminism signifies feminism's 'pastness' – its disappearances or departures – but rather that we have reached the time of ghost feminism.

Discarded at certain junctures as 'dead history' (Friedan 88), feminism is a ghost that popular culture cannot lay to rest. As our investigation of the postfeminist mystique makes clear, popular moves to divest feminism of its politics – to make it again 'dead history' – establish instead the resilience of its legacy. Speculating about the role of feminism in popular memory, Imelda Whelehan wonders whether young women might soon be 'galvanised by the current atrophy of political debate', whether they will one day 'feel nostalgic for the heady days of the women's movement' (2000: 179). While nostalgia is routinely put to conservative use in popular culture – reinvigorating models of traditional femininities that feminism seemed to have laid to rest – its political possibilities, as identified by Whelehan, have recently been reawakened.

One signal raiding of feminism's archive emblematizes this reawakening. In October 2012, during the run-up to the US presidential election, Wonder Woman, golden whip in hand and bracelets gleaming, was returned to the cover of *Ms.* magazine. Towering over banners of protest against the 'war on women' and set against the backdrop of the White House, she returns as a rallying figure for women, to remind us that feminism's battles are yet to be won, that justice is yet to be enacted. By revisiting the 1940s image of Wonder Woman once again for the cover of this 40th anniversary edition, *Ms.* engenders a nostalgia for earlier feminist moments that is re-orientated towards the envisioning of feminist futures. Rekindling its earlier intimacies with Wonder Woman, the 2012 *Ms.* cover asserts – via a system of sustained intertextual referencing – the magazine's historic role as the vanguard of popular feminism, while invoking a series of anachronistic feminist 'presents' (1940s, 1970s, 2010s) in order to speculate about the role of feminism in these challenging political times. Here, then, the redeployment

of images from the past serves the radical agenda of the feminist present by mounting new feminist calls-to-arms.

If, according to Friedan, the 'feminine mystique' arises from the corpse of feminism, the postfeminist mystique reveals – inadvertently perhaps – that feminism is not 'dead history' (88), but *undead* history: its unremitting recrudescence suggests that it is not so much a ghost from the past as a revenant that keeps coming back. Feminism refuses to leave because its business remains unfinished.

Notes

Notes to Foreword

1 There is also a thematic resemblance to the cover of the fortieth anniversary edition of *Sex and the Single Girl*.
2 For further information on the *Ms.* policy of first including advertisements, their battle to get revenue and its positive and negative impacts, see Gloria Steinem's 'Sex, Lies, and Advertising' (1995).

Notes to Introduction

1 This dual sense is also emphasized by Farrell in her study of the relationship between *Ms.* magazine and popular feminism: 'In speaking of a "popular feminism", I refer to both a feminism that is widespread, common to many, and one that emerges from the realm of popular culture' (5).
2 This patriotic context was remobilized in the association between Wonder Woman and Sarah Palin during the 2008 Presidential elections. For a discussion of *Wonder Woman*'s construction of empowered womanhood 'in the service of nationalism and "the good fight" of a nation at war' see Mitra C. Emad (964).
3 This anti-feminist discourse was not unheralded. The 'bloomer costume', proposed by Amelia Bloomer, founder of the feminist newspaper *The Lily* in 1851, and adopted by dress reformers in the US, was met by ridicule and lampooning on both sides of the Atlantic. Dress reformers were not only characterized as anti-feminine in their rejection of traditional femininity, but were also pathologized. On 27 May 1876, a *New York Times* editorial described dress reform as a strange 'nervous disorder', identifying one of its most horrible symptoms as 'an abnormal and unconquerable thirst for trousers' ('A Curious Disease' 6). The pathologization of the Bloomerites anticipates the accusations of 'mental instability' levelled at post-war working

women. The transgression of sartorial norms represented by women wearing trousers was perceived as an illegitimate seizure of male authority and power that threatened the very fabric of the social order.

4 Whelehan argues that breasts and bras, 'whether we like it or not, have dogged the women's movement since the sixties just as breast imagery has invaded the mass media and advertising' (2000: 1–2), while for Hilary Hinds and Jackie Stacey, 'fetishism of the bra and the breast [...] has lasted for 30 years as a metonym for the essence of women's liberation'. This, they propose, 'suggests the depth of the preoccupation with the threat of unleashing an excessive and unconstrained feminine body as the metaphorical consequence of women's liberation'. With reference to Marina Warner's analysis of the cultural significance of the breast in *Monuments and Maidens*, Hinds and Stacey argue that 'in the myth of the bra-burner [...] the breast becomes a synecdoche for the woman; the liberated breast stands for the liberated woman, each freed from its customary constraints' (159). Media representations of the bra-burner, they continue, set to work a 'complex interplay of ambiguous connotations': 'On the one hand, bralessness reveals the contours of the "unrestrained" breast, thereby *re*sexualising it as a sign of *sexual* liberation; on the other hand, by refusing the fetishistic commodification and containment of the breast effected (symbolically and literally) by the bra, bralessness as a sign of *women's* liberation aims to *de*sexualise the breast' (160; emphasis in original). We will return to the significance of bras and breasts in the popular imagination in chapter two.

5 Blonde, youthful and attractive, Steinem had already been adopted by the mainstream media as the women's movement's 'glamour girl' (Faludi, 1991: 356). Susan Douglas, for example, recounts how Steinem 'became extremely effective as the exemplar of the new, liberated young woman; she was the compromise the news media had been looking for, a feminist who looked like a fashion model' (230). She describes Steinem's appearance on the cover of *Newsweek* on 16 August 1971 with the headline 'The New Woman'. The entire first paragraph focused on Steinem's appearance, making reference to 'her long, blond-streaked hair falling just so above each breast' and her 'most incredibly perfect body' (227). Steinem's credentials as the poster girl for popular feminism have recently been rearticulated by the casting of Sarah Jessica Parker as Steinem in the forthcoming biopic of Linda Lovelace, *Lovelace* (2013).

6 At the same time, of course, the appropriation of the iconic comic book superwoman cohered with the 'magazine's economic imperatives' and was thus consistent with the broader commercial concerns of Madison Avenue and the magazine's investors (Farrell 54). Farrell notes that the *Ms.* editors' decision to use the Wonder Woman image on the front cover was

economically savvy in that its principal investor, Warner Communications, owned National Periodical Publications, which published, and was planning the republication of, the Wonder Woman comics (54–55).

7 Predictably, perhaps, 1972 saw Wonder Woman in conflict with some rather under-nuanced opponents – for example, the 'Beauty Hater' (#200). The close of that year saw the publication of *Wonder Woman's* special 'Women's Lib' issue (#203), in which Diana Prince distances herself from the women's liberation movement and declares that 'in most cases' she does not 'even like women'.

8 Edgar writes: 'Wonder Woman had feminist beginnings, but like many of us, she went into a decline in the fifties. To celebrate her reincarnation, now in the making for publication in 1973, *Ms.* presents one of the originals here; the true forties version of how *WW* came to America' (Edgar 52).

9 This tension between the world of comic books and feminism has resurfaced in the wake of recent controversies about DC Comics' New 52 Reboot, in which the (very few) female characters who have their own titles have been raunchily re-costumed and rewritten (see Taylor). The rebooted *Wonder Woman*, initially viewed as one of the strongest of the New 52 titles, has been subject to increasing criticism as a result of changes to Wonder Woman's personal history. Originally forged from clay and brought to life as an Amazonian warrior princess by the power of the gods, she is recast in the New 52 as the daughter of Zeus and her bracelets are worn in order to keep the power she has inherited from her father in check.

10 This term is drawn from Gilles Deleuze and Félix Guattari's *A Thousand Plateaus* (1980). We draw on its implications at more length in the chapters which follow.

11 The text's popularity might partly be attributed to its flirtation with the detective and Gothic genres and specifically its language of investigation. Peter Knight, for example, points out that 'in many places the book reads like a thriller, with Friedan the lone detective chasing up the clues to the mysterious mystique' (118).

12 As we acknowledge in chapter three, there are earlier precedents for this; Virginia Woolf's 'Professions for Women' (1931), for example, charts the author's ghostly encounter with the anachronistic figure of the Victorian 'Angel in the House'.

13 See Faludi (1991) and Hollows (2006).

14 We return to bell hooks's critique of Friedan's *The Feminine Mystique* in chapter three. For more on the 'nostalgia for whiteness' see McRobbie (2009: 41–43).

Notes to Chapter 1

1 For a discussion of the relationship between postfeminism and third wave feminism see Gillis and Munford (2004).

2 Faludi points out, for example, that Elizabeth Cady Stanton's most popular speech was 'Our Girls', addressed to American daughters, while her daughter, Harriet Stanton Blatch, played an instrumental role in the revitalization of suffrage (35).

3 As Alan Baddeley explains in *Essentials of Human Memory*, '[a]mnesia is a general term meaning temporary or permanent impairment of some part of the memory system. [...] Hysterical amnesia [...] may involve forgetting an intensely stressful experience or even forgetting who one is'. In addition, he claims, it 'is almost always associated with a need, conscious or unconscious, to escape from intolerable anxiety, and it is usually temporary – in due course there is a return to a normal state of memory' (219).

4 As well as a statement of disidentification and self-individuation, Madonna's 'She's Not Me' might also be a rallying cry against the timeworn tendency to understand female relationships in terms of matrilineal inheritance and intergenerational tension.

5 In addition to replicating Madonna's own 'Like A Virgin'-era belt, 'Boy Toy' is also the name of one of Madonna's production companies.

6 Such returns are usefully illuminated in Simon Reynolds' *Retromania* (2011), which explores contemporary popular culture's 'addiction to its own past'. Locating 'retro' in 'the intersection between mass culture and personal memory', Reynolds points to its obsession with 'the relatively immediate past, [with] stuff that happened in living memory', which it 'seeks to be amused and charmed by'. For Reynolds, popular culture's playful relationship to its own past 'is related to the fact that retro is actually more about the present than the past it appears to revere and revive. It uses the past as an archive of materials from which to extract subcultural capital [...] through recycling and recombining: the bricolage of cultural bric-a-brac' (xxx–xxxi).

Notes to Chapter 2

1 Like Whelehan, Susan Douglas foregrounds the contradictory implications of Brown's single girl for the formation of a feminist consciousness: 'Now, I don't want to hold Helen Gurley Brown up as some paragon of feminism, since the bottom line of her message has always been the absolute importance of pleasing men. But looking at her book, thirty years later, with all its fatuous advice about buying wigs, bleaching leg hair, and making "chloroform

cocktails" (coffee, ice cream, and a fifth of vodka), we see some startling stirrings of female liberation' (68).

2 This desire to expand the marriage market is signalled from the very opening of the text in Brown's confessional declaration: 'I married for the first time at thirty-seven. I got the man I wanted. It *could* be construed something of a miracle considering how old *I* was and how eligible *he* was. [...] But *I* don't think it's a miracle that I married my husband. I think I deserved him! For seventeen years I worked hard to become the kind of woman who might interest him. And when he finally walked into my life I was just worldly enough, financially secure enough (for I also worked hard at my job) and adorned with enough glitter to attract him' (3–4; emphasis in original).

3 In a later discussion of prime-time television and feminism, Dow describes how the 'legacy' of *The Mary Tyler Moore Show*'s lifestyle feminism lives on in television shows of the 1990s and, most particularly, *Ally McBeal* (2002: 259).

4 'Such models', writes Suzanne Leonard, 'are predicated [...] on the idea that, although the postfeminist working girl benefits from a legacy of feminist critique over the issues of marriage and work, for her these debates have little historical specificity or urgent import' (104). Moreover, these depictions tend to make invisible the material conditions of the postfeminist working girl's actual work, focusing instead on the 'dramatic, psychological, romantic, or sensationalized aspects of her laboring' (104).

5 She observes at the beginning of the first episode that: 'There are thousands, maybe tens of thousands of women like this in the city. We all know them, and we all agree they're great. They travel, they pay taxes. They'll spend $400 on a pair of Manolo Blahnik strappy sandals. And they're alone. It's like the riddle of the sphinx: why are there so many great, unmarried women, and no great, unmarried men?' ('Sex and the City' 1.1).

6 In her reading of Peggy's negotiation of professional roles, Tonya Krouse makes a brief but pertinent reference to Joan Riviere's notion of the masquerade and, in particular, her assertion that 'women who wish for masculinity may put on a mask of womanliness to avert anxiety and the retribution feared by men' (qtd in Krouse 197).

7 This schizophrenic position is itself a product of industrial late capitalism and the conflicting identities it requires us to inhabit. For more on the conjunctions of capitalism and schizophrenia, see Deleuze and Guattari (1980).

8 The proximity of sex and work in the series' delineations of professional femininity are fully realized in series five when Joan agrees to sleep with Herb Rennet (Gary Basaraba), the dealer manager of Jaguar, in exchange for his support of the agency's bid for the company's campaign ('The Other Woman' 5.11).

FEMINISM AND POPULAR CULTURE

9 We return to electroconvulsive therapy and the re-education of the working girl in chapter four.

10 A similar narrative arc is extended across the ABC television series *Men in Trees*, which stars Anne Heche as New York-based relationship guru Marin Frist. Marin decides to stay in Elmo, a remote Alaskan town and the latest stop on her book tour, after she discovers her fiancé is being unfaithful. In Elmo, where the ratio of men to women is ten to one, Marin redefines her goals and uses her experiences in small-town America as inspiration for a new book about men. With the encouragement of her editor, Marin is able to carve out a career that enables her to lend fresh attention to her home and develop the kinds of relationships that were apparently foreclosed to her as a professional woman working in the city.

11 In line with feminism's co-option by the discourses of neoliberalism, the 'elements of feminism' that Hollows discerns within postfeminist representations of rural femininities are closely associated with free enterprise and consumerism, speaking to the long-standing entanglement of feminism and consumer culture that we outline in the Introduction.

Notes to Chapter 3

1 If the *Real Housewives of...* series showcases the home (and the housewife) as glamorous sites of order and abundance, then *How Clean is Your House?* (2003–09), *Supernanny* (2004–11), *Anthea Turner: Perfect Housewife* (2006–07), *Help! My House is Falling Down* (2010–11) and *The Hoarder Next Door* (2012) conjure up dystopian visions in which the home is presented as a potentially toxic environment in urgent need of expert management. For a more detailed discussion of the toxic home see Hunt 23–34.

2 McRobbie contends that '[e]lements of feminism have been taken into account, and have been absolutely incorporated into political and institutional life'. As she goes on to note, 'these elements are then converted into a much more individualistic discourse' that 'acts as a substitute for feminism' (2009: 1).

3 These manuals are indicative of the extent to which homemaking is perceived to have disappeared from the purview of young women. For the generations of middle-class women who have come of age in the wake of second wave feminism, after all, the professional sphere, rather than the home, is most likely to have been the focus of their aspirations. For these women, the appeal of domesticity – with its rhythms and routines – has not necessarily been dulled through familiarity, as it was for some of their foremothers: as Gaby Hinsliff observes in *Half a Wife* (2012), '[t]he last thing a woman wants for Christmas if she spends her days doing housework is a chintz-clad ironing board' (32).

When home is a place from which one is all too often absent, however, its lure becomes all the more powerful; in this context, a prettified ironing board or a designer cake stand can function as the means by which working women buy into domesticity, signalling an emotional – not to mention financial – investment in the nurturing tasks that they have too little time to undertake. Given the gender-coded design of prestige homeware, from the retro-floral patterning of Cath Kidston's dust cloths to Nigella Lawson's ovoid mixing bowls, there can be little doubt about its intended market. So feminized is it, in fact, that it materializes those whispered injunctions, embedded in the cultural texts with which we are concerned in this chapter, calling women back to the home.

4 Charlotte's decision is only validated by the other women in the cinematic afterlife of the television series. In *Sex and the City 2* (2010), it is revealed that the career-focused Miranda – to whom Charlotte once defended her right to choose – has resigned from her job as a lawyer in order to spend more time with her husband and son at their Brooklyn home.

5 For a further discussion of Bree and camp see Richardson (2006).

6 It is interesting that this querying of feminist priorities is articulated by Glenn Close, who is famed for her on-screen portrayals of indomitable women, including Alex Forrest in *Fatal Attraction* (1987), the Marquise de Merteuil in *Dangerous Liaisons* (1988), and Patty Hewes in the FX television drama *Damages*.

7 In *American Horror Story*, too, Vivien's decision to hire a housekeeper (Frances Conroy/Alexandra Breckenridge) marks the beginning of her family's persecution within the Los Angeles home to which she, her husband and her daughter move in the wake of various personal tragedies. While Vivien initially busies herself restoring parts of the family home to their original 1920s splendour, her activity around the house decreases as Moira, the housekeeper, takes over the cleaning and the cooking, working for free when the Harmons encounter financial difficulties. Towards their teenage daughter, Violet, both Vivien and her husband, Ben, adopt a 'policy of benign neglect' ('Open House' 1.7), failing to realize when she commits suicide in her bedroom ('Piggy Piggy' 1.6). In each of these texts, the home is rendered unstable as soon as the efficiency and dedication of the female homemaker is set in doubt.

Notes to Chapter 4

1 Sarah Projansky similarly identifies a 'long-standing tradition of focusing cultural attention on girls as problems, as victims of social ills, as symbols of ideal citizenship, and as all-round fascinating figures' (2007: 42).

2 For further discussion of the figure of the girl and 'becoming' see Driscoll (191–99).

3 As Derrida suggests, the spectre too is a 'becoming-body, a certain phenomenal and carnal form of the spirit' (5).

4 For more on Riot Grrrl see Feigenbaum (2007).

5 Sherrie A. Inness, in her introduction to *Action Chicks: New Images of Tough Women in Popular Culture* (2004), points out that the 'tough woman' can be traced back beyond Wonder Woman and Rosie the Riveter to Calamity Jane and Annie Oakley's performances in dime Westerns (2).

6 The series arose from the 'dead' body of Joss Whedon's film of the same name, released in 1992.

7 A particularly prominent strand of third wave feminism, Girlie feminists locate 'girlishness' as central to a feminist politics of agency and resistance. According to Baumgardner and Richards, 'Girlies are adult women, usually in their mid-twenties to late thirties, whose feminist principles are based on a reclaiming of girl culture (or feminine accoutrements that were tossed out with sexism during the Second Wave), be it Barbie, housekeeping, or girl talk' (400). Girlie celebrates the trappings of traditional femininity not only to abjure patriarchal definitions of femininity, but to challenge the perceived inflexibility of second wave identity politics.

8 In this respect, girl power typifies a postfeminist sensibility that fails to consider 'the implications of expressing choice largely in the realm of the sexualized body, normative femininity, and consumer culture' (Karlyn 27).

9 For example, in 'Teacher's Pet' (1.4) the substitute biology teacher Miss French turns out to be a She-Mantis luring young boys for her reproductive pleasure. See also representations of Catherine in 'Witch' (1.3) and the mummy in 'Inca Mummy Girl' (2.4).

10 'Low, hidden, earthly, dark, material, immanent, visceral. As bodily metaphor, the grotesque cave tends to look like (and in the most gross metaphorical sense be identified with) the cavernous anatomical female body. […] Blood, tears, vomit, excrement – all the detritus of the body that is separated out and placed with terror and revulsion (predominantly, though not exclusively) on the side of the feminine – are down there in that cave of abjection' (Russo 1–2).

11 Contemporary representations of the intelligent woman as an aberrant or unruly figure have a precedent in the depiction of Special Agent Dana Scully in *The X-Files* (1993–2002), the cult American conspiracy series that was relentlessly concerned with female bodies and, especially, questions of impregnation and the reproductive body. Although Scully is positioned as an adult woman, both in terms of her professional experience and her styling, her characterization is partly aligned with teen expressions of girl

identity. Driscoll, for example, highlights the series' preoccupation with the 'innocence/knowledge boundary articulated by a girl' and 'insistent reference to institutional narratives of faith and doubt' (234). The representation of Scully is especially significant insofar as it provides a touchstone for portrayals of the intellectual woman – marking a shift away from popular representations of women's dangerous bodies (bodies that transgress but ultimately reaffirm traditional gender ideologies) to representations of women's dangerous minds.

12 Representations of the intellectual girl as a monstrous and undisciplined figure might be interpreted in relation to what Jessica Ringrose describes as the 'postfeminist panic' over female success prompted by the discourse of girl power (12–27).

13 Aired on ABC in September 2011, just a couple of weeks after the 9/11 terrorist attacks, *Alias* makes an early attempt to register the corresponding shifts in the collective American psyche. With its stylish and muscular ass-kicking heroine, Sidney Bristow was quickly located, alongside Buffy and Xena, in the lineage of 'Athena's daughters: strong, intelligent, heroic warriors who defend the right as they see right' (Wilcox ix). Sidney is a graduate English student who is recruited by SD6, which she believes to be a black ops division of the CIA. Upon her discovery of SD6's true identity, she becomes, like her father, a double agent for the CIA. *Alias* paved the way for several new series that have contextualized the aftermath of 9/11 in terms of girls' loyalty to their fathers, most notably in the depiction of Amanda Clarke (Emily VanCamp) in *Revenge* (2011–).

14 This 'girling' is emphasized by the casting of Claire Danes, who played the intelligent if melancholic teenager Angela Chase in the popular but short-lived series *My So-Called Life* (1994–95).

15 The notion of the 'enemy within' reawakens strains of Cold War domestic anti-communism and anxieties about gender roles that are discussed by Faludi in *The Terror Dream*.

16 For more on Thelonius Monk see Kelly (2009).

17 Plath's haunting presence in the series telegraphs the mental states and collapses of its 'mad women'. The evocation of 'The Hanging Man' also foreshadows Lane Pryce (Jared Harris) committing suicide by hanging himself in 'Commissions and Fees' (5.12).

Notes to Chapter 5

1 According to Freud, repression is an unconsciously motivated mechanism for forgetting; in repression, then, 'intolerable idea[s]' are expunged from conscious thought in order to protect the psychic integrity of the subject

and maintain his or her 'proper functioning'. Once repressed, however, the 'unwanted material' does not go away, but instead 'acts like a foreign body which, long after its entry, must continue to be regarded as an agent that is still at work' (1957: 2). Hidden but active, the 'foreign body' is transformed in the unconscious before returning, incognito, in the form of a (hysterical) symptom.

2 For a more thoroughgoing analysis of Moers' 'Female Gothic', its potential limitations and its critical influence, see Andrew Smith and Diana Wallace.

3 For Elaine Showalter, 'the critical theorization of the Female Gothic as a genre that expressed women's dark protests, fantasies, and fear' was '[o]ne of the earliest critical manifestations of the change in consciousness that came out of the women's liberation movement of the late 1960s' (1991: 127).

4 By regulating female sexuality, explained Gloria Steinem, men strived to seize ownership of 'the most basic means of production – the means of reproduction' (1987: 49).

5 According to Susan Wolstenholme, 'Gothic-marked narratives always point to the space where the absent mother might be' (151), while Claire Kahane highlights the female Gothic fascination with 'the spectral presence of a dead-undead mother, archaic and all-encompassing, a ghost signifying the problematics of femininity which the heroine must confront' (336).

6 This is certainly true in the short-lived teen Gothic series *Point Pleasant* (2005), in which a mysterious girl, Christina, is dragged from the sea during a ferocious storm and taken to the family home of the local doctor, Ben Kramer. Although her first words are 'Where am I?', the question with which she grows increasingly preoccupied is 'Where am I *from*?'. When she is asked how her father can be contacted, Christina can only respond 'I don't remember'. Her mother, likewise, is little more than a distant memory: 'I don't have [a mother]. I mean, I have one, obviously, but I don't know her' ('Pilot' 1.1). Christina's failure to remember – or to know – her parents becomes a more pressing concern as she starts to exhibit deadly telekinetic powers that she suspects are linked to her mysterious origins.

7 This perhaps invites consideration alongside attempts to reclassify 'rape' as 'forcible rape' in order to minimize the number of women who would qualify for abortions under proposed new legislation.

8 In some of these fictions the decision not to abort is made at a narrative level, when the character in question discovers she is not pregnant. One of the few exceptions to this is the abortion storyline in *Six Feet Under*, in which Claire (Lauren Ambrose), made pregnant by her college boyfriend, has a termination without any apparent negative consequences. It is worth mentioning, however, that *Six Feet Under* was aired on the subscription-only channel HBO, and thus not reliant on the approval and endorsement of its

sponsors. While 'Vagina Panic' (1.2), an early episode of *Girls* (also aired on HBO), appears to resolve the abortion question in a fairly conventional manner (with the timely discovery that Jessa [Jemima Kirke] is not pregnant), the series otherwise punctures many of the taboos that structure the treatment of abortion in other television fictions. Hannah (Lena Dunham) comments at the start of the episode that 'people say [abortion] is a huge deal, but how big a deal are these things actually? [...] What was [Jessa] going to do [...] have a baby and, you know, take it to her babysitting job? It's just not realistic.' This 'realistic' approach to abortion is reflected further in the selection of the abortion clinic as the episode's main venue, as well as in the characters' repeated use of the word 'abortion' in place of the euphemistic synonyms favoured by other shows.

9 This particular monstrous pregnancy invites consideration alongside *Rosemary's Baby* (1968). The female obstetrician even suggests, in response to Vivien's query about whether the ultrasound scan showed 'hooves', that 'every pregnant woman worries if they've got a little devil in them' ('Open House' 1.7).

10 For Sarah Projansky, 'popular culture texts that discuss rape in the context of feminism claim there is a "murkiness" surrounding rape, and they blame that murkiness (at least in part) on feminism' (2001: 92).

11 In *Dollhouse*, the role of Echo is played by Eliza Dushku, who was previously cast as the confident, sexually assured slayer, Faith, in *Buffy the Vampire Slayer*.

12 This equation is further galvanized through the visual coding of Robert Pattison's body in the film series.

13 Shaped by contemporary social concerns, the *Twilight* franchise's glorification of abstemious behaviour, alongside its pro-heterosexual, pro-marriage, pro-family messages, is consistent with the Bush administration's endorsement of abstinence-only education and its injection of huge sums of money into related pedagogical initiatives (see Valenti 111–13).

Bibliography

Books, Journals, Newspaper and Online Sources

'A Curious Disease'. *New York Times* (27 May 1876): 6.

Arthurs, Jane. '*Sex and the City* and Consumer Culture: Remediating Postfeminist Drama'. *Feminist Media Studies* 3.1 (2003): 83–98.

Bachelard, Gaston. *The Poetics of Space*. Boston: Beacon, 1994.

Baddeley, Alan. *Essentials of Human Memory*. Hove: Psychology Press, 1999.

Baker, Katie J. M. 'The Official Guide to Legitimate Rape'. *Jezebel* (20 August 2012): <http://jezebel.com/5936160/the-official-guide-to-legitimate-rape>. Accessed: 20 February 2013. 27 paras.

Baudelaire, Charles. 'The Painter of Modern Life'. 1863. *The Painter of Modern Life and Other Essays*. Trans. and ed. Jonathan Mayne. 2nd edn. London: Phaidon Press, 1995. 1–41.

Baumgardner, Jennifer, and Amy Richards. *Manifesta: Young Women, Feminism, and the Future*. New York: Farrar, Straus and Giroux, 2000.

Beauvoir, Simone de. *The Second Sex*. 1949. Trans. and ed. H. M. Parshley. London: Pan-Picador, 1988.

Bean, Kellie. *Post-Backlash Feminism: Women and the Media Since Reagan-Bush*. Jefferson, North Carolina: McFarland and Co., 2007.

Becker, Susanne. *Gothic Forms of Feminine Fictions*. Manchester: Manchester University Press, 1999.

Bellafante, Ginia. 'Bewitching Teen Heroines'. *Time* (5 May 1997): 82–84.

———. 'Feminism: It's All About Me!' *Time* (29 June 1998): 54–62.

Benjamin, Walter. *Charles Baudelaire: A Lyric Poet in the Era of High Capitalism*. Trans. Harry Zohn. London: Verso, 1973.

Bolotin, Susan. 'Voices from the Post-Feminist Generation'. *New York Times Magazine* (17 October 1982): 28+.

Botting, Fred. *Gothic Romanced: Consumption, Gender and Technology in Contemporary Fictions*. London: Routledge, 2008.

Bowlby, Rachel. *Feminist Destinations: Further Essays on Virginia Woolf.* Edinburgh: Edinburgh University Press, 1997.

Brabon, Benjamin A., and Stéphanie Genz. 'Introduction: Postfeminist Gothic'. *Gothic Studies* 9.2 (2007): 1–6.

Brooks, Ann. *Postfeminisms: Feminism, Cultural Theory and Cultural Forms.* London: Routledge, 1997.

Brown, Helen Gurley. *Sex and the Single Girl.* 1962. Port Lee: Barricade Books, 2003.

Brown, Lori A. *Feminist Practices: Interdisciplinary Approaches to Women in Architecture.* Surrey: Ashgate, 2011.

Brownmiller, Susan. *Against Our Will: Men, Women and Rape.* New York: Simon and Schuster, 1975.

Brunsdon, Charlotte. 'Feminism, Postfeminism, Martha, and Nigella'. *Cinema Journal* 44.2 (2005): 110–16.

———. *Screen Tastes: Soap Opera to Satellite Dishes.* London: Routledge, 1997.

Bruzzi, Stella, and Pamela Church Gibson. 'Fashion is the Fifth Character: Fashion, Costume and Character in *Sex and the City*'. *Reading* Sex and the City. Ed. Kim Akass and Janet McCabe. London and New York: I.B.Tauris, 2004. 115–29.

Buse, Peter, and Andrew Stott. 'Introduction: A Future for Haunting'. *Ghosts: Deconstruction, Psychoanalysis, History.* Ed. Peter Buse and Andrew Stott. Basingstoke: Palgrave, 1999. 1–20.

Buse, Peter, Ken Hirschkop, Scott McCracken and Bertrain Taite. *Benjamin's Arcades: An Unguided Tour.* Manchester: Manchester University Press, 2005.

Bushnell, Candace. *Sex and the City.* New York: Warner, 1996.

Butler, Judith. *Antigone's Claim: Kinship Between Life and Death.* New York: Columbia University Press, 2000.

Byers, Michele. 'Constructing Divas in the Academy: Why the Female Graduate Student Emerges in Prime-Time Television Culture'. *Higher Education Perspectives* 1 (1996/97): 99–118.

Castle, Terry. *The Apparitional Lesbian.* New York: Columbia University Press, 1995.

Certeau, Michel de. *The Practice of Everyday Life.* Trans. Steven Rendall. Berkeley and Los Angeles: University of California Press, 1984.

Chesler, Phyllis. *The Death of Feminism: What's Next in the Struggle for Women's Freedom.* Basingstoke: Palgrave, 2006.

Clery, E. J. *Women and Gothic: From Clara Reeve to Mary Shelley.* Tavistock: Northcote House, 2000.

Cohen, Marcia. *The Sisterhood: The Inside Story of the Women's Movement and the Leaders Who Made it Happen.* Santa Fe: Sunstone Press, 2009.

Condit, Celeste Michelle. *Decoding Abortion Rhetoric: Communicating Social Change.* Champaign, Illinois: University of Illinois Press, 1994.

Daugherty, Anne Millard. 'Just a Girl: Buffy as Icon'. *Reading the Vampire Slayer: An Unofficial Critical Companion to Buffy and Angel.* Ed. Roz Kaveney. London: Tauris Parke, 2002. 148–65.

DeLamotte, Eugenia C. *Perils of the Night: A Feminist Study of Nineteenth-Century Gothic.* New York: Oxford University Press, 1989.

Deleuze, Gilles, and Félix Guattari. *A Thousand Plateaus: Capitalism and Schizophrenia.* 1980. Trans. Brian Massumi. London: Continuum, 2004.

Denfeld, Rene. *New Victorians: A Young Woman's Challenge to the Old Feminist Order.* London: Simon and Schuster, 1995.

Derrida, Jacques. *Specters of Marx.* 1993. Trans. Peggy Kamuf. London: Routledge, 1994.

Detloff, Madeline. 'Mean Spirits: The Politics of Contempt Between Feminist Generations'. *Hypatia* 12.3 (Summer 1997): 76–99.

Dillon, Sarah. *The Palimpsest.* London: Continuum, 2007.

di Mattia, Joanna. '"What's the Harm in Believing?": Mr Big, Mr Perfect, and the Romantic Quest for *Sex and the City's* Mr Right'. *Reading* Sex and the City. Ed. Kim Akass and Janet McCabe. London: I.B.Tauris, 2004. 17–32.

Dinnerstein, Dorothy. *The Mermaid and the Minotaur.* New York: Harper and Row, 1976.

Douglas, Mary. *Natural Symbols: Explorations in Cosmology.* New York: Pantheon, 1982.

Douglas, Susan. *Where the Girls Are: Growing up Female with the Mass Media.* New York: Random House, 1995.

Dow, Bonnie. '*Ally McBeal*, Lifestyle Feminism, and the Politics of Personal Happiness'. *The Communication Review* 5 (2002): 259–64.

———. *Prime-Time Feminism: Television, Media Culture, and the Women's Movement since 1970.* Philadelphia: University of Pennsylvania Press, 1996.

Driscoll, Catherine. *Girls: Feminine Adolescence in Popular Culture and Cultural Theory.* New York: Columbia University Press, 2002.

Dyer, Richard. *White: Essays on Race and Culture.* New York and London: Routledge, 1997.

Echols, Alice. *Daring to Be Bad: Radical Feminism 1967–1975.* Minneapolis: University of Minnesota Press, 1989.

Edgar, Joanne. 'Wonder Woman Revisited'. *Ms.* 1.1 (July 1972): 52–55.

Edgerton, Gary R., and Katherine C. Edgerton. 'Pathologizing Post-9/11 America in *Homeland*: Private Paranoia, Public Psychosis'. *Critical Studies in Television* 7.1 (2012): 89–92.

Edgerton, Jeremy G. '"Smoke Gets in Your Eyes": Historicizing Visual Style in *Mad Men.*' Mad Men: *Dream Come True TV.* Ed. Gary R. Edgerton. London: I.B.Tauris, 2011. 55–71.

Edwards, Tamala M. 'Who Needs a Husband?' *Time* 156.9. (5 July 2007 [first published 28 August 2000: 46–53]): <http://www.time.com/time/magazine/article/0,9171,997804,00.html>. Accessed: 30 July 2010. 31 paras.

Elfving, Taru. 'Haunted: Writing with the Girl'. *Girls! Girls! Girls! In Contemporary Art*. Ed. Catherine Grant and Lori Waxman Butler. Bristol: Intellect, 2011. 107–24.

Emad, Mitra C. 'Reading Wonder Woman's Body: Mythologies of Gender and Nation'. *The Journal of Popular Culture* 39.6 (2006): 954–84.

Faludi, Susan. 'American Electra: Feminism's Ritual Matricide'. *Harper's Magazine* (October 2010): 29–42.

———. *Backlash: The Undeclared War on American Women*. New York: Doubleday, 1991.

———. *The Terror Dream: Fear and Fantasy in Post-9/11 America*. New York: Metropolitan Books, 2007.

Farrell, Amy Erdman. *Yours in Sisterhood: Ms. Magazine and the Promise of Popular Feminism*. Chapel Hill and London: University of North Carolina Press, 1998.

Farrell-Beck, Jane, and Colleen Gau. *Uplift: The Bra in America*. Philadelphia: University of Pennsylvania Press, 2002.

Feigenbaum, Anna. 'Remapping the Resonances of Riot Grrrl: Feminisms, Postfeminisms, and "Processes" of Punk'. *Interrogating Postfeminism: Gender and the Politics of Popular Culture*. Ed. Yvonne Tasker and Diane Negra. Durham and London: Duke University Press, 2007. 132–52.

Fields, Jill. *An Intimate Affair: Women, Lingerie, and Sexuality*. Berkeley: University of California Press, 2007.

Fielding, Helen. *Bridget Jones's Diary*. London: Picador, 1996.

Firestone, Shulamith. *The Dialectic of Sex: The Case for Feminist Revolution*. New York: Bantam, 1970.

Fleenor, Juliann E. 'Introduction'. *The Female Gothic*. Ed. Juliann E. Fleenor. Montréal: Eden Press, 1983. 3–28.

Fouz-Hernández, Santiago, and Freya Jarman-Ivens, eds. *Madonna's Drowned Worlds: New Approaches to her Cultural Transformations, 1983–2003*. Aldershot: Ashgate, 2004.

Freud, Sigmund. 'Repression'. 1915. Trans. C.M. Baines and James Strachey. *The Standard Edition of the Complete Psychological Works of Sigmund Freud*. Vol. 14. London: Hogarth Press, 1957. 141–158.

———. 'The Uncanny'. 1919. Trans. James Strachey. *Writing on Art and Literature*. Stanford: Stanford University Press, 1997. 193–233.

Freud, Sigmund, and Josef Breuer. *Studies in Hysteria*. 1895. Trans. James Strachey. *The Standard Edition of the Complete Psychological Works of Sigmund Freud*. Vol. 2. London: Hogarth Press, 1953–74.

Friedan, Betty. *The Feminine Mystique*. 1963. London: Penguin, 1965.

Fry, Stephen. 'Lady Gaga Takes Tea with Mr. Fry'. *Financial Times* (27 May, 2011): <http://www.ft.com/cms/s/2/0cca76f0-873a-11e0-b983-00144feabdc0.html#axzz2LpPNzzXR>. Accessed: 20 February 2013. 55 paras.

Fukuyama, Francis. *The End of History and the Last Man.* New York and London: Free Press, 2006.

Genz, Stéphanie. *Postfemininities in Popular Culture.* Basingstoke: Palgrave Macmillan, 2009.

Gerhard, Jane. 'Carrie Bradshaw's Queer Postfeminism'. *Feminist Media Studies* 5.1 (2005): 37–49.

Gill, Rosalind. *Gender and the Media.* Cambridge: Polity, 2007.

———. 'Sexism Reloaded, or, it's Time to get Angry Again!'. *Feminist Media Studies* 11.01 (2011): 61–71.

Gillis, Stacy, and Rebecca Munford. 'Genealogies and Generations: The Politics and Praxis of Third Wave Feminism'. *Women's History Review* 13.2 (2004): 165–82.

Gorton, Kristin. '(Un)fashionable Feminists: The Media and Ally McBeal'. *Third Wave Feminism: A Critical Exploration.* Ed. Stacy Gillis, Gillian Howie and Rebecca Munford. 2nd rev. edn. Basingstoke: Palgrave, 2007. 212–23.

Greer, Germaine. *The Female Eunuch.* 1970. London: Flamingo Modern Classic, 1993.

Grosz, Elizabeth. *Volatile Bodies: Toward a Corporeal Feminism.* Bloomington: Indiana University Press, 1994.

Guilbert, Georges-Claude. *Madonna as Postmodern Myth: How One Star's Self-construction Rewrites Sex, Gender, Hollywood, and the American Dream.* Jefferson, N.C. and London: McFarland, 2002.

Hanson, Helen. *Hollywood Heroines: Women in Film Noir and the Female Gothic Film.* London: I.B.Tauris, 2007.

Haralovich, Mary Beth. 'Women on the Verge of the Second Wave'. Mad Men: *Dream Come True TV.* Ed. Gary R. Edgerton. London: I.B.Tauris, 2011. 159–76.

Harris, Anita. *Future Girl: Young Women in the Twenty-First Century.* New York: Routledge, 2004.

Harvey, David. *The Condition of Postmodernity: An Enquiry into the Origins of Cultural Change.* Oxford: Blackwell, 1997.

Heggie, Vanessa. '"Legitimate rape" – a medieval medical concept'. *The Guardian* (20 August 2012): <http://www.guardian.co.uk/science/the-h-word/2012/aug/20/legitimate-rape-medieval-medical-concept>. Accessed: 8 November 2012. 12 paras.

Helford, Elyce Rae. 'Introduction'. *Fantasy Girls: Gender in the New Universe of Science Fiction and Fantasy Television.* Ed. Elyce Rae Helford. Lanham: Rowman & Littlefield, 2000. 1–12.

Henry, Astrid. *Not My Mother's Sister: Generational Conflict and Third-Wave Feminism*. Bloomington: Indiana University Press, 2004.

'HerStory: 1971-Present'. *Ms. Magazine*. <http://www.msmagazine.com/about.asp>. Accessed: 12 October 2010. 14 paras.

Hesford, Victoria. 'Feminism and its Ghosts: The Spectre of the Feminist-as-Lesbian'. *Feminist Theory* 6.3 (2005): 227–50.

Heywood, Leslie, and Jennifer Drake. 'Introduction'. *Third Wave Agenda: Being Feminist, Doing Feminism*. Ed. Leslie Heywood and Jennifer Drake. Minneapolis: University of Minnesota Press, 1997. 1–20.

Hinds, Hilary, and Jackie Stacey. 'Imaging Feminism, Imaging Femininity: The Bra-Burner, Diana, and the Woman Who Kills'. *Feminist Media Studies* 1.2 (2001): 153–77.

Hinsliff, Gaby. *Half a Wife*. London: Chatto and Windus, 2012.

Hoeveler, Diane Long. *Gothic Feminism: The Professionalization of Gender from Charlotte Smith to the Brontës*, Liverpool: Liverpool University Press, 1998.

Hogeland, Lisa. *Feminism and its Fictions: The Consciousness-Raising Novel and the Women's Liberation Movement*. Philadelphia, PN: University of Pennsylvania, 1998.

Hollows, Joanne. 'Can I go Home Yet? Feminism, Post-feminism and Domesticity'. *Feminism in Popular Culture*. Ed. Joanne Hollows and Rachel Moseley. London: Berg, 2006. 97–118.

hooks, bell. *Feminist Theory: From Margin to Center*. 1984. Cambridge, Mass.: South End Press, 2000.

Hooper, Ruth. 'Flapping Not Repented Of'. *New York Times* (16 July 1922): 13.

Hopkins, Susan. *Girl Heroes: The New Force in Popular Culture*. London: Pluto Press, 2002.

Hunt, Anna. 'Domestic Dystopias: *Big Brother*, *Wife Swap* and *How Clean is Your House?*' *Feminism, Domesticity and Popular Culture*. Ed. Stacy Gillis and Joanne Hollows. Oxford and New York: Routledge, 2009. 123–34.

Hurley, Kelly. *The Gothic Body: Sexuality, Materialism and Degeneration at the Fin de Siècle*. Cambridge: Cambridge University Press, 2004.

Huyssen, Andreas. *Present Pasts: Urban Palimpsests and the Politics of Memory*. Stanford: Stanford University Press, 2003.

———. *Twilight Memories: Marking Time in a Culture of Amnesia*. London: Routledge, 1995.

Inness, Sherrie A., '"Boxing Gloves and Bustiers": New Images of Tough Women'. *Action Chicks: New Images of Tough Women in Popular Culture*. Basingstoke: Palgrave, 2004. 1–17.

Irigaray, Luce. *Thinking the Difference*. London: Routledge, 1994.

Jacobus, Mary. 'Madonna: Like a Virgin, or, Freud, Kristeva, and the Case of the Missing Mother'. *The Oxford Literary Review* 81–2 (1986): 35–50.

Jaco, Charles. Interview with Todd Akin. *The Jaco Report.* Fox 2 (19 August 2012): <http://fox2now.com/2012/08/19/the-jaco-report-august-19-2012/>. Accessed: 20 February 2013.

Jameson, Fredric. 'Marx's Purloined Letter'. *Ghostly Demarcations: A Symposium on Jacques Derrida's Specters of Marx.* Ed. Michael Sprinkler. London: Verso, 2008.

———. *Postmodernism, or, the Cultural Logic of Late Capitalism.* Durham: Duke University Press, 1991.

Johnson, Leslie, and Justine Lloyd, eds. *Sentenced to Everyday Life: Feminism and the Housewife.* London: Berg, 2004.

Jones, Carl. *The Secret Life of the Expectant Mother: Nine Months of Mysterious Intuitions and Heightened Perceptions.* New York: Citadel Press, 1997.

Jowett, Lorna. 'Lab Coats and Lipstick: Smart Women Reshape Science on Television.' *Geek Chic: Smart Women in Popular Culture.* Ed. Sherrie A. Inness. New York: Palgrave, 2007. 31–48.

Kahane, Claire. 'The Gothic Mirror'. *The (M)other Tongue: Essays in Feminist Psychoanalytic Interpretation.* Ed. Shirley Nelson Garner, Claire Kahane and Madelon Sprengnether. Ithaca: Cornell University Press, 1985. 334–51.

Karlyn, Kathleen Rowe. *Unruly Girls, Unrepentant Mothers: Redefining Feminism on Screen.* Austin: University of Texas Press, 2011.

Karras, Irene. 'The Third Wave's Final Girl'. *thirdspace: a journal of feminist theory & culture* 1.2 (March 2002): <http://www.thirdspace.ca/journal/article/view Article/karras/50>. Accessed: 8 November 2012. 23 paras.

Kearney, Mary Celeste. 'When *Mad Men* Pitches Feminism: Popular Education and Historical Witnessing Through DVD Special Features'. *Memory Connection* 1.1 (2011): 42–35.

Kelly, Robin. *Thelonius Monk: The Life and Times of an American Original.* New York: Free Press, 2009.

Klein, Naomi. *The Shock Doctrine: The Rise of Disaster Capitalism.* London: Penguin, 2007.

Knight, Peter. *Conspiracy Culture: From Kennedy to The X-Files.* London: Routledge, 2000.

Kristeva, Julia. *Powers of Horror: An Essay on Abjection.* 1980. Trans. Leon S. Roudiez. New York: Columbia University Press, 1982.

Krouse, Tonya. 'Every Woman Is a Jackie or a Marilyn: The Problematics of Nostalgia'. *Analyzing* Mad Men*: Critical Essays on the Television Series.* Ed. Scott F. Stoddart. Jefferson: McFarland & Company, 2011. 186–204.

Leonard, Suzanne. '"I Hate My Job, I Hate Everybody Here": Adultery, Boredom, and the "Working Girl" in Twenty-First-Century American Cinema'. *Interrogating Postfeminism: Gender and the Politics of Culture.* Ed. Yvonne Tasker and Diane Negra. Durham and London: Duke University Press, 2007. 100–31.

Levin, Ira. *The Stepford Wives.* New York: Random House, 1972.

Lewis, Reina. 'Looking Good: The Lesbian Gaze and Fashion Imagery'. *Feminist Review* 55 (1997): 92–109.

Malatino, Hilary. 'The Becoming-Woman of the Young-Girls: Revisiting Riot Grrrl, Rethinking Girlhood'. *Rhizomes* 22 (2011): <http://www.rhizomes. net/issue22/malatino.html.> Accessed: 10 October 2012. 27 paras.

Manners, Marilyn. 'All the Stupid "Sex Stuff" or Fun with Feminism at the End of the Millennium'. *Strategies* 12.1 (1999): 25–33.

Marcus, Jane. 'Thinking Back Through Our Mothers'. *New Feminist Essays on Virginia Woolf*. Ed. Jane Marcus. London: Macmillan, 1981.

Marston, William Moulton. *Wonder Woman: A Ms. Book*. Intro. Gloria Steinem. With an interpretive essay by Phyllis Chesler. New York: Holt, Rinehart, and Winston, 1972.

Marston, William Moulton, and H.G. Peter. *The Wonder Woman Archives: Volume 1*. New York: DC Comics, 1998.

McCabe, Janet. 'In Debate: Remembering 9/11: Terror, Trauma and Television 10 Years On'. *Critical Studies in Television* 7.1 (2012): 79–82.

McClary, Susan. *Feminine Endings: Music, Gender and Sexuality*. Minneapolis: University of Minnesota Press, 2002.

McRobbie, Angela. *The Aftermath of Feminism: Gender Culture and Social Change*. London: Sage, 2009.

———. *Feminism and Youth Culture: From 'Jackie' to 'Just Seventeen'*. Boston: Unwin Hyman, 1991.

McVeigh, Karen. 'Romney's abortion comments leave campaign scrambling to unify ticket'. *The Guardian* (10 October 2012): <http://www.guardian. co.uk/world/2012/oct/10/romney-abortion-comments-ryan-differences>. Accessed: 10 December 2012. 22 paras.

Meyer, Stephenie. *Breaking Dawn*. London: Atom, 2008.

———. *New Moon*. London: Atom, 2007.

———. *Twilight*. London: Atom, 2006.

Meyers, Helene. *Femicidal Fears: Narratives of the Female Gothic Experience*. Albany: State University of New York Press, 2001.

Millett, Kate. *Sexual Politics*. 1970. London: Virago, 1997.

Moers, Ellen. *Literary Women*. London: Women's Press, 1976.

Morgan, Robin. *Sisterhood is Powerful: An Anthology of Writing from the Women's Liberation Movement*. New York: Vintage, 1970.

Munford, Rebecca. '"The Desecration of the Temple"; or, "Sexuality as Terrorism"? Angela Carter's (Post)feminist Gothic Heroine'. *Gothic Studies* 9.2 (Nov 2007): 58–70.

Murugan, Meenasarani Linde. 'Maidenform: Temporalities of Fashion, Femininity, and Feminism'. *Analyzing* Mad Men: *Critical Essays on the Television Series*. Ed. Scott F. Stoddart. Jefferson: McFarland & Company, 2011. 166–85.

Natoli, Joseph P. *Postmodern Journeys*. New York: State of New York University Press, 2000.

Negra, Diane. *What a Girl Wants? Fantasizing the Reclamation of Self in Postfeminism*. London: Routledge, 2009.

Nurka, Camille. 'Postfeminism Autopsies'. *Australian Feminist Studies* 17.38 (2002): 177–89.

Oakley, Ann. *From Here to Maternity: Becoming a Mother*. Harmondsworth: Penguin, 1981.

———. *Housewife*. Harmondsworth: Penguin, 1974.

Orloff, Judith. *The Second Sight*. 2nd edn. New York: Three Rivers, 2010.

Oxford English Dictionary Online. <http://www.oed.com/>.

Paglia, Camille. *Sex, Art and American Culture: Essays*. New York: Vintage, 1992.

Palmer, Paulina. *Lesbian Gothic: Transgressive Fictions*. London: Cassell. 1999.

Pearson, Allison. *I Don't Know How She Does It*. London: Vintage, 2003.

Pender, Patricia. '"Kicking Ass is Comfort Food": Buffy as Third Wave Feminist Icon'. *Third Wave Feminism: A Critical Exploration*. Ed. Stacy Gillis, Gillian Howie and Rebecca Munford. 2nd rev. edn. Basingstoke: Palgrave, 2007. 224–36.

Philips, Melanie. 'These Slut Walks prove feminism is now irrelevant to most women's lives'. *Daily Mail* (13 June, 2011): <http://www.dailymail.co.uk/debate/article-2002887/Slut-Walks-prove-feminism-irrelevant-womens-lives.html>. Accessed: 21 February 2013. 39 paras.

Pisters, Patricia. 'Madonna's Girls in the Mix: Performance of Femininity Beyond the Beautiful'. *Madonna's Drowned Worlds: New Approaches to Her Cultural Transformations*. Ed. Santiago Fouz-Hernández and Freya Jarman-Ivens. Aldershot, Hants: Ashgate, 2004. 22–35.

Plain, Gill, and Susan Sellers. 'Introduction'. *A Cambridge History of Feminist Literary Criticism*. Ed. Gill Plain and Susan Sellers. Cambridge: Cambridge University Press, 2007. 1–3.

Pollock, Griselda. *Vision and Difference: Femininity, Feminism and the Histories of Art*. London: Routledge, 1988.

Press, Andrea, and Terry Strathman. 'Work, Family and Social Class in Television Images of Women: Prime-Time Television and the Construction of Postfeminism'. *Women and Language* 16.2 (1993): 7–15.

Probyn, Elspeth. 'Perverts By Choice: Towards an Ethics of Choosing'. *Feminism Beside Itself*. Ed. Diane Elam and Robyn Wiegman. New York: Routledge, 1995. 261–81.

Projansky, Sarah. 'Mass Magazine Cover Girls: Some Reflections on Postfeminist Girls and Postfeminism's Daughters'. *Interrogating Postfeminism: Gender and the Politics of Popular Culture*. Ed. Yvonne Tasker and Diane Negra. Durham and London: Duke University Press, 2007. 40–72.

————. *Watching Rape: Film and Television in Postfeminist Culture*. New York: New York University Press, 2001.

Radner, Hilary. 'Pretty Is as Pretty Does: Free Enterprise and the Marriage Plot'. *Film Theory Goes to the Movies*. Ed. Jim Collins, Hilary Radner and Ava Preacher Collins. New York: Routledge, 1993. 56–76.

Reagan, Leslie J. *When Abortion Was A Crime: Women, Medicine, and Law in the United States, 1867–1973*. Berkeley and Los Angeles: University of California Press, 1997.

Redfern, Catherine. '*Reclaiming the F-Word*: More Info'. *Contemporary UK Feminism: The F-Word* (30 May 2010): <http://www.reclaimingthefword.net/book/>. Accessed: 25 January 2013. 2 paras.

Redfern, Catherine, and Kristin Aune. *Reclaiming the F-Word: The New Feminist Movement*. London and New York: Zed, 2010.

Reynolds, Simon. *Retromania: Pop Culture's Addiction to its own Past*. London: Faber and Faber, 2011.

Rich, Adrienne. 'Dearest Arturo'. *What is Found There: Notebooks on Poetry and Politics*. New York and London: W. W. Norton and Company, 1993. 22–27.

————. *Of Woman Born: Motherhood as Experience and Institution*. 1976. London: Virago, 1977.

Richardson, Niall. 'As Kamp as Bree: Post-feminist Camp in *Desperate Housewives*'. *Reading* Desperate Housewives: *Beyond the Picket Fence*. Ed. Kim Akass and Janet McCabe. London: I.B.Tauris, 2006. 86–94.

Ringrose, Jessica. *Postfeminist Education? Girls and the Sexual Politics of Schooling*. Abingdon and New York: Routledge, 2013.

Rohy, Valerie. *Anachronism and Its Others: Sexuality, Race, Temporality*. New York: State University of New York Press, 2009.

Roiphe, Katie. *The Morning After: Sex, Fear, and Feminism*. Boston: Little Brown, 1993.

Roof, Judith. 'Generational Difficulties; or, The Fear of a Barren History'. *Generations: Academic Feminists in Dialogue*. Ed. Devoney Looser and E. Ann Kaplan. Minneapolis: University of Minnesota Press, 1997. 68–87.

Rushdy, Ashraf H. A. *Remembering Generations: Race and Family in Contemporary African American Fiction*. Chapel Hill: University of North Carolina Press, 2001.

Russo, Mary. *The Female Grotesque: Risk, Excess and Modernity*. London: Routledge, 1994.

Sarachild, Kathie. 'The Power of History'. *Feminist Revolution: An Abridged Edition with Additional Writings*. Ed. Kathie Sarachild. New York: Random House, 1978. 12–43.

Schwichtenberg, Cathy, ed. *The Madonna Connection: Representational Politics, Subcultural Identities, and Cultural Theory*. Boulder: Westview Press, 1993.

Sconce, Jeffrey. *Haunted Media: Electronic Presence from Telegraphy to Television.* Durham: Duke University Press, 2000.

Scott, Linda M. *Fresh Lipstick: Redressing Fashion and Feminism.* New York: Palgrave Macmillan, 2005.

Sedgwick, Eve Kosofsky, 'The Character in the Veil: Imagery of the Surface in the Gothic Novel'. *PMLA* 96 (1981): 255–70.

———. *The Coherence of Gothic Conventions.* 2nd edn. London: Methuen, 1986.

Sheridan, Emily. 'Madonna finally breaks silence over Lady Gaga song'. *Daily Mail* (14 January 2012): <http://www.dailymail.co.uk/tvshowbiz/article-2086396/Madonna-finally-breaks-silence-Lady-Gagas-Born-This-Way.html>. Accessed: 21 January 2013. 17 paras.

Showalter, Elaine. *The Female Malady: Women, Madness and English Culture, 1830–1980.* London: Virago 1987.

———. *Sister's Choice: Tradition and Change in American Women's Writing.* Oxford: Clarendon Press, 1991.

Siegel, Deborah L. 'Reading Between the Waves: Feminist Historiography in a "Postfeminist" Moment'. *Third Wave Agenda: Being Feminist, Doing Feminism.* Minneapolis: Minnesota University Press, 1997.

Simons, Margaret A. *Feminist Interpretations of Simone de Beauvoir.* University Park, PA: Pennsylvania State University Press, 1995.

Smith, Andrew, and Diana Wallace. 'The Female Gothic: Then and Now'. *Gothic Studies* 6.1 (2004): 1–7.

Spare Rib. Vol. 197–207. Spare Rib Ltd., 1989.

Spencer-Steigner, Steven, and Britta Wheeler. 'Madonna, the Libertine?' *Thresholds: Viewing Culture* 7 (1993): 65–80.

Spicer, Tracy. 'Germaine Greer Would Be So Proud'. *Sunday Telegraph (Australia)* (5 March 2011): <http://www.couriermail.com.au/ipad/women-reclaiming-their-power/story-fn6cc53j-1226016351627>. Accessed: 21 February 2013. 43 paras.

Steinem, Gloria. 'Foreword'. *To Be Real: Telling the Truth and Changing the Face of Feminism.* Ed. Rebecca Walker. New York: Anchor, 1995. xiii–xxviii.

———. 'Humanism and the Second Wave'. *Humanist* (May–June 1987): 11–15, 49.

———. 'Introduction'. *Wonder Woman.* New York: Abbeville Press, 1995. 5–19.

———. 'Sex, Lies, and Advertising'. *Women: A Feminist Perspective.* 5th edn. Ed. Jo Freeman. Mountain View, California: Mayfield Publishing, 1995. 316–30.

Tasker, Yvonne. *Spectacular Bodies: Gender, Genre and the Action Cinema.* London: Routledge, 1993.

Tasker, Yvonne, and Diane Negra. 'Introduction: Feminist Politics and Postfeminist Culture'. *Interrogating Postfeminism: Gender and the Politics of Popular Culture.*

Ed. Yvonne Tasker and Diane Negra. Durham and London: Duke University Press, 2007. 1–25.

Taylor, Tosha. "'Girls Like This Stuff, Right?'": DC's *New 52* and the Problem of the Female Comic Book Fan'. Paper presented at *Going Underground?: Gender and Subcultures*. Northumbria Univeristy, UK. 7 September 2012.

Tropp, Laura. 'Faking a Sonogram: Representations of Motherhood in *Sex and the City*'. *Journal of Popular Culture* 39.5 (2006): 861–77.

Turner, Anthea. *How to Be the Perfect Housewife*. London: Virgin, 2010.

Valenti, Jessica. *The Purity Myth: How America's Obsession with Virginity is Hurting Young Women*. Berkeley: Seal, 2009.

Vidler, Anthony. *The Architectural Uncanny: Essays in the Modern Unhomely*. Cambridge: MIT Press, 1992.

Walby, Sylvia. *The Future of Feminism*. Cambridge: Polity, 2011.

Walker, Rebecca. 'Becoming the Third Wave'. *Ms.* 39 (Jan.–Feb. 1992): 41.

Walkerdine, Valerie. *Daddy's Girl: Young Girls and Popular Culture*. Basingstoke: Macmillan, 1997.

Wallace, Rob. 'Terrorism and the Politics of Improvisation'. *The Politics of Post-9/11 Music: Sound, Trauma, and the Music Industry in the Time of Terror*. Farnham: Ashgate, 2011. 79–92.

Warner, Marina. *Monuments and Maidens: The Allegory of the Female Form*. London: Vintage, 1996.

Waters, Melanie. 'Fangbanging: Sexing the Vampire in Alan Ball's *True Blood*'. Ed. Basil Glynn, James Aston and Beth Johnson. *Television, Sex and Society: Analyzing Contemporary Representations*. London: Continuum, 2012. 33–46.

———. 'The Horrors of Home: Femininity and Feminism in the Suburban Gothic'. *Women on Screen: Femininity and Feminism in Visual Culture*. Ed. Melanie Waters. Basingstoke: Palgrave, Macmillan, 2011. 59–73.

Weisman, Jonathan, and John Eligon. 'G.O.P. Trying to Oust Akin from Race for Rape Remarks'. *New York Times* (20 August 2012): <http://www.nytimes.com/2012/08/21/us/politics/republicans-decry-todd-akins-rape-remarks.html?pagewanted=all&_r=0>. Accessed: 8 November 2012. 25 paras.

Werde, Bill. 'Good Romance'. *Billboard*. 26 February, 2011. 32–36.

Westervelt, Bruce. 'Madonna's camp denies approving of "Born This Way"'. *Examiner* (18 February 2011): <http://www.examiner.com/article/madonna-s-camp-denies-approving-of-lady-gaga-s-born-this-way>. Accessed: 8 November 2012. 7 paras.

Wheatley, Helen. *Gothic Television*. Manchester: Manchester University Press, 2006.

Whelehan, Imelda. *The Feminist Bestseller: From Sex and the Single Girl to Sex and the City*. Basingstoke: Palgrave, 2005.

———. 'Having it all (again?)'. Paper presented at ESRC Seminar on *New Femininities*. London School of Economics, UK.19 November 2004.

———. *Modern Feminist Thought: From the Second Wave to 'Post-Feminism.'* Edinburgh: Edinburgh University Press, 1995.

———. *Overloaded: Popular Culture and the Future of Feminism*. London: Women's Press, 2000.

White, Mimi. 'Mad Women'. Mad Men*: Dream Come True TV*. Ed. Gary R. Edgerton. London: I.B.Tauris, 2011. 147–58.

Whiteley, Sheila. *Women and Popular Music: Sexuality, Identity and Subjectivity*. London: Routledge, 2000.

Wilcox, Rhonda. 'Foreword: Out Far or In Deep'. *Athena's Daughters: Television's New Women Warriors*. Ed. Frances Early and Kathleen Kennedy. Syracuse: Syracuse University Press, 2003. ix–xii.

Wilkes, Paul. 'Mother Superior to Women's Lib'. *New York Times Magazine* (29 November 1970): 27–29, 140–43, 149–50.

Willis, Ellen. 'Foreword'. Alice Echols. *Daring to Be Bad: Radical Feminism 1967–1975*. Minneapolis: University of Minnesota Press, 1989. vii–xvi.

Wilson, Elizabeth. *The Sphinx in the City: Urban Life, the Control of Disorder, and Women*. London: Virago, 1991.

Winnicott, D. W. *The Maturational Processes and the Facilitating Environment: Studies in the Theory of Emotional Development*. Hogarth Press: Institute of Psycho-Analysis, 1965.

Wolf, Naomi. *The Beauty Myth: How Images of Beauty Are Used Against Women*. 1990. London: Vintage, 1991.

———. *Fire with Fire: The New Female Power and How to Use It*. New York: Random House, 1993.

———. 'Sex and the Sisters.' *The Sunday Times* (20 July 2003): <http://www.thesundaytimes.co.uk/sto/news/article223358.ece.>. Accessed: 10 October 2012. 64 paras.

Wolff, Janet. 'Gender and the Haunting of Cities (Or, the Retirement of the Flâneur)'. *The Invisible Flâneuse?: Gender, Public Space, and Visual Culture in Nineteenth-Century Paris*. Ed. Aruna D'Souza and Tom McDonough. Manchester: Manchester University Press, 2006. 18–31.

Wollstonecraft, Mary. *A Vindication of the Rights of Woman*. 1792. Ed. Miriam Brody. London: Penguin, 1992.

Wolstenholme, Susan. *Gothic (Re)visions: Writing Women as Readers*. Albany: State University of New York Press, 1993.

Woolf, Virginia. *A Room of One's Own. A Room of One's Own and Three Guineas*. 1929. Ed. Hermione Lee. London: Vintage, 2001. 1–98.

———. 'Professions for Women'. 1931. *The Crowded Dance of Modern Life*. London: Penguin, 1993. 101–106.

————. 'Street Haunting: A London Adventure'. 1927. *The Crowded Dance of Modern Life*. London: Penguin, 1993. 70–81.

Zieger, Susan. 'Sex and the Citizen in *Sex and the City*'s New York'. *Reading* Sex and the City. Ed. Kim Akass and Janet McCabe. London: I.B.Tauris, 2004. 96–111.

Television and Film

Alias. ABC, 2001-2006.

Ally McBeal. Fox, 1997–2002.

American Horror Story. FX, 2011–.

 1.1. 'Pilot'. Dir. Ryan Murphy. 5 October 2011.

 1.2. 'Home Invasion'. Dir. Alfonso Gomez-Rejon. 12 October 2011.

 1.3. 'Murder House'. Dir. Bradley Buecker. 19 October 2011.

 1.4. 'Halloween (Part 1)'. Dir. David Semel. 26 October 2011.

 1.5. 'Halloween (Part 2)'. Dir. David Semel. 2 November 2011.

 1.6. 'Piggy Piggy'. Dir. Michael Uppendahl. 9 November 2011.

 1.7. 'Open House'. Dir. Tim Hunter. 16 November 2011.

 1.8. 'Rubber Man'. Dir. Miguel Arteta. 23 November 2011.

 1.12. 'Afterbirth'. Dir. Bradley Buecker. 21 December 2011.

 2.1. 'Welcome to Briarcliff'. Dir. Bradley Buecker. 17 October 2012.

 2.2. 'Tricks and Treats'. Dir. Bradley Buecker. 24 October 2012.

'Born This Way'. Perf. Lady Gaga. Dir. Nick Knight. Interscope. 28 February 2011.

Buffy the Vampire Slayer. WB, 1997–2001; UPN, 2001–2003.

 1.1. 'Welcome to the Hellmouth'. Dir. Charles Martin Smith. 10 March 1997.

 1.1. 'Welcome to the Hellmouth'. Audio commentary included on DVD issue of *Buffy the Vampire Slayer: Season 2*. 20th Century Fox, 1998.

 1.3. 'Witch'. Dir. Stephen Cragg. 17 March 1997.

 1.4. 'Teacher's Pet'. Dir. Bruce Seth Green. 24 March 1997.

 2.4. 'Inca Mummy Girl'. Dir. Ellen S. Pressman. 6 October 1997.

 2.11. 'Ted'. Dir. Bruce Seth Green. 22 September 1997.

 3.11. 'Gingerbread'. Dir. James Whitmore Jr. 12 January 1999.

 3.20. 'The Prom'. Dir. David Solomon. 11 May 1999

 4.1. 'The Freshman'. Dir. Joss Whedon. 5 October 1999.

 4.9. 'Something Blue'. Dir. Nick Marck. 30 November 1999.

 4.14. 'Goodbye Iowa'. Dir. David Solomon. 15 February 2000.

 4.22. 'Restless'. Dir. Joss Whedon. 23 May 2000.

 5.16. 'The Body'. Dir. Joss Whedon. 27 February 2001.

 5.17. 'Forever'. Dir. Marti Noxon. 17 April 2001.

5.22. 'The Gift'. Dir. Joss Whedon. 22 May 2001.

6.7. 'Once More, with Feeling'. Dir. Joss Whedon. 6 November 2001.

6.16. 'Hell's Bells'. Dir. David Solomon. 5 March 2002.

6.17. 'Normal Again'. Dir. Rick Rosenthal.12 March 2002.

6.20. 'Villains'. Dir. David Solomon. 14 May 2002.

7.7. 'Conversations with Dead People'. Dir. Nick Marck. 12 November 2002.

7.22. 'Chosen'. Dir. Joss Whedon. 20 May 2003.

Charmed. The WB, 1998–2006.

2.14. 'Pardon My Past'. Dir. John Paré. 17 February 2000.

Desperate Housewives. ABC, 2004–12.

1.1 'Pilot'. Dir. Charles McDougall. 3 October 2004.

3.5. 'Nice She Ain't'. Dir. David Warren.22 October 2006.

3.12. 'Not While I'm Around'. Dir. David Grossman. 14 January 2007.

5.8. 'City on Fire'. Dir. David Grossman. 16 November 2008.

The Devil Inside. Dir. William Brent Bell. Paramount, 2012.

Dollhouse. Fox, 2009–10.

Ghost Whisperer. CBS, 2005–10.

1.1 'Pilot'. Dir. John Gray. September 23, 2005.

Girls. HBO, 2012–.

1.2. 'Vagina Panic'. Dir. Lena Dunham. 22 April 2012.

Homeland. Showtime, 2011–.

1.1. 'Pilot'. Dir. Michael Cuesta. 2 October 2011.

1.2. 'Grace'. Dir. Michael Cuesta. 9 October 2011.

1.3. 'Clean Skin'. Dir. Dan Attias. 16 October 2011.

1.4. 'Semper I'. Dir. Jeffrey Nachmanoff. 23 October 2011.

1.5. 'Blind Spot'. Dir. Clark Johnson. 30 October 2011.

1.6. 'The Good Soldier'. Dir. Brad Turner. 6 November 2011.

1.7. 'The Weekend'. Dir. Michael Cuesta. 13 November 2011.

1.8. 'Achilles Heel'. Dir. Tucker Gates. 20 November 2011.

1.11. 'The Vest'. Dir. Clark Johnson. 11 December 2011.

1.12. 'Marine One'. Dir. Michael Cuesta. 18 December 2011.

2.1. 'The Smile'. Dir. Michael Cuesta. 30 September 2012.

Juno. Dir. Jason Reitman. Fox, 2007.

Knocked Up. Dir. Judd Apatow. Universal, 2007.

The Last Exorcism. Dir. Daniel Stamm. Lionsgate, 2010.

Mad Men. AMC, 2007–.

1.1. 'Smoke Gets in Your Eyes'. Dir. Alan Taylor. 19 July 2007.

1.6. 'Babylon'. Dir. Andrew Bernstein.23 August 2007.

1.13. 'The Wheel'. Dir. Matthew Weiner. 18 October 2007.

2.3. 'The Benefactor'. Dir. Lesli Linka Glatter. 10 August 2008.

2.4. 'Three Sundays'. Dir. Tim Hunter. 17 August 2008.

2.5. 'The New Girl'. Dir. Jennifer Getzinger. 24 August 2008.

2.6. 'Maidenform'. Dir. Phil Abraham. 31 August 2008.

2.8. 'A Night to Remember'. Dir. Lesli Linka Glatter. 14 September 2008.

3.5. 'The Fog'. Dir. Phil Abraham. 13 September 2009.

4.6. 'Waldorf Stories'. Dir. Scott Hornbacher. 29 August 2010.

5.8. 'Lady Lazarus'. Dir. Phil Abraham. 6 May 2012.

5.11. 'The Other Woman'. Dir. Phil Abraham. 27 May 2012.

5.12. 'Commissions and Fees'. Dir. Christopher Manley. 3 June 2012.

5.13. 'The Phantom'. Dir. Matthew Weiner. 10 June 2012.

'Birth of An Independent Woman'. Dir. Cicely Gilkey. Special feature included on DVD of *Mad Men: Season 2*. Lionsgate, 2009.

The Mary Tyler Moore Show. CBS, 1970–77.

Medium. NBC, 2005–09; CBS, 2009–11.

1.1. 'Pilot'. Dir. Glenn Gordon Caron. 23 January 2005.

1.6. 'Coming Soon'. Dir. Vincent Misiano. 7 February 2005.

2.5. 'Sweet Dreams'. Dir. Aaron Lipstadt. 17 October 2005.

2.14. 'A Changed Man'. Dir. Lewis H. Gould. 6 February 2006.

3.12. 'The One Behind the Wheel'. Dir. Leon Ichaso. 14 February 2007.

4.3. 'To Have and To Hold'. Dir. Aaron Lipstadt. 21 January 2008.

4.9. 'Wicked Game (Part 1)'. Dir. Peter Werner. 24 March 2008.

4.10. 'Wicked Game (Part 2)'. Dir. Arlene Sanford. 31 March 2008.

5.4. 'About Last Night'. Dir. Aaron Lipstadt. 23 February 2009.

5.5. 'A Taste of Her Own Medicine'. Dir. Ronald L. Schwary. 2 March 2009.

5.11. 'The Devil Inside (Part 1)'. Dir. Peter Werner. 20 April 2009.

6.12. 'Dear Dad…'. Dir. Aaron Lipstadt. 4 December 2009.

6.19. 'Sal'. Dir. Craig Sweeny. 30 April 2010.

6.20. 'Time Keeps on Slipping'. Dir. Miguel Sandoval. 7 May 2010.

7.1. 'Bring your Daughter to Work Day'. Dir. Aaron Lipstadt. 24 September 2010.

My Living Doll. CBS, 1964–65.

1.1 'Boy Meets Girl'. Dir. Lawrence Dobkin. 27 September 1964.

New in Town. Dir. Jonas Elmer. Lionsgate, 2009.

Point Pleasant. Fox, 2005.

1.1 'Pilot'. Dir. Tucker Gates. 19 January 2005.

Real Housewives of Orange County. Bravo, 2006–.

The Rite. Dir. Mikael Håfström. Warner Bros., 2011.

Rosemary's Baby. Dir. Roman Polanski. Paramount, 1968.

The Secret Circle. The CW, 2011–12.

1.21. 'Prom' Dir. Alex Zakrzewski. 3 May 2012.

Sex and the City. HBO, 1998–2004.

 1.1. 'Sex and the City'. Dir. Susan Seidelman. 6 June 1998.

 1.5. 'The Power of Female Sex'. Dir. Susan Seidelman. 5 July 1998.

 4.3 'Defining Moments'. Dir. Allen Coulter. 10 June 2001.

 4.7. 'Time and Punishment'. Dir. Michael Engler. 8 July 2001.

 4.18. 'I heart NY'. Dir. Martha Coolidge. 10 February 2002.

 6.9. 'A Woman's Right to Shoes'. Dir. Tim Van Patten. 17 August 2003.

Sex and the City 2. Dir. Michael Patrick King. Warner Bros., 2010.

The Stepford Wives. Dir. Bryan Forbes. Columbia, 1975.

The Stepford Wives. Dir. Frank Oz. Paramount, 2004.

Tru Calling. Fox 2003–05.

 1.5. 'Haunted'. Dir. Michael Katleman. 4 December 2003.

True Blood. HBO, 2008–.

 5.8. 'Somebody That I Used To Know'. Dir. Stephen Moyer. 29 July 2012.

The Twilight Zone. CBS, 1959–64.

 1.7. 'The Lonely'. Dir. Jack Smight. 13 November 1959.

 2.8. 'The Lateness of the Hour'. Dir. Jack Smight. 2 December 1960.

 3.35. 'I Sing the Body Electric'. Dir. William Claxton and James Sheldon. 16 May 1962.

Ugly Betty. ABC, 2006–2010.

 1.1. 'Pilot'. Dir. Silvio Horta. 26 September 2006.

 2.11. 'Dress for Success'. Dir. Matt Shakman. 8 January 2009.

 w3.1. 'The Manhattan Project'. Dir. Victor Nelli, Jr. 25 September 2008.

The X-Files. Fox, 1993–2002.

Index